LAND GIRL
SUFFRAGETTE

LAND GIRL SUFFRAGETTE

THE EXTRAORDINARY STORY OF OLIVE HOCKIN

Author • Artist • Arsonist

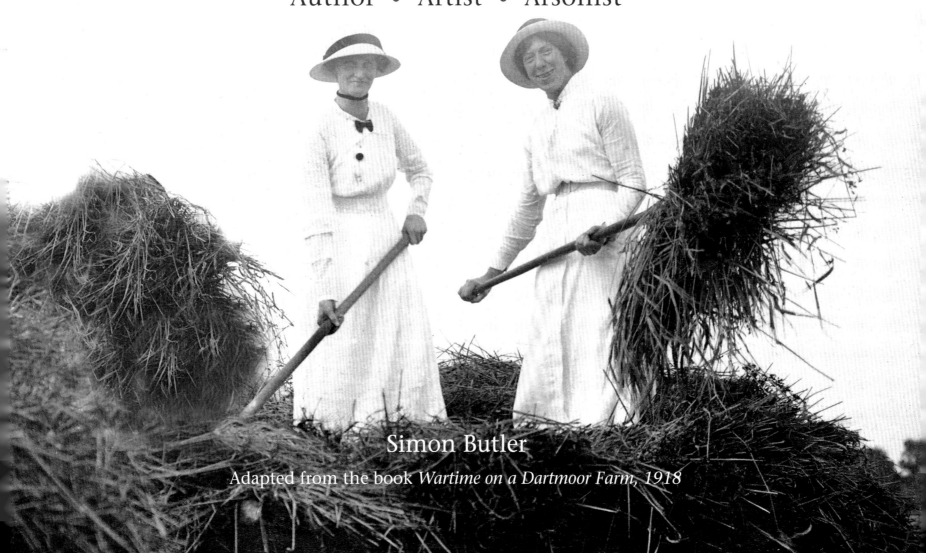

Simon Butler

Adapted from the book *Wartime on a Dartmoor Farm, 1918*

First published in Great Britain in 2016
Copyright © Simon Butler 2016

FOR ANN
& ANNA

British Library Cataloguing-in-Publication Data
A CIP record for this title is available from the British Library

ISBN 978 1 906690 62 5

HALSTAR
Halsgrove House,
Ryelands Business Park,
Bagley Road, Wellington, Somerset TA21 9PZ
Tel: 01823 653777 Fax: 01823 216796
email: sales@halsgrove.com

An imprint of Halstar Ltd, part of the Halsgrove group of companies
Information on all Halsgrove titles is available at: www.halsgrove.com

Printed and bound in China by Everbest Printing Investment Ltd

Policemen dash to arrest suffragettes determined to chain themselves to the railings of Buckingham Palace c.1914.

Contents

Acknowledgements 6

Foreword 7

Introduction 9

Two Girls on the Land 19

Postscript 141

Bibliography 143

Home Office list of suffragettes arrested between 1906–1914. It contains names and other details of over 1300 persons, including Olive Hockin, along with Sylvia and Emmeline Pankhurst, Annie Kenney and Emily Wilding Davison.

Acknowledgements

Thanks are due to Michelle Leared who kindly provided me with information regarding Olive's family. I am grateful too that she allowed me to photograph many of Olive's artworks owned by her late husband, Paul.

Thanks also to Rupert Maas who was gracious in providing background to Olive's life and paintings when he learned of my intention to republish *Two Girls on the Land*.

I am grateful also to V. Irene Cockcroft who generously provided information and a copy of the painting, believed to be of the Berkshire woodlands close to where Olive lived before the First World War. Irene's book *New Dawn Women*, telling the story of those women involved in the Arts & Crafts movement at the beginning of the twentieth century, is essential reading for those wishing to place in context the suffrage artists, among them Olive Hockin.

Harry Butler, of Los Angeles, eventually tracked down an original copy of *Two Girls on the Land*, in the University of Wisconsin Library. With only a damaged copy otherwise available, his kind help allowed me continue with the project.

Finally thanks to my colleagues at Halsgrove without whose enthusiasm, indulgence and expertise, writing books would be less enjoyable.

Foreword

A few years back, while researching my book *The Farmer's Wife: The Life and Work of Women on the Land*, I came across a brief reference to Olive Hockin and her book, published in 1918, *Two Girls on the Land*. This told the story of her year working on a farm on Dartmoor during the First World War – interesting to me as I have written about the war and have lived among farming people on Dartmoor for forty or so years.

By coincidence, around this time, I met the gallery owner and painting specialist Rupert Maas, who had recently appeared on the TV programme, *Antiques Roadshow*, where he valued a painting by Olive Hockin brought to him by its owner. Rupert put me in touch with Michelle Leared whose late husband, Paul, was Olive's grandson. Michelle kindly allowed me to photograph paintings and other ephemera belonging to Olive and provided important threads of information which helped to form the introductory chapter of this book.

The best known aspects of Olive Hockin's life revolve around her 'criminal' actions related to the suffrage movement in the years immediately preceding the First World War, information easily enough found. She is a noted but otherwise largely neglected participant in the militant feminist movement. Details of her life before and after this period are obscure and worthy of deeper biographical study – not the intended purpose of this book. The republication of *Two Girls on the Land* alone is a worthwhile undertaking for it provides a fascinating insight into country life during the world's first global conflict. In this, written by a woman, it is quite singular.

The years 1914–18, which saw the slaughter of almost a million men, the 'flower' of British youth, ironically provided the springboard which led to the emancipation of women and the 1928 Representation of the People (Equal Franchise) Act. Olive's book contains many direct references (along with unintentional insights) into her aspirations for the future progress of women in society, while she dedicated herself to the unremitting grind of working on an impoverished moorland farm. Nor are her descriptions of her fellow workers without humour – there's much of *Cold Comfort Farm* to be enjoyed in her writing. It's a pleasure to throw a little more light on the life of this remarkable person and to bring her work to a new readership.

Simon Butler
Manaton 2016

Olive Hockin in her studio.

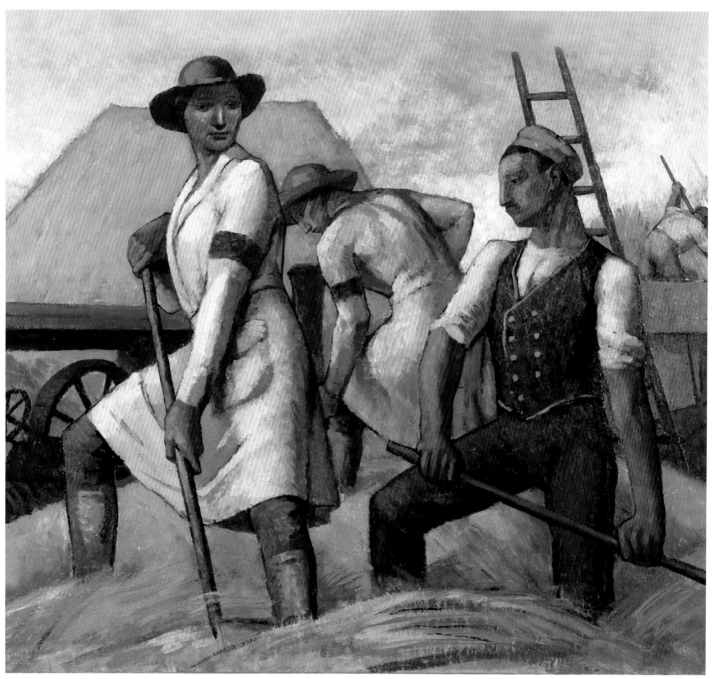

'The Women's Land Army and German Prisoners, 1918', by Randolph Schwabe. Lancashire-born Schwabe was unable to serve in the armed forces due to poor health but he was an official war artist in both the First and Second World Wars. Many of his paintings depict Women's Land Army workers. He became Principal of the Slade School of Fine Art in 1930, which Olive had attended a quarter of a century earlier.
© Reproduced with permission of the Imperial War Museum.

Introduction

On 20 February 1913 *The Times* reported the sensational news that a bomb had been planted at Pinfold Manor, a country retreat that was currently being built for Lloyd George, then Chancellor of the Exchequer. In fact two devices, each of five pounds of explosive, had been set on timers to detonate in the early hours of 19 February, one of which failed. The other, placed in an upstairs bedroom, caused considerable damage to the new property that stood close to Walton Heath golf course, a favoured haunt of the Prime Minister to be.

Outrage was poured upon outrage when it was discovered the culprits were women, members of the militant Women's Social and Political Union (WSPU), despised by many – and best known as suffragettes.

Nor were the culprits discovered through diligent police work, for on the very evening they were at work sorting through the wreckage for clues, Emmeline Pankhurst, one of the leaders of the suffrage movement, addressed a meeting of followers in Cardiff: 'We have blown up the Chancellor's house,' she declared. 'For all that has been done in the past I accept responsibility. I have advised, I have incited, I have conspired.' Relieved of the necessity of tracking down the real culprits, Pankhurst was arrested on 25 February and early the following month was given a three-year prison sentence. She immediately went on hunger strike.

It was to be a year of increasing militant activity by those determined to secure equal rights for women. Earlier in their campaign, attacks had been limited to

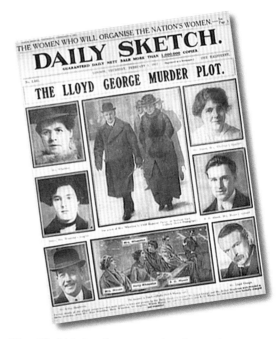

The Pinfold bombs were aimed at the destruction of property, but with typical media distortion, the bombers are accused of attempting to murder the Chancellor.

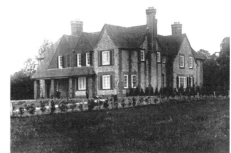

Pinfold Manor, on completion.

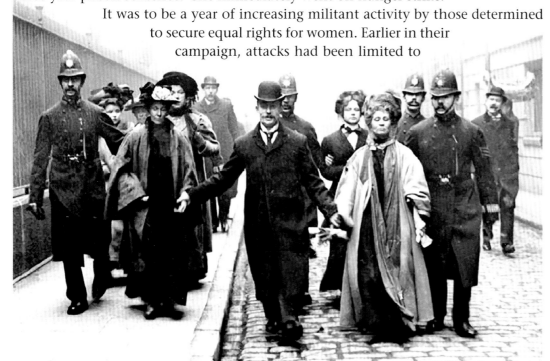

Emmeline Pankhurst under arrest in 1910.

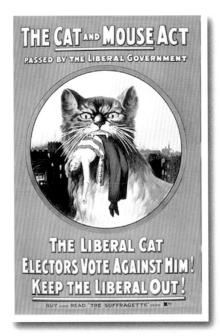

Poster campaigning against the so-called 'Cat and Mouse Act' which proposed that convicted women on hunger strike would be released until their health had recovered, when they would be sent back to prison.

The cry for equal political rights began to reach a noticeable pitch from the mid 1800s onwards. A notable event along the way is commemorated in Bertha Newcombe's painting 'The Apple Seller', completed in 1910. It depicts the instant in which John Stuart Mill MP is presented with the 1866 suffrage petition which, due to it's large size, has been hidden under the stall of an apple seller prior to delivery. Mill had agreed to present the petition to Parliament provided a hundred signatories could be found. In fact 1500 signed the petition – the last, it is said, being the name of the apple seller. The 1866 petition marked the start of organised campaigning by women for the vote.

government property, now bombings and arson attacks on personal property were seen as the only way in which women's voices would be heard. 'Militancy was right,' cried Mrs Pankhurst. 'No measure worth having has been won in any other way.' And Lloyd George was a particular target, for while professing support for women's rights, he recognised that politically there was lukewarm interest among the male electorate for universal suffrage.

Mid year saw the death of Emily Wilding Davison under the hooves of the King's horse at Epsom, a tragedy that became the most indelible of all the militants' protests. As the style of protest escalated so did the response of the authorities to what was seen as a major source of social unrest at a time when Europe itself was fomenting socialism and revolution. So called 'Cat and Mouse' laws, introduced in 1913, were enacted specifically to combat the growing number of imprisoned suffragettes who resorted to hunger strikes. This barbaric law allowed for the early release of prisoners who were so weakened by hunger that they were at risk of death, only to be recalled to prison once their health was recovered, where their sentence would continue.

Such draconian measures by the government remind us of the fear and confusion amongst politicians for whom, hitherto, World Order meant British Rule and whose political judgements were based on late Victorian values contained within a largely stable society. The Poor – while always a thorn in the side of the Establishment –

were relatively easy to deal with, but the momentum and leadership behind the suffrage movement came from within the upper middle classes. These 'New Dawn Women'* – women of wealth and influence, educated, artistic and embracing new ideals – posed a new and greater threat to a male-dominated hierarchy. Among these was Olive Hockin whose voice has been lost among more strident voices of those times, but whose life in many ways epitomises those of the thousands who fought and gave sacrifice for their right to a more equal society.

<div align="center">* * *</div>

Olive Hockin's relative obscurity among the better known protagonists of the suffrage movement has left the details of her life largely unrecorded. Even the date of her birth is contentious. On the face of it, she is typical of those educated and aspirational young people who, carried along by revolutionary fervour, were intent upon cultural as well as social change as society emerged from the strictures of late Victorian Britain and into the twentieth century. The beginnings of avant garde art movements, scientific discovery, religious non-conformity, socialism and psychoanalysis; all these gave the young, particularly those wealthy enough to indulge themselves, scope for experimentation in how they lived their lives.

In unravelling a little of Olive's background it becomes clearer how her childhood and family background would sow in her character the seeds of self reliance, independent thought and determination. Along with what is possible to discern from documentary study, such characteristics are equally evident in her writing.

Popular sources record that Olive was born in 1881, although it appears she was actually born in the previous year, on 20 December. Her father, Edward Hockin was aged 42 at the time of her birth, her mother Margaret Sarah Floyer in her mid twenties. Both father and mother came from Westcountry stock – the Hockins from Poughill near Bude in Cornwall, the Floyers from Devon. Edward was a local JP, according him social standing, but the Floyers were landed gentry providing society with generations of Oxford-educated barristers, churchmen and doctors. Margaret's father, Ayscoghe Floyer, was a Wadham College man, taking holy orders and a curacy at Marshchapel in Lincolnshire. Later his Devon roots drew him back to St Marychurch near Torquay where he married Louisa, daughter of the Hon. Mrs Shore. The pair had seven children, four boys and three girls. Pertinent to our story is Margaret's sister, Mabel Frances, who married Glynne Barrington Leared Williams, of Estancia San Anselmo, in Argentina.

Margaret was Edward's second marriage; his first, in 1861,was to Frances Mary Maxwell Wright. Frances died in 1873 but not before providing the couple with three children, Bessie, Eleanor and John, half-brothers and sisters to Olive. His second

An anti-government poster produced by the WSPU.

Throughout their campaigning suffragettes met with strong opposition and ridicule. The National League for Opposing Women's Suffrage produced pamphlets with such titles as 'Women's Emancipation by One Who Doesn't Want It.'

*See *New Dawn Women* by V. Irene Cockcroft

Anne Anderson's illustration for the story of The Snow Queen; typical of her later style of illustration. Anne and Olive met as teenagers in Argentina and, later, attended The Slade together.

A watercolour by Olive, dated 1905. It's an unusual subject, said to be the bazaar in Cairo, and although Olive was widely travelled there's no record of a Middle Eastern trip. The painting was made during the first period of Olive's attendance at The Slade and the mysticism apparent in her later work is entirely absent.

marriage took place in Marshchapel in 1876 and he and Margaret also had three children, including two boys Arthur Ayscoghe (1877) and Frank (1878). Olive's birth in December 1880 came just six months before her father, Edward, also died, on 29 May that year. Olive's mother later remarried, a gentleman, Townsend Kirkwood, and settled with him in his home near Burghfield, Berkshire.

Such a complex family history would inevitably inform the young Olive's character and perhaps it is from this we might look to discover something behind the forces that drove her to her later 'crimes'. Certainly we might discern an insecurity that translated into empathy for her less fortunate compatriots; a thread we follow throughout her memoir, *Two Girls on the Land*.

At some point in her teens we find Olive in Argentina and enjoying her first encounter with the Leared family. She is the guest of Olive's Aunt, Mabel Frances and her husband, Glynne, a trainer of polo ponies and a close relative of the Leared family. British cattlemen had introduce the sport to South America and successful breeders of polo ponies were highly esteemed. This is the home of Richard Hughes Leared (1832–1908) whose three sons, Frank, Richard and John became expert polo players, representing the famous Media Luna Club of Buenos Aires and appearing in championship matches at England's famous Hurlingham Club.

While staying at the Estancia San Anselmo, east of Bahia Blanca, Olive meets Anne Anderson, five years her senior, and the two become lifelong friends. On their return to England the pair enrol at The Slade School of Fine Art, Anne living with Olive's friend, Guinevere Donnithorne, at Palace Gardens, London. Anne shared with Olive her passion for the work of the Pre-Raphaelites, and particularly admired Olive's interpretation of their style, but was eventually drawn towards illustration for which she is now best known. In 1912 Anne married fellow illustrator Alan Wright and the pair moved to Little Audrey, gatehouse to Olive's mother's home at Burghfield Common, Berkshire.

Olive's own painting career found her continuing to attend The Slade, taking a mixture of full and part-time courses between 1901 and 1904, returning to study fine art between 1910-11. In 1908 Olive worked from a studio in South Edwards Square, Kensington, and later worked from a studio at 28 Campden Hill Gardens – the address at which she was arrested in 1913.

While still an admirer of the Pre-Raphaelites, her work was taking on a more spiritual quality influenced by Annie Besant, a theosophist, socialist and women's rights activist. Theosophism – whose adherents practice the art of self realisation, seeking to understand the mysteries of the natural world through spiritual enlightenment – was now at the heart of Olive's creative practice. She became a contributor to *Orpheus*, the journal of the Theosophical Art-Circle, and her major paintings began to take on an ethereal quality; esoteric and with echoes of the occult.

Photograph courtesy © I.V. Cockroft. Private Collection.

A watercolour by Olive Hockin showing two men fishing beside a lake. It is dated 1902, around the time Olive's mother moved to Burghfield in Berkshire, an area abounding with flooded gravel pits, and where Olive spent much time with members of her literary and artistic circle.

A painting on board in watercolour and pencil by Olive Hockin. It has more recently been catalogued with the title 'A Dryad' although it is inscribed on the verso "'Equipose' – Olive Leared. The end of psychoanalysis (with Carl Jung)." The use of Olive's married name confirms a date after 1922 and the implication that it involved psychoanalysis with Jung lends the work a considerable fascination. We know that Olive's friend Baynes was closely associated with Jung and that Olive was in love with Baynes according to Annabel Farjeon. In Diana Baynes Jansen's book Jung's Apprentice, *she records that in 1920 Olive accompanied Baynes' sister, Ruth, to Zurich where the two women spent time painting and walking. Ruth was persuaded by her brother to undergo analysis by Jung – is this what the painting refers to? Or did Olive herself undergo analysis?*

This move accords with her circle of friends; young lions of the literary and art world who are looking to sweep away old conventions – the Drugs, Sex and Rock & Roll generation of Edwardian England.

Centred on London, Olive shared links with the group through their respective homes in Berkshire, Olive's mother's home at Burghfield Common and her Uncle, Frederick Floyer's house at Mortimer, a few miles distant. Mortimer was also the home of Helton Godwin Baynes (1882–1943), a 'golden boy' of his generation who, among other talents, became a friend and translator of Carl Jung. Godwin was central to a group who called themselves 'The Four Just Men', which included Clifford and Arnold Bax, and Maitland Radford. Clifford, who also had attended The Slade (along with Godwin's brother, Keith), was a rising literary star, and editor of *Orpheus*; Arnold a future Master of the King's Music. Radford's family hovered on the periphery of the Bloomsbury circle, a friend of D.H. Lawrence and his wife Frieda. Other figures in the circle included the poets Robert Brooke, Edward Thomas, and Eleanor Farjeon.

The group dabbled with socialism, neo paganism and explored, theoretically at least, breaking down the barriers of sexual constraint. Baynes in particular was attractive to women and Olive fell under his spell, as described by Annabel Farjeon:

Baynes, who loved and was much loved by woman, went in for romantic paganism. One woman in love with him for years was a painter, Olive Hockin, with whom Eleanor now and then shared a lonely life in the Berkshire Woods.

Cryptic references to sexual encounters between members of the group leave us little wiser as to the physical extent of their passion, although many of the relationships, as described, are heavy with repressed homosexuality. In reading Olive Hockin's *Two Girls on the Land* the difficulty for the modern reader to escape the notion of a sapphic relationship between 'Sammy' and 'Jimmy' can't be ignored.

An untitled work by Olive Hockin similar in style and theme to her Dryad painting and likely to be of similar date.

A major work by Olive Hockin in oil on canvas, 35x35 inches. Undated, it is catalogued as 'A Cobwebbed Woodland' and contains elements of the artist's earlier works with her later move towards mysticism.

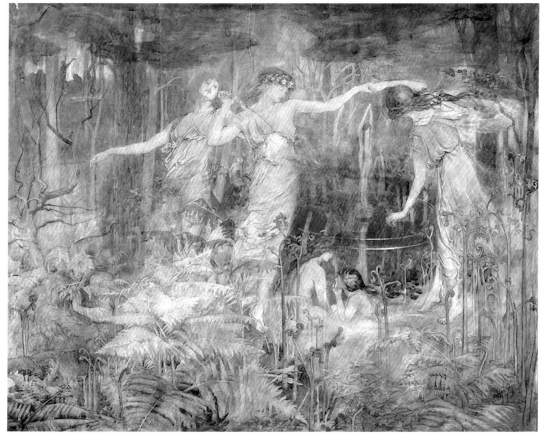

'Oh Pan! Pan! Bring back they reign again upon the earth!' A painting, dated 1914, which perhaps more than any other embodies in her work, Olive's adherence to theosophy whilst containing clear elements of the interests of her circle in neo paganism. Watercolour on paper 24x32 inches.

'The Woods at Night' by Olive Hockin, watercolour 20x15 inches.

Annabel Farjeon continues with a description of events when her sister, Eleanor, visits the Baynes' home at Mortimer. Here Olive suggests Eleanor spends the night with her in the Berkshire woods bordering a lake – this in order to help Eleanor overcome 'her lack of physical courage'. In the morning, Olive strips off and plunges into the lake, although failing to persuade Eleanor to join her:

In the middle of the lake, quite far away, a flat stone rose from a hidden base, like a little altar. 'There's something on it!' called Olive: 'Someone has been there.' She swam out, and presently came back smiling. 'It's a crown of wild parsely. Godwin has been sacrificing to the deity. Swim out and see.'

* * *

In July 1912 Sylvia Pankhurst, writing in the 19 July issue of *Votes for Women*, announces 'we have a new worker in our movement.' This is Olive Hockin, volun-

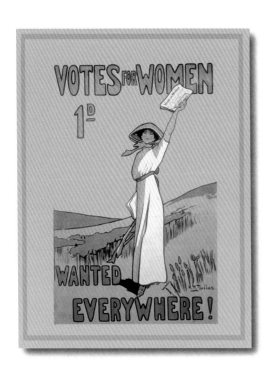

teering to prepare banners for the 'Bastille Day' rally in Hyde Park. This is the first reference we have of Olive's move towards militancy in the suffrage movement and in the following year comes the bomb blast at the Chancellor's country retreat.

While no evidence attributes Olive's hand in the Pinfold bombing, she was already marked out as a potentially dangerous militant by the authorities who were regarding the suffrage movement as a whole with increasing alarm. In March 1912, the WSPU, which had previously always given notice of their militant demonstrations, undertook mass breaking of windows along Oxford and Regent Street. Individuals, some of whom, like Emily Wilding Davison, already had multiple convictions to their name, perpetrated personal attacks on telegraph wires, postboxes and art galleries. In 1913 attacks on Royal Mail property and the destruction of letters was seen as a turning point in the WSPU use of militant tactics, moving away from the notion of gaining public sympathy in order to obtain equal rights, to outright coercion – a Government forced to act in the face of public outrage.

Golf courses and sports pavilions – seen largely as male preserves – became a favoured target and, on the night of 26 February 1913, just six days after the attack on Lloyd George's house, Roehampton golf pavilion was severely damaged by fire. A few days later, following surveillance, the police raided Olive's flat at 28 Campden

Convicted suffragettes refused to have their photographs taken for police records, making it difficult for the camera by moving or pulling faces. The authorities then resorted to subterfuge, embarking upon the first of what is now universally tolerated, surveillance photography. Police photographers followed subjects in the street or captured women while exercising in prison yards. These photographs were then edited – each being kept in a dossier along with details of the subject. Here four suffragettes are snapped, from left to right they are: Margaret Scott, Rachel Peace, Margaret Mc-Farlane and Olive Hockin.

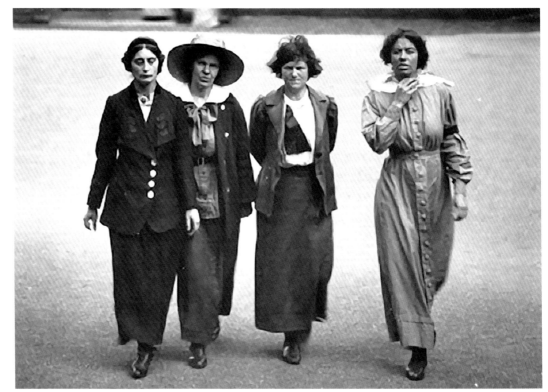

Hill Gardens, seizing evidence, and Olive was arrested. The police suspected Norah Smythe as her fellow arsonist but Olive alone was charged. While awaiting trial in Holloway Prison, Olive was to make history in being among the first persons to have their photograph taken for the purpose of undercover surveillance.

Her trial opened on 1 April, the charge reading as follows:

HOCKIN, Olive (32) , conspiring with others unknown to feloniously set fire to a building and certain matters and things therein, the property of the Roehampton Club, Limited, and to commit certain other offences against the Malicious Damage Act, 1861, and placing in a post office letter-box a certain fluid.

Over twenty witnesses appeared for the prosecution and masses of evidence was produced to connect the accused with both the pavilion fire and the damage to the letter box. Most damning was evidence found among the ruins of the pavilion – the remains of a copy of the *Daily Herald* and the *Suffragette* with Olive's name and address pencilled on them, presumably material intended to help start the fire.

In her defence, Olive told the court she had been attracted to the suffrage movement after she became aware of the evils of prostitution, believing that nothing would be done until women achieved equal power with men.

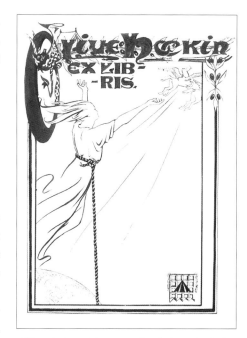

Olive designed her own bookplate depicting winged horses flying off into the heavens while a female figure remains bound to the earth. The little motif bottom right is interesting: a portcullis (traditionally representing the Crown) and the broad arrow (used to denote Government property – and the mark of the convict).

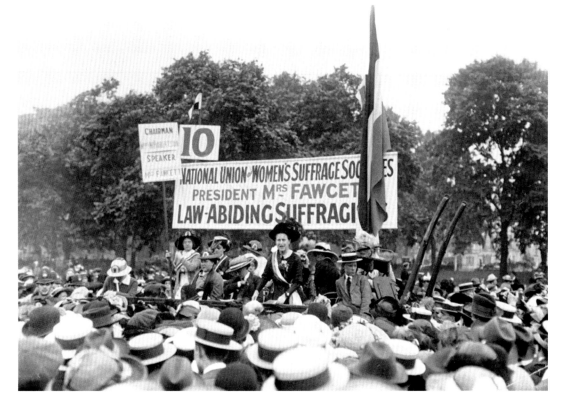

A 'Law-Abiding Suffragists' rally in Hyde Park. Millicent Fawcett was a moderate campaigner for universal suffrage and led the National Union of Women's Suffrage Societies which distanced itself from Pankhurst and the militant WSPU. By 1913 the former union had 50 000 members, compared to 2000 of the WSPU, and while the NUWSS continued campaigning throughout the war, the more militant union did not. Ironically the WSPU became more jingoistic in its support for the war while its larger sister contained many more pacifists.

Found guilty of arson in relation to the pavilion fire, but not guilty in the matter of the other offences, Olive was sentenced to four months' imprisonment and ordered to pay half the costs of the prosecution.

In common with many other convicted suffragettes Olive immediately threatened a hunger strike but eventually agreed to serve out her term so long as she was allowed to continue to paint.

We hear little of Olive following her release, except for her design of the cover for the front page of the summer issue of *Votes for Women* in June 1914. The month following, Mrs Pankhurst, after another arrest and hunger strike, fell seriously ill. On 16 July, while attending a WSPU meeting in Holland Park she was arrested yet again and taken away in a police ambulance. Less than a month later Britain was a war and a world that had once seemed so immutable was changed forever. Yet as far as militant suffrage was concerned it can also be seen as the eye of a storm, a hiatus in which the impending social revolution was put on hold for four years as those who had sacrificed so much for change set aside their demands and aspirations for the duration.

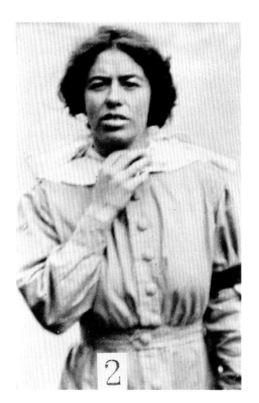

From a snapshot taken surreptitiously, the Home Office cropped this photograph of Olive which was then attached to her official records.

Two Girls on the Land

What follows is a complete and unedited copy of Olive Hockin's book *Two Girls on the Land*, her account of a year spent on a Dartmoor farm in 1917.* While it stands alone as an absorbing portrayal of rural life during the Great War, the photographs and notes accompanying the original work are there to provide background to the farming landscape as Olive knew it – a world that has largely disappeared.

Dartmoor in 1914 remained quite remote from the rest of Devon, cut off by the ruggedness of the terrain and intemperate climate. Remote farms stood at the end of unmetalled lanes, many without electric power (oil lamps providing light) and dependent upon their own water supply, often brought by a 'leat' – granite-lined miniature canals that wandered, sometimes for miles, across the open moor. Such spartan existences bred a stoic resistance to hardship and a rugged independence of outlook, as Olive encounters and records on numerous occasions.

Farming at heights often above 1500 feet, on thin acidic soil, cultivating small fields in which the most regular crop was stones, made for a precarious life, often little more than subsistence for many families. Sheep, a handful of hardy cattle, a milking cow and a yardful of chickens paints a fairly accurate picture. The open moor provided rough grazing while hay, oats and barley were grown as additional food for livestock. A bad winter and wet spring could bring such a livelihood close to the brink.

Railways circled the moor but only the Princetown line could be said to venture anywhere close to its heart. These links provided farmers with the opportunity of selling surplus produce to a wider market, and Olive describes her trips herding sheep down to the nearest depot. Trains also brought tourists, and from the end of the 1800s these visitors, curious to explore the darker recesses of this peculiar place, began to make their presence felt. Olive herself arrives by train, tramping three miles from the station to the farm. Frustratingly she doesn't identify the actual place, fictionalising it as By-the-Way Farm, and no doubt similarly disguising the names of the farmer and her fellow workers. It is possible, however, by unravelling some of the comments she makes regarding distances to known places, Tavistock for instance, to place the farm on the western side of the moor, perhaps in the area triangulated by Princetown, Yelverton and Tavistock.

News of the war itself is peripheral to Olive's account. Perhaps because of their sense of independent isolation the people of Dartmoor were less than enthusiastic about joining the war effort with as much gusto as other parts of the country and little

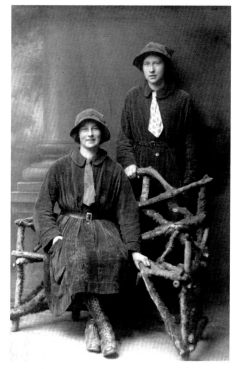

A studio photograph of two Land Girls who worked on Dartmoor c.1917. Their heavy smocks and hats, both corduroy, are not regulation wear although typical of the time.

*The actual dates of Olive's time on the moor are unclear. The book was published in 1918. She refers also to having worked previously on farms before coming to Dartmoor, in all totalling two and a half years.

mention is made of the conflict by Olive's protagonists in *Two Girls on the Land*. We do know that the county as a whole was notoriously slow in recruiting fighting men, so much so that in 1916 a *Daily Mail* headline ran 'Devon Farmers' Sons Still Hiding'. Their sons notwithstanding, farmers certainly felt the loss of their horses – thousands were taken from farms to fill the immediate needs of the military – but Olive's charges, Bob, Topsy, Prince and Captain, appear to have escaped the impressment by the Army.

Curiously, too, for one who herself was incarcerated for her beliefs, Olive makes no mention of Dartmoor's notorious prison which, from 1916, and now renamed the 'Princetown Work Centre', housed over a thousand Conscientious Objectors, many of whom were set to work on the land.

This is not to say that Olive's story is told without reference to her passionate belief in equality between men and women, her plea for collective responsibility in caring for the natural world, and her cry against the human impulse that 'in the name of Liberty, Justice, and Honour he kills off the best even of the human race'.

<p style="text-align:center">* * *</p>

Was Olive Hockin a Land Girl? Certainly most current references to her suggest so. 'Land Girl' is generally applied to any women volunteering to work on the land during both the First and Second World Wars, but it also implies membership of the Women's Land Army. Official documents recording the names of WLA members in the First World War have not survived but there is some reasonable doubt that Olive ever was a member of that organisation, although she certainly extols their work in her Preface giving the impression of membership. Whilst a civilian organisation, the WLA was set up in 1915 under the auspices of the government's Board of Agriculture, and run very much on military lines. Would-be volunteers were required to fill in enrolment forms and provide three references as to their good character, followed by a medical examination and an aptitude assessment. Would a women with a recent criminal record be considered suitable?

Successful candidates would then be appointed particular roles whether on farms, in forestry or with the forage corps – there was to be no free-for-all such as that Olive admits to on arriving at By-the-Way Farm:

> *Nor had I any appointment at this place – nor was I, in fact, in any wise expected, for I had already discovered that an application for work by letter would be treated simply as a joke and left unanswered! I knew nothing whatever about him, but having seen in an advertisement that the tenant of this particular farm was desirous of a capable man to drive his horses and to work his land, I had just walked up to offer my services.*

Olive's Land Girl status matters little. What follows is a remarkable story in itself.

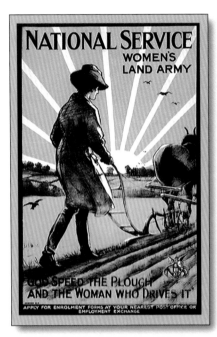

A First World War recruitment poster for the Women's Land Army. By the war's end over 250 000 women had served by working on the land, 23 000 in the Land Army itself.

TWO GIRLS ON THE LAND

WAR-TIME ON A DARTMOOR FARM

BY

OLIVE HOCKIN

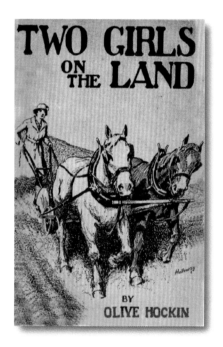

Published in 1918 by Edward Arnold, original copies of Two Girls on the Land *are difficult to find. The poor quality paper that publishers were obliged to use during the war soon disintegrated, yellowing and brittle. The cover, reproduced here, is signed 'Holloway', probably the illustrator Edgar Alfred Holloway (1870–1941), a war artist during the Boer War and later an illustrator of children's books.*

LONDON

EDWARD ARNOLD

1918

PREFACE

I DO not know if this little record of the joys and vicissitudes of life on the land is likely to encourage, or to deter, others from experimenting in the work for themselves. It was written by no means with the latter object, but merely as a record of the days as they went along, and mostly, just for the personal interest of going over it all in memory. There is plenty to enjoy in the life, but there is also much to endure, and it seems to me that the Land Army Volunteer is none the less likely to succeed if she makes the plunge with her eyes open, prepared to "do her bit" in spite of the drawbacks, and ready to face the inevitable daily fatigue – the long tedious hours in heat and cold, the paralysing monotony and mental stagnation – with the same cheerful stoicism with which her brother faces the incomparably greater discomforts (not to mention the dangers) of life in the trenches.

And on the farm, out in the open air and away in the quiet depths of the country, are compensations unobtainable in any other employment. To those who would otherwise be confined to factories or shops, the compensations must preponderate enormously, and the conclusion that I came to personally during my two and a half years' experience of a labourer's life was that could the hours of work only he shortened, almost the whole of the drawbacks would disappear.

And under the present organisation of women's agricultural work, with its vast network of committees and secretaries and voluntary organisers, with friends at headquarters to advise them, to train them and place them, and to stipulate for holidays and decent wages; who shop for them, hunt up local friends for them, and even publish a magazine solely to keep in touch with them – with all this the Land Army girls of to-day have a better chance of obtaining fair conditions than was possible in the early days of the war, when a shilling a day (without one's food) for eight or nine hours of exhausting work was a commonplace bargain.

Above all, every girl who comes in to take a share of the work not only provides her contribution to the country's needs – gaining for herself in the process increased health, strength, and a permanent and invaluable practical training – but she tends also to lighten the weight of labour for those who are already overburdened. And even though the difference in the sum of human toil be infinitesimal, yet for this alone the work is well worth while.

O. H.
May, 1918.

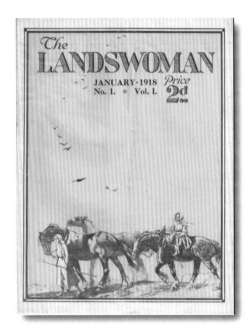

The Landswoman *was the official magazine of the WLA. It was published monthly from January 1918 (hence Olive's timely reference to it) and was edited by Meriel Talbot who was also in charge of WLA recruitment. Originally costing twopence, the price had risen to sixpence by Christmas 1919 due to rising paper costs – then ceased.*

CONTENTS

CHAPTER

I	ARRIVAL	January	25
II.	JIMMY	February	29
III.	'Taties	March	33
IV	SUNDAY	March	39
V.	OUR COTTAGE	April	46
IV.	SPRING TILLAGE	May	52
VII.	RAIN	May	60
VIII.	HAY-TIME	June	66
IX.	SUMMER	July	81
X	SHEEP	August	90
XI	A CLIMAX AND RESPITE	September	96
XII	IN CHARGE	October	107
XIII.	ROOTS & AN AUTUMN MORNING	November	117
XIV.	FROST BOUND	December	126
XV.	DEFECTION	January	131

Women's Work in Wartime *was one of many books published between 1914–1918 encouraging and providing information for, among others, WLA workers.*

TO THE
LABOURER
ON WHOSE UNCEASING TOIL

OUR EASE DEPENDS

TWO GIRLS ON THE LAND
I. ARRIVAL
January

THE snow lay deep on all the roads as I started on my three-mile tramp from the station. To right and left the hills showed white against a cold grey sky, and before me the road wound on towards the moor, solitary, with ever scarcer fields and ever fewer signs of habitation; only here and there, some lonely farm was seen tucked into a sheltering group of trees, grey and quiet among its own white-mantled fields. Outdoor work was suspended; besides myself no living creature wandered abroad, only a few sheep, their curly blanket coats showing dark and dirty on the snow, looked at me with lazy unconcern from their shelter under the hedgerow.

Before me rose hill after hill, and beyond stretched the long sweeping line of the moor, barring my path against the western sky. I climbed the nearest ridge, and dipped again to the valley, crossed a swirling brook which carved its jig-saw course along some meadows, and beyond it found my turning – in accordance with directions gleaned at the station. Up the narrow twisting lane I went, a lane too narrow for any but a single cart to pass, with steep high banks on either side, topped by luxuriant self-grown hedges, and ivy and hartstongue ferns peering everywhere from underneath the snow. I squeezed myself against the bank as a heavy cart came lumbering down with a load of mangolds, the horse slithering awkwardly on the slippery road.

"Am I right for By-the-Way Farm?" said I.

"Straet on up over, Missy; yu'll see they buildings up yonder."

So straight on up over – according to the generous Devonshire wealth of prepositions – I went, and at the top of the hill came upon the imposing buildings of the farm I sought.

Dartmoor Farms come in all shapes and sizes but Bellaford Farm is typical insofar as it is a fine example of a Dartmoor longhouse. Built on to a slight slope, such houses were entered via a cross passage that led, on one hand, into living accommodation and on the other into a byre, where the animals were sheltered. The slope meant effluent ran away from the inhabited part of the house. Thatch was the typical roofing material. Here the track to the farm runs away over the open moor, redolent of Olive's tramp up to By-the-Way Farm.

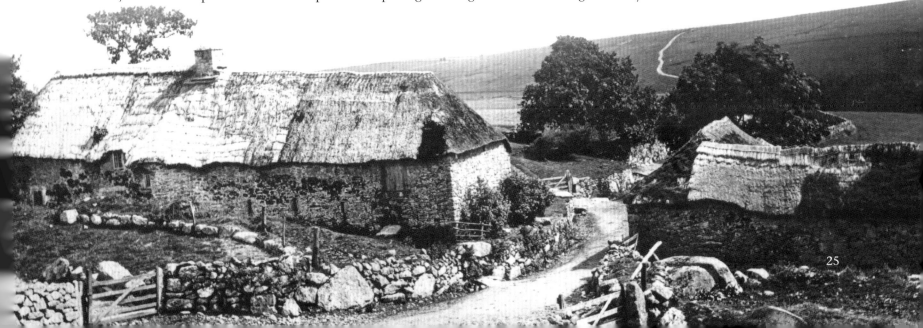

25

Here I hesitated, to lay hold upon my ebbing courage. In those early days of the war it was not common for a young woman to go about seeking situations as a farm-hand. In the West Country especially, such a thing was almost unknown, and long after the sight of lady farm-workers had become a commonplace in the home counties, the idea would be greeted with sceptical and derisive laughter by the slow-moving old farmers of Devon. Nor had I any appointment at this place – nor was I, in fact, in any wise expected, for I had already discovered that an application for work by letter would be treated simply as a joke and left unanswered! I knew nothing whatever about him, but having seen in an advertisement that the tenant of this particular farm was desirous of a capable man to drive his horses and to work his land, I had just walked up to offer my services.

I paused to survey the situation, and hugged to myself my scant qualifications. These were, namely, some months experience on another farm; a great love of horses, and indeed of every other animal tame or wild (not even excepting pigs); and further, an unbounded confidence in my own ability to do any mortal thing I wished to do. Thinking it over, it was not much to offer to an employer, but it had to do, and summoning my fleeting wits I entered the yard.

The yard alone was an awe-inspiring place at first sight. A vast zinc dome, supported by iron pillars, gave it by its dim lighting the appearance of a derelict cathedral – from the scent it might have been occupied by cavalry, but closer inspection showed in the centre a low wall surrounding the manure-pit. At the side one or two carts seemed stranded, and a litter of old iron, tools, pots and tins filled the window-sills and the corners.

All round were doors of varying sizes opening into the dark mysteries of stables or barn, and along the length of two sides ran an open loft, whereon were tossed loose piles of hay and straw, in which fowls were searching busily for unthrashed grain.

As I peered about, I heard a sound and looked up quickly. Coming down the wooden steps from the loft, basket of eggs on arm, crimson blouse and large blue apron, skirts well lifted from the dust, portly and imposing, yet smiling and bridling too – such was my first sight and impression of her who is to be known henceforth as "The Missus."

Smiling and bridling still, she came towards me, supposing me to be a wandering tourist who had lost my way.

But no, I stammered out my confused explanation:

"Please, I had come" – merely in answer to an advertisement for a horseman!

My lady gasped – but to do her justice, rose to the occasion with a bound.

"Well, really! You must come in and tell me about it. Do you know, we've been reading such a lot in the *Daily Mail* about 'Ladies on the Land'. We were looking at the pictures of them only last night. But I am afraid my husband only laughs at the idea. He says that a woman about the place would be more trouble than she is worth, and we quite made up our minds that no woman could possibly do the work!"

"But – – " I began.

"But of course," she continued volubly, "one has heard of women being able to milk, and feed the calves, and do light work of that sort; but you could not possibly plough, or drive the horses. Why, think of a girl lifting all that great heavy harness!"

"But – – " said I again.

"And then there's the weather – all this snow, and the rain and cold – being out in all weathers. No woman could possibly stand it, I am quite sure of that!"

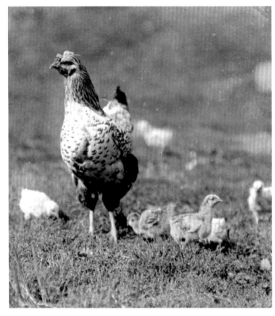

As Olive writes, 'Fowls, being the property of the Missus, are a source of strife on most farms...' The farmer's wife would be responsible for feeding them – supplementing grain with household scraps, boiled down and sometimes mixed with broken eggshells (said to ensure the shell of the eggs laid by the hens were strong). Eggs fed the family, the surplus could be sold, while older birds provided meat.

"But, you see, I have – " I attempted again, but again was quelled.

"As a matter of fact," the good lady continued almost without a pause, "we are so terribly short-handed that I have sometimes suggested to my husband that he should try and get a woman to help on the farm. We read so much about them in the papers. But it's no use, I assure you! He only laughs and says it's nonsense to talk about such a thing. He won't believe it, whatever Lord Selborne (it was Lord Selborne in those days) says. No woman," she reiterated, "could possibly stand the work."

I began to realise by this time that no matter what credentials and qualifications I had come possessed with, I should never be allowed the opportunity of stating them. With persistence, however, and in disjointed sentences, I did manage to convey the fact that I had done some work before, that I had even worked through most of the winter (for by this time it was the latter end of January), and that I did not mind mud or cold, or rain or snow. And at last she begged me to come in and wait until her husband should return from the village – for certainly, she said, he was at his wits' end to know where to turn for labour. His last man was leaving in a month's time, and a half-witted boy was all that would be left to him. That I could be as much use even as the half-witted boy she frankly professed to doubt. Still, she agreed in the end to take my part and talk her husband over, and to persuade him at any rate to give me a trial.

You will notice, by the way, a strange incongruity in the attitude of the farmer, with the condescending frame of mind in which we ladies prepare to stoop to "menial employment" by way of tiding over his time of enforced shortage of labour! The idea that it could be anything but a favour to allow anyone, be it man, woman, or child, to work for ten or twelve or fourteen hours a day for the munificent daily dole of two shillings and sixpence had never yet occurred to the Devonshire agricultural potentate. That he could be under an obligation to anyone that he employed is a reversal, apparently, of all his primal and traditional instincts! But the time is not far off when this is to be very thoroughly brought home to the farmer, for he soon will have to realise that seven days' work a week, with barely time to eat and sleep, year in, year out – until crippled by rheumatics or released by death – is not a career that appeals to any man who can possibly escape while young.

And the pity of it! Such wholesome, interesting, and beautiful work – work that should appeal to all that is best in men or women! And spoilt, solely because the means to live can only be obtained by excess of toil.

But at this time, as I followed the "Missus" through her kitchen entrance, I was blissfully unaware of the fate in store, and innocent of such mature reflections. Young and energetic, full of life and health, of patriotic enthusiasm and conscientious endeavour, all I asked was for scope to test my powers, and honourable work on which to expend my immense fund of energy.

We passed into the parlour, and I was left alone to examine my surroundings. It was a "genteel" but comfortable room, whose prevailing colours were crimson and green. The walls were green, the chairs and sofa of crimson plush, and the dining-table covered with a crimson rep. Inevitable white lace curtains shrouded the windows, and photographs of master and mistress, in wedding or festive garb, profusely decorated the walls.

Next to the crimson draperies the room seemed full of cats. There were fluffy cats and skinny cats, black cats and tabby cats, big cats and little cats, in every posture of blissful contentment, utterly oblivious to war-time or snow-time, or any such human troubles.

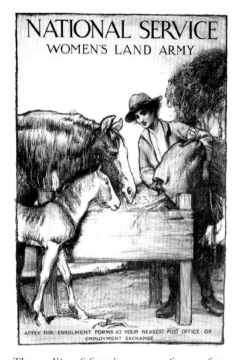

The reality of farming was a far cry from what the recruitment posters idealised, as Olive soon discovered. And though there is some doubt as to whether Olive was ever an offical WLA recruit, her job at By-the-Way Farm was not her first experience of working the land as she explains in the second chapter.

A government poster of 1915 exhorting men and women to play their part in the war effort. While the WSPU declared itself behind the prosecution of the war, in Olive's writing we sense the changing mood of the nation as the war continued. By 1917 the country was exhausted by the exigencies brought about by the conflict; the losses of fighting men more difficult to accept in the name of King and Country. Thoughts became more directed to the kind of country people wanted to see after the war's end.

Kitty Clogg, Billy Muggins, Black Organ! – How your names bring back to me the atmosphere of that green and crimson room! How in after times of work and rush, your dear seductive ways and your lazy, heavenly content came to be a solace and a joy when we ached from the endless labours of the day! Dainty little Kitty Clogg, who limped; Billy Muggins, plain old dear, whose fur was softer than the softest down; Thomas Muggins who found, alas! an early grave; Black Or-r-r-gan, small of stature, but terrific, like the thunder, as to voice ; and Lady Grey, the baby pet of all (a gentleman she was in truth, but we could never bring ourselves to admit it) – Lady Grey, who would lie in blissful happiness upside down or inside out, any old way, so long as she was nursed and petted. How you all bring back those winter evenings and the circle round the fire! I can see it now: the Missus sewing (but talking always), the "Maester" asleep with large red handkerchief over his face, man and maid in the background covertly exchanging signals, I and – But I am travelling much too far beyond my chapter.

So I waited, and made friends with the cats. The Missus, disappearing, suggested that her lord should be fed on his return before according me the interview, and with the suggestion I sympathetically concurred.

I should like to have overheard that preparatory conversation. The ordeal, however, when it came, was neither long nor alarming. A typical "jolly farmer" soon appeared, round and rubicund, obviously well-fed and large in addition, with twinkling blue eyes and a humorous rosy face. Though slightly embarrassed, and evidently sceptical as to the powers and uses of the (normally) skirted sex, it was not long before I was definitely engaged to come in two days time, and, in exchange for the sum of five shillings a week, with my board and lodging, to do whatever I was told and go where I was bid.

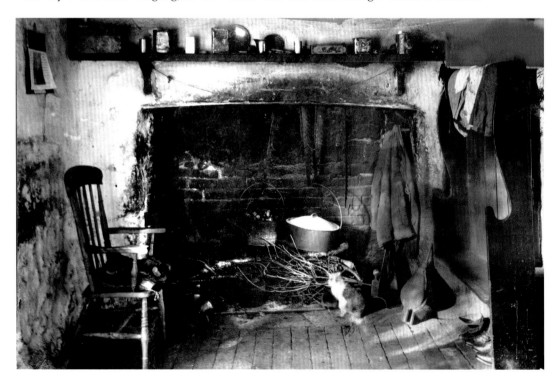

Perhaps a less salubrious Dartmoor farmhouse kitchen than enjoyed by 'The Maester' and 'The Missus' but it contains most of the elements then familiar: the large pan for making cream hanging over a low heat, the high-backed settle, the heavy coat hung up to dry – not forgetting the cat!

II. JIMMY
February

"WELL, Maester! What news from market?"

"Oh I" (I wish I could write all the syllables and the wealth of innuendo that could be conveyed in Maester's "Oh") – "0-o-o-oh!" said he, "great talk about my nuboiee, I can tell you!"

"Is there, to be sure? And what do you tell them about your new boy?" I ask, as I pause in my passage across the yard, foaming bucket of milk in either hand.

It was market-day, I had finished the evening milking, and Maester, who had been away since the early morning train, had just driven in, looking very glorious and rosy from his outing.

"Yur, Sammy!" he said, climbing out of the dog-cart,

"Put your milk away, there's a good gal, an' come and take the 'arse, then I'll tell you, ..."

"Sammy," I may as well explain, is what I have speedily come to. The name followed me from my previous place, and had been given me by the never-to-be-forgotten kind Missus of those other days. My real name being apparently too much for them to handle, the only alternative at my new quarters seemed to be that of "Miss Somebody" – a homeless sort of designation that did not appeal to me; so –

"Sammy" I suggested, and "Sammy" I remained to the end.

I left my milk in the dairy and returned to "let out" the horse. He, of course, must be at once introduced – Bobby by name, commonly known as "Barb"; a useful grey, equally at home with the saddle, the plough, the manure cart, or in trotting with the "pleasure trap" to market. (Be it known, however, that secretly he and I both fancied ourselves in the first capacity.) My especial charge was Bobby, and great was the care which I lavished always upon his dappled coat.

Altogether I was very much at home in the stable by this time with Bob and his companions. Besides him there were Topsy, a big black mare with uncertain temper; Prince and Captain, the principal plough-team; and a wicked little Dartmoor pony, who could open any door-latch and wriggle out of any halter that yet had been invented. And I had, moreover, to my own satisfaction at any rate, disproved the foregone conclusion that a woman is incapable of lifting the harness!

It did take some lifting, I must confess, especially the complicated fore-horse harness, with its hames and stretcher and heavy chains. But I discovered, in this as in many other things that are supposed to be beyond the powers of woman, that it is knowledge that is needed more than physical strength. No experienced man exerts himself more than he need, and heavy work seems to be done much on the ju-jitsu system – a little strength exerted in the precise spot at the precise moment, and such is far more effective than the exhausting efforts put forth by the uninitiated. A few useful hints from Coombe, the horse-man who was for a short while our contemporary, put me up to the mark in many puzzling situations.

Not Olive's Prince, but a horse of the same name from Foxworthy Farm on eastern Dartmoor. It shows the amount of complex harness required to couple a horse to a farm cart, 'supposed to be beyond the powers of women'!

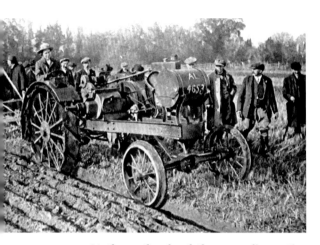

At the outbreak of the war, discounting steam traction engines, there were fewer than 1500 tractors employed on Britain's farms, while over a million horses were in use. As the war progressed 5000 tractors were on order from America and increasing numbers of WLA members were trained to use them. Here Land Girl takes part in a ploughing competition c.1917.

WLA member ploughing, 'an accomplishment, I was always told, beyond the wildest dreams of woman's abilities.'

"'Old it yur," he would say, "over they there chains and under them; throw thikky over your shoulder, catch 'old the 'emses, an' there 'ee be!" – and a ponderous confusion of chains and leather became on the horse an orderly array of harness.

The friendly Coombe also put me in the way of ploughing, and after a little practice I soon got on with the work, and spent many a day following the horses up and down those fields. And though it is considered the most highly skilled work on a farm (an accomplishment, I was always told, beyond the wildest dreams of woman's abilities), ploughing is really by no means the most fatiguing, as many women now are finding.

To the beginner it is exhausting, certainly, for only by an occasional happy chance does one seem to come round at the corners to the desired spot for starting the new furrow – and once the plough is round in the wrong place, there is nothing for it but to lift it bodily over to the right one. I shall not forget my first day out alone! How I tugged and pulled and shoved and lifted that unwieldy miserable implement! How enraged I got with the horses, with the plough and the mud and myself, and all that grew under the blue dome of heaven! And for a week I was black and blue with stiffness and bruises, only to find in the end that no pulling and lifting had ever been necessary. To feel the balance' something as of a bicycle – and to bring round the horses just to the right point, does not really need much strength, but it does need judgment and some experience, and is therefore, given the opportunity, as much within the reach of a woman's powers as of a man's.

And once one gets into it, and the horses are going steadily, it is fascinating work, strolling along in the furrow, resting easily upon the handles, watching the pied wagtails scurrying about tail-wagging busily over the newly turned-up soil, while a following line of sea-gulls streams up into the sky behind, circling and crying overhead. When the plough is rightly "set" – a process which needs a good deal of experience – it will travel almost of itself, provided no rocks occur to jolt it out of its course ; and there is just enough mental occupation to make the day interesting, in turning the corners, watching that the furrow runs straight, and calculating the width of the lessening strip of unploughed land, so as to take a clean straight cut at the finish. As compared with harrowing or rolling,

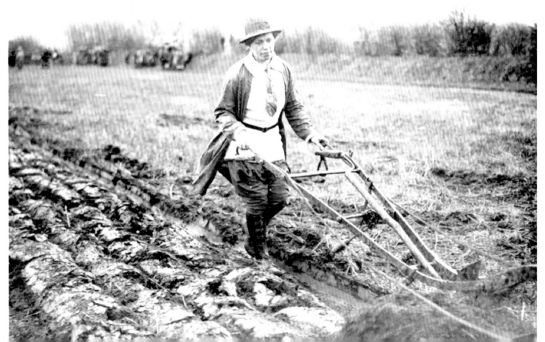

ploughing, though it needs more skill, is far less tiring work, since the ploughman walks all day in the hard furrow. Anyone knows how exhausting it is to walk even once across a newly-ploughed field – and with harrows of course, one is plunging over the deep land all day, across and across the furrows, for continuous hours, which is an infinitely more tiring performance when the ground is heavy

But it was some time before I attained the easy nonchalance of the "old hand" and could drive my horses steadily and straight, and in spite of Coombe and his timely help, many were the mistakes I made, and many the holes I got into and managed to scramble out of again. In carting, also, I found that to handle a horse in the way I had been accustomed to do, comfortably seated on the box behind, is a very different matter from finding oneself under its nose, the monstrous elephant-like creature towering up above, and a juggernaut of a cart lumbering on to one from behind! I confess that my heart was in my mouth many a time when plunging up those banks through the narrow Dartmoor gateways.

"But I can't 'elp laughin'!" says Maester from behind, as Bobby and I all but carry away one of his stone gateposts, and the cart crashes on, swaying perilously on one wheel!

He was a good-natured man enough to work for, magnanimous over one's mistakes, and with always a joke and a smile as he gave one an order. A bit muddle-headed, however, and somewhat cotton-woolly in the brain, as I discovered before very long. The absence of the "business mind" rather appealed to me at first, until I found that its place was filled, not by generosity or any artistic sense, or even by good craftsmanship, but just by cotton-wool. If he had had the brains he would have been as quick to take advantage of anyone as the sharpest of "business men". But since they were conspicuously absent he passed, on general acquaintance, for a jovial good-natured sort of fellow, and was easy enough on the whole to get on with.

On market-days he rose to a great height of splendour with his smartly-cut riding-breeches, his golden watch-chain reposing upon a bright-coloured waistcoat, and signet-ring polished and shining upon his fat little finger! Market-day to a farmer is evidently the chief social function of the week, and whether they have anything to sell or not, to attend the market is as rigid a duty as to some people is Sunday church. A farmer who is not seen regularly in the market-place, making one in the groups at street corners, or standing about outside the Unicorn's Head or the Three Jolly Brewers, is considered quite out of the running in local farming society.

When work was finished that evening, and the whole establishment were gathered round the table at tea, with lavish piles of bread and butter before us rapidly growing less, I referred to the gossip of the day.

"You did not tell me, Maester," I remarked, "what they're all saying about your new boy?"

"Oh, plenty of talk, Sammy, I can assure you!" he answered with sly discretion.

"Yes – I expect there is! But tell me what they say."

"There's Mr. Luscombe, now, he tells me 'is Missus says she's not agoin' to let 'e 'ave any women round the place workin' for 'im!"

"And what do you say to that?" I asked.

"Well," says Maester, twinkling, " I tells 'im 'e must be a bad man if 'is Missus can't trust 'im more'n that!"

"Quite right, John!" chimes in the Missus.

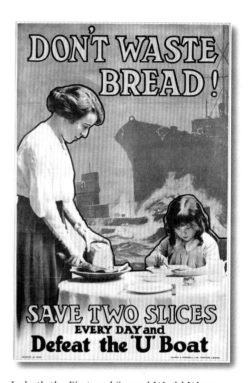

In both the First and Second World Wars, as food shortages increased, there built a resentment between those who lived urban lives and country-dwellers who were accused of keeping food to themselves. The fact is that country people, long used to subsistence, had a ready access to food and more resources for maintaining a steady supply of milk, eggs, vegetables and so on. Even so, 'the lavish piles of bread and butter' described here by Olive were not universally available, even in the countryside, where the poorest families were too often close to starvation.

"Well, I hope you speak up for your new boy, anyhow?" said I.

"Well, what I tells 'em is that I'm so pleased with the one I've got that I wishes I'd 'alf a dozen!"

"Oh, you do, do you?" said I, smilingly comparing this in my mind with his scepticism when I first arrived.

"Well," I continued, "if you really want half a dozen 'new boys' I can at any rate find you one more if you like."

This was the opportunity I had been waiting for. My design had been that when I had sufficiently impressed him with the capability and general indispensability on a farm of what he terms "females," that I should propose a friend of my own to join me. She, I may say, was waiting every day for the summons. But I had had to bide my time and choose a propitious moment before suggesting anything so rash as the repeating of his first unprecedented experiment.

He took my remark cautiously.

"Well, Sammy, d'ye think ye could? And what might her be like now? Is her a good-looking maid?"

"Now, John!" chimes in the Missus archly from behind the plated teapot. "I won't have you asking those sort of questions!"

"Now you be quiet, me dear! This isn't your business!"

"Oh, isn't it, indeed? It is very much my business. I'll have quite enough to do to look after you with one young woman about, let alone two!"

"If I have two, then, Missus, they'll be able to look after each other!" says Maester with a twinkle, and a humorous glance in my direction.

But the conversation was getting beyond me – certainly into regions that I never foresaw when I walked up to the door in answer to an advertisement such a little while ago. It was a joke, too, that was never to lose its novelty (though to us it never lost its staleness). I remember how, later on, Jimmy and I used to wonder sometimes what attitude was really expected of us when the many variations on this theme recurred. We decided that we ought to try to giggle and look coy, but I am afraid we never managed the part, and our boredom with the subject only increased as it grew merrier on the tongue of the Missus.

In the end I brought the conversation back to the question of Jimmy; and after a good deal of cogitating, it was agreed that I should write to her, and we arranged finally that she and her prospective employer should meet next market-day and mutually inspect each other. Maester's report was that on the appointed day, outside the Unicorn's Head, the place of assignation, a wholesome little face with dark brown eyes smiled at him across the pavement, while Jimmy declares that her horizon was blocked by bright blue eyes and a beaming portly form.

Mutually satisfied, they fixed it up, and a few days later, with bag and baggage, tunic and breeches and all prepared Jimmy arrived at By-the-Way Farm on the moor.

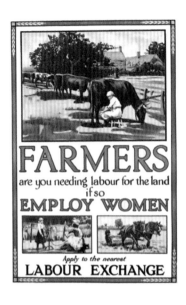

FARMERS
are you needing labour for the land
if so
EMPLOY WOMEN

Apply to the nearest
LABOUR EXCHANGE

III. 'TATIES
March

OH, you readers in furnished dining-rooms, who only know potatoes on your table baked and luscious in their wrinkled jackets; brown and savoury round your roast; with sausages perhaps as creamy mash; or even white and floury, peeled and plainly boiled – little do you reck, as you help them from your dishes, of the toil and sweat and aching backs of those who labour over them the season through! Toil and trouble, dirt and heat and bitter cold, all seem to reach their climax in the potato-field as the seasons pass, from seed-time on to harvest.

Work with potatoes is never done; and whether it is planting or hoeing, or "vouring," or digging, or picking over, or marketing, every performance as it comes seems a more back-breaking task than the last. But capping them all, for sheer dismal dreariness, nothing perhaps beats the opening of a water-logged "cave" on a cold and muddy day.

It was Jimmy's first day on a farm, almost at the end of the potato season – and a drastic enough introduction for one whose worst discomfort had been to come in drenched from a tramp on the moor. Picture to yourself a field of mud in the latter days of February. The

Harvesting potatoes on a Dartmoor farm near South Tawton. If for immediate sale the potatoes would be carted away and taken to market. Those for use on the farm would be buried in a 'cave' or 'clamp' – covered with layers of straw and earth in order to protect them from frost. These would then be dug out later in the year for consumption. But as Olive says, in practice, digging out the caves would often reveal piles of rotting vegetables.

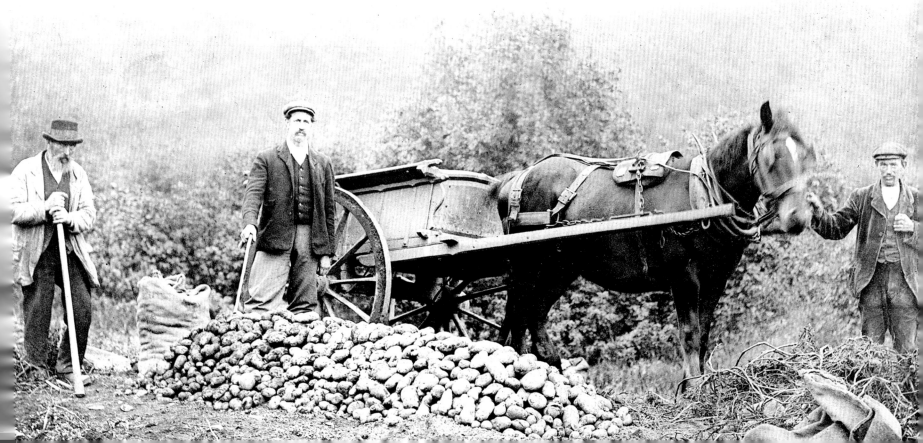

snow had mostly thawed and left the ground a morass of heavy saturation; the frost had gone, but the mud had come, and a moist but bitter wind was bellowing from the west. Picture, then, a steep hillside of mud, sodden and uneven – for the land, dug last autumn when the crop was harvested, had lain untilled the winter through. The dull expanse is broken only here and there by long sausage-shaped mounds of earth – or caves, in which lies hidden the treasure we now are out to seek.

The group at the cave is not unpicturesque, in a rather squalid and gipsy-like way. Most conspicuous first stands a big rough tripod, from which are hung the weights. Spread about are bundles of muddy bags and two or three large baskets showing signs of the season's wear. Maester's homely figure, his extensive waist encircled by a sack tied round with cord, is seen bending over the pit with a curved and perforated shovel, attempting to "shooell" up such of the potatoes as are fit. Jimmy, in muddy boots and leggings, sou'wester and oilskin coat, also with a torn and dirty sack about her like an apron, is rolling back the sodden rushes that lie like thatch upon the heap. Alternately, as the baskets are filled, we lift them on to the weights and fill up the bags – eight score pounds in each.

The theory is beautiful; and farmers will boast that they can pick up a truck-load before dinner-time. But on a Dartmoor farm – or, at any rate, at our particular By-the-Way Farm – theories we found seldom fitted in with practice. For alas! the rooks or rabbits had been at the caves, the snow had got through, and the 'taties were wet, mucky, rotten, and altogether depressing. Instead of shovelling them steadily into the baskets, shaking out the dry soil from among them, needs must we go upon our knees in the mud and with frozen fingers pick them up by hand, sorting out the good ones, and – ugh! the bad ones! Does anyone know the smell of a really rotten potato, and the revolting squish of yellow, evil-smelling custard that one's fingers slide into? I think the combination of mud and a stooping posture, cold wet fingers and rotten potatoes, is one that might be calculated to make one – well, depressed.

But the day goes on; we stop for an hour at dinner-time and get comfortably warm by the kitchen fire – only to emerge once more into the bitter blast. The wind, though westerly, was as cold as any from the north, and howled in belching gusts up the slope of the hill, tossing bags and overcoats about, impeded by nothing in its passage from the snow-capped moor till it reached our exposed, defenceless little group in the midst of the open field.

With a spade, first the sodden earth must be scraped off the caves; then the rushes, wet and sticky, rolled back from among the potatoes; and then the potatoes sorted and picked. Except when shovelling, which we did in turns, there was not enough exertion in the work to warm a hen; and when kneeling on a mud-caked bag and fumbling among the mucky tubers, there was nothing for it but to hump one's shoulders and endure.

One after another the baskets got filled, and forty pounds or so at a time we lifted on to the weights, and lifted again, shaking their burdens into the bags – in itself a sufficiently severe test on the arms when continued for some eight hours or so during the day.

I watched Jimmy, I remember, those first few days to see how she stood it all. But nothing daunted Jimmy! Then or later, nothing that had to be done was ever too much for her. With resolute shoulders and sturdy step she would tackle it all – whether it were picking up 'taties, cleaning out pigsties, dosing a sheep, loading a shrieking sow in a cart – whatever came along, "Right-o!" she seemed to say – "let's get on with it…"

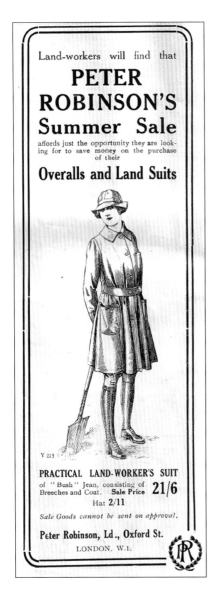

An advertisement from the Landswoman, *the offical magazine of the WLA. One of a number used to illustrate Olive's story as they are exactly contemporary with the period she spent working on Dartmoor.*

But how our backs and arms did ache those first few months! When it was not potatoes that had to be lifted, it was mangolds for the cows – or it might be the whole day long shaking out heavy manure in the fields, or daily wheeling out the laden barrow from the shippen. Everything seemed to tell on the arms and hands. Night after night I remember waking up with arms dead with cramp, and rubbing them into life again before one could sleep. And as for our hands – farm-work may well be designated "manual work," for indeed they seem to bear the brunt of it; and for more than a year we would wake up in the mornings with hands so stiff that the fingers would not touch the palms. Milking is the principal cause, but it is increased, no doubt, by rheumatism from the incessant wet and cold.

"Now, Sammy!" says Maester at last, as dusk descends and milking-time draws near," you can be off and fetch out Barb, and we mun load up what we've got afore the night. An' if Coombe be back from the station, tell him to be quick out with the waggon as well."

I jumped up with alacrity, welcoming any change of posture or occupation, especially to get back to my beloved horses, for as Maester used very truly to remark, " As 'appy as a duck in a mud-puddle is Sammy when she's out with a 'arse!"

Coombe, with Prince and Captain, was in the yard, so I sent them off and got out my Bob and the carry. "Carry" is the local name for a wain – or "Scotch cart," as they call it in some places. It is a useful sort of vehicle, with a flat bottom and no sides, but with detachable lades in the front and back.

Some two-and-twenty bags were waiting when I got back, and Jimmy with perished fingers was tying them up at the neck. With the aid of a stout wooden bar we helped to load them, sedan-chair fashion, putting fourteen into the waggon and eight for Bobby in the wain.

"And I shall let yon take 'em down and truck 'em tomorrow, Sammy," said Maester, "and that will finish up the load."

That was good news to me, for though lifting the bags from cart to truck, and packing them back tidily, is pretty heavy work, a change of scene and an hour in the day sitting down, even on a bumpy springless cart, was a relief to the muscles not by any means to be despised.

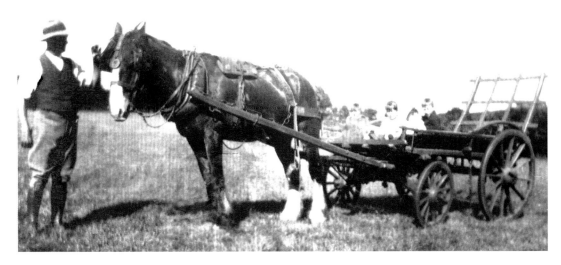

The kind of cart that Olive describes as a 'carry' – this one on a farm near Manaton on Dartmoor.

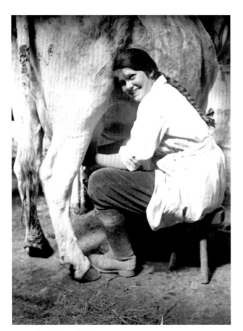

Land Girl milking.

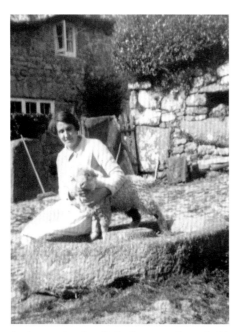

'What seductive little beggars those half-tame lambs can be!' In a Dartmoor farm-yard sometime after the war.

The potatoes safely housed in the yard, milking was the next job, and the complicated work of the evening began. Tom, the half-witted boy, happened to be there, and was occupied as usual scraping mangolds. "Happened to be there," I say, because his home was only a mile or two away, and whenever the spirit moved him, or his work disagreed with him, he would drop his tools, disappear over the garden wall, and make a bee-line home across the fields. Subsequently, he would be returned under the wing of his mother, sheepish and sullen, with much explanation and apology on her part, but little on his. This happened frequently when the snow was about or the frost was keen. Eventually he disappeared for good, and personally I could not but feel for him. Our own homes were out of reach of temptation.

What a rush that evening work used to be! And how we longed, with an immense longing, for the cup of tea that would crown its finish! The working day was meant to end at six p.m. (which in itself was an hour later than on other farms), but it was often seven or after before we could get off our heavy boots and sit down to tea. How well I remember that tearing evening round – mangolds for the cows, hay for the bullocks, turnips for the yearlings, corn and hay for the horses, then hay again for the cows! It seemed like a never-ending circle. Then milk for the youngest calves, to be given by hand – all in addition to the milking, separating, and putting of everything to bed for the night.

At that time, too, lambing was in full swing. The lambs were creatures especially dear to Jimmy– in fact, the feeding of the babies of the establishment, both calves and lambs and little pigs, came to be her particular work; and the picture of her in those early days which recurs to me most vividly is one of a determined little figure, marching across tie field with feeding-bottle in hand, pursuing or inveigling some little woolly sprite to come and take its dose.

What seductive little beggars those half-tame lambs can be! At one time when the snow was deep outside we had the whole flock in the covered yard. Hurdled pens were fixed up all round for the mothers with the newly born, while the older lambs skipped about loose in the centre. What races they would run, those merry little, spindle-legged, long-tailed babies! All of a sudden, full-tilt down the yard they would go, leaping over obstacles and scampering round the pit; then a step might be heard and the groups would scatter in and out behind the carts, peering round again with twitching tails and mischievous, white, twinkling noses. If the step were a friendly one, a full charge would be made to meet it, broken off suddenly with a change of purpose, and off they would go in another direction, playing "peep-bo" around the waggon.

A cradle lived permanently by the kitchen fire those cold days, and often a sickly lamb was nursed back to life by warmth and special care. Some would take their bottle greedily, nearly swallowing glass and all; and some needed as much tempting and coaxing as an ailing baby.

Only the ewes with lambs stayed in at night. Expectant mothers still remained outside, and I remember, when they counted them up, the bewildering mental arithmetic which taxed our farmer and his man at night. Something of this sort went on: "Twenty-vour yaws, thirty-sax little 'ogs, two bide een, one gaw oot, vaive lambed – vifty-vour outside..." I never could follow it, but it often ended in a lantern search being made under the snowy hedgerows for some poor mother who, knowing her time had come, had wandered away seeking shelter and solitude.

But the large and varied family got put to bed at length, and with untold relief we could

pull off our boots and wash our hands, and hope for half an hour of peace before the final process of "bedding-up" the horses took place.

Tea over, Coombe and Miss Minton usually vanished into the kitchen, whence murmurs of subdued and confidential talk escaped; and Maester settled himself into his red arm-chair, with Lady Grey, as usual, upside down between his knees.

"My little pussy!" he chuckles, rubbing her backwards with a large red hand. "Eh? 'Oo's my little pussy? My little sweet'eart, eh?" I can hear him now, and the wheedling falsetto voice which was kept particularly for the beloved cats.

"That's how he always talks!" said the Missus, nodding aside to me, with a proud and indulgent glance at her spouse. "Isn't he a great baby?"

Sometimes, before subsiding into his forty winks, the "baby" looks plaintively across to me where I lie curled up on the sofa with a book.

"And arn't ye going to play me a tune, Sammy?" says he.

"Now, John! It's too bad of you," puts in the Missus. "Sammy's tired, you can see she is!" But as I love strumming, especially to anyone forbearing enough to listen, I generally relent and go to the piano to try what will come through my stiffening fingers. The piano was old, but a good many of the notes still sounded, and some were in tune – and at any rate, if only as a lullaby, the performance had its effect, for loud snores soon resounded through the red pocket-handkerchief.

Sometimes I would strike a bargain when this was demanded of me, and suggest that if I played him his lullaby, Maester must go out and do my horses for me. When this was accepted I would get off early to bed; but more often we went out together to the stable, with the lantern swinging as we crossed the yard, and sending monstrous fantastic shadows up into the dome. By its light we brushed down our horses and fed then, shook up their beds and cleaned them out, and finally went the solemn round of the houses, making sure that no cows were loose, no calves having fits, and everyone in his own abode.

It is a queer and uncanny place, a farm-yard in the dead of night! The feeling of unearthly presences possesses one as strongly as it does sometimes in a dark wood. I have come out alone some evenings, late at night; the long black, shadowy buildings in themselves look ghostly and unsubstantial, like mere shadows against the sky, and the whole world is dark and empty and quiet.

And yet, if you stand quite still under the sky and listen, out of the darkness on all sides comes the sound of faint breathing – slow and quiet from the cows near by, yonder from the pigsties a steady and comfortable snoring, and now and again perhaps a snort and the rattle of a halter weight from the stable. All seems silent again, and then a little rustle in the straw to the side of you, and a darkling rat goes scudding homeward. You take a step or two across the yard, and nearly fly headlong over some large recumbent beast – sow or bullock, or whoever may be turned in loose. But neither resents your importunity: the pig will only snuggle a little closer into her lair of straw, and the bullock ruminates on in bovine beatitude.

The beasts, for the time, have come into their own and are alone in their own world. Interfering man they know shuns the kindly darkness, and lurks safely out of harm within his four stone walls. The animals can sleep, or wander at will, feeling they are safe from the disturbances of the day.

"They du tell me," said a country man once, "they du tell me that in Lunnon town the

Solitary walker under moonlight passing Haytor on Dartmoor. From a postcard by Devon artist Andrew Beer produced just before the outbreak of war in 1914.

folks be walkin' about the streets until – "here he hesitated as if fearing to exaggerate" until eleven o'clock at night!"

But in the country, by eleven o'clock scarcely anywhere will you see a light, even in an upper window, for there the hours of darkness are the hours of rest, and in woods and moors and along the country roads none but poets, artists, and malefactors wander abroad.

IV. SUNDAY
March

IT was seven o'clock and the sun, having just risen behind the potato-field, was shooting beams of gold through my white lace curtains. I lay amongst the billowy feather- bedding, studying the wondrous photographs on the wall opposite and rejoicing in the extra hour of rest which constitutes a farmer's Sunday. The sunbeams had just reached a wicker-chair, over which lay a truly iniquitous creation in wool of magenta pink and emerald squares. Dreamily fascinated by this atrocity, I waited to see what the sunbeams would make of it, and was wondering lazily which would eclipse the other when the morning clarion rang out from the landing and dispelled my fancies.

"Sam-mee!"

"All right, Maester!" I groaned.

"Jimmy!"

A cartoon submitted by a member of the Land Army Agricultural Section to the Landswoman *magazine in 1918. It reflects precisely the feelings of Olive on early rising.*

39

"Ye-e-es " (sotto voce).

"Miss Minton!" – this to the indoor "assistant."

No answer.

"Sammy, call Miss Minton, will you?" And then from the distance the voice echoes down the passage, arousing Coombe and the boy.

This was the morning alarm that usually went off about six; but on Sundays we lay in bed to the respectable and civilised hour of seven.

Half an hour later, down front stairs and back, one by one we assembled in the kitchen – a very unswept and rakish-looking place at that hour – and struggled sleepily into boots and leggings.

We made our way to the yard – Jimmy to feed her cows, Coombe and I to the stables, and Maester to the barn to dole out cake and corn; and then, after a welcome cup of tea indoors, the morning work began. I cleaned out my half of the stable and brushed down Bob and Topsy, combing out their manes for Sunday, and then came round to the shippen where Jimmy, on a three-legged stool, her head pressed well into the cows broad side, was struggling with her first efforts in milking. How she worked at it, squeezing and pulling at the well-filled udder! Such tremendous effort and such small results! But it was not many weeks before the steady double purr of the milk resounded from her pail; and by harvest-time, when every available hand was wanted in the fields, she was able to take on the whole line of cows by herself.

Sisters Ada and Mabel Friend, in 1918, milking by hand at their farm in Northlew in Devon, watched by their father.

I picked up a bucket, tied up my head in a handkerchief, and set to work to help, for there were eight or ten cows to get round. No one would think how distinctly individual cows can be until they come to milk them. Every one has different tricks and ways, and each seems to need some slightly different handling. Some have teats so large and thick that one's fingers will hardly close round them, while some – more difficult still – are almost too small to hold. From some, especially from those lately come into milk, the milk will flow just with a touch, while others need really severe muscular finger-work to get them to yield even a small stream of milk. These I must say we generally leave to the last in the hope that Maester would come along and help, but were frequently paid out by having to milk them at the end, when our fingers were already tiring.

Young heifers, after they first calve, are particularly entertaining to milk – entertaining sometimes, but exasperating at others, when time is short, for the last thing one wants to do on a Sunday morning is to stop about with a fidgety cow – trailing one's bucket and stool along from side to side in desperate attempts to get near her. There was Nancy, for instance, whose especial game was gently and deliberately to lift her leg and, before we could realise or avert the calamity, to plant it firmly, with all her weight upon it, in the pail.

Hand milking; seldom as enjoyable as this milkmaid appears to make it.

There was also one particularly lively heifer I remember who, not content with dancing during the whole process, used to wind her hind-leg literally over one's head in her efforts to kick over the bucket – "Joanna," I believe Jimmy called her, because (she explained) she was so rumbunctious. But whatever that might mean she was certainly a source of much bad language in the shippen – a regular bully, both to us and the other cows.

It is curious, but comforting, to find that however ready they were to run their horns into each other – and with some it seemed to be a continual source of amusement – the cows as a rule were most careful to refrain from touching us, even by accident as they turned round in the stall. Indeed, it does not take long to discover, for all her fearsome aspect, how nervous and sensitive a creature is the domestic cow. She is far more fearful of a human being than the humans need ever be of her. Neither are cows nearly so phlegmatic as they seem, but can be quite sensible to changes of scene or weather, and even, at times, obviously exhilarated with the joy of life. I remember one particular hill-slope that we had to descend when bringing down the cows at milking-time. It seemed to have a peculiarly intoxicating effect upon them, for regularly, as soon as we reached one point, down would go their heads and off they would scamper, charging each other and frolicking and kicking like young lambs, sobering down only when they reached the gate, where they waited in a group for me to arrive and open it. Thence to the yard they would continue a dignified course, more suited to their years and the public road.

"Damn!" came suddenly from the other end of the shippen; and Jimmy stood up, wiping her face with her handkerchief. She had not yet learnt to escape the impatient flick of the tail that was always Priscilla's parting coup, and which was nicely calculated to catch her across the face, just as she rose from the stool. When the tail was dirty, as it most often was, the experience is better imagined than described.

"I say, James," said I, coming along with my bucket full, "as soon as we're through, let's go off and have a breather out on the moor!"

"Yes, rather!" replied she. " I'm saturated with the stink of this place. I feel soaked through with it."

"We ought to be done by about ten or eleven. We'll ask the Missus to let us have some

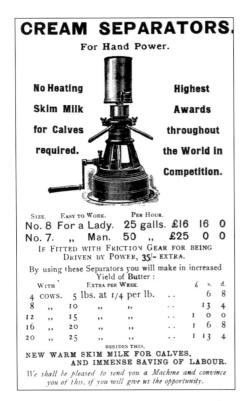

Cream separators are used to produce skimmed milk for feeding to calves, leaving the cream from which to produce butter or clotted cream.

bread-and-cheese or something, and then we needn't be back until the evening milking!"

"Jolly good idea!" responded Jimmy, and with this thought to cheer us we proceeded with the countless little jobs that even on a Sunday have to be got through. Coombe and the farmer were out with the sheep, and Tom was scraping mangolds. Jimmy took the milk into the dairy and turned the separator" – enjoying usually a high-pitched conversation with the Missus the while" – and I released the cows and turned them down to the meadows. I came back to find Jimmy, with pails of separated milk, struggling in the big calves' pen, devoured on all sides by ravening beasts.

"Come here, Sammy, for goodness sake!" she cried.

"Come and keep these others back, or I shall be swallowed alive." For the hungry brutes were butting her and sucking her clothes all round. So valiantly, with a stick, I held them at bay, while the latest baby sucked up the milk through Jimmy's fingers.

"He's a beggar for biting, that little chap, isn't he?" I remarked, as Jimmy seemed to be having some struggles.

"Ow-oo! I should think he was!" she answered, groaning. "His teeth are like little knives. I wish I could get him to drink from the bucket. He's no business to go on being such a baby," and she withdrew her fingers for a minute from his mouth.

Woof! Bang! was the answer to that. And a powerful charge with his head nearly sent everything flying. In the scrimmage another calf got his head into the bucket, and the remainder of the milk went down his throat in two seconds.

That process over, we repaired indoors for the eagerly devoured general breakfast, which was served at about half-past nine in the kitchen, presided over by the Missus, whose genteel hour of rising was usually judged to be just in time to fry the fish or bacon.

We all assembled round the table – all, that is, except Tom the boy. The distinctions of class are very subtle, for while the horseman, Coombe, as grubby and unkempt a man as ever I've seen, and Miss Minton, the hard-working "assistant," were admitted to table on equal terms, poor lonesome Tom, being only "the Boy," was banished with a plate to the outer scullery, where in uncomfortable solitude he ate such scraps as were vouchsafed him. It seemed rather a hard-hearted arrangement, as I sometimes remarked. But the Missus told me if I had ever seen him eat! Still, one felt the poor chap was not getting

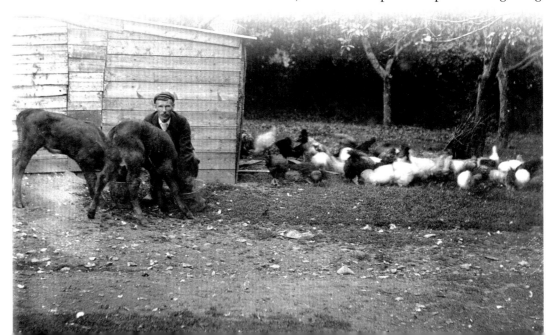

Feeding calves skimmed milk from a bucket at Sandford Courtenay, just north of Dartmoor, c.1915.

much of a chance to learn any civilised manners, and could hardly be blamed even if his eating did not quite come up to polite farm-house standards.

After breakfast there were the yearlings and bullocks to turn out, the shippen to clean and put ready for the afternoon's milking, and each cow's manger to fill with a generous basket of mangolds. But all was accomplished at last, and Jimmy and I could go in to change our boots and get into clean and feminine clothes.

At the kitchen-door was Maester, also returning to tidy up.

"You'll give the pigs their wash at dinner-time, won't you, Samuel?" says he.

"Oh, no, Maester! Not a bit of it!" said I firmly. "We are just going out."

"But the boy's gone off 'ome, and the pigs must be seen to," he demurred, "an' the 'arses'll want their corn too."

"Can't help it, Maester," I answered, feeling that some time or other we should have to make a stand. "We've been working the livelong day the whole week through, and if I don't get a breather on a Sunday I shall bust!"

"H'm!" said he, rather taken aback. "Very well. When are ye goin' to be in?"

"Oh! we'll be back in time to get up the cows," I assured him.

"Very well, then," he answered rather grumpily. " I suppose I'll 'ave to manage," and we went our different ways.

"It does seem rather rough on the old boy," I remarked later, as we started up the road with a knapsack full of books and sandwiches. "He'll have to do it all himself!"

"I can't see why the Missus shouldn't ever lend a hand," said Jimmy. "Besides, it's his own place after all, and he doesn't even want to go out. He wouldn't miss his hot Sunday dinner for anything, I can see that."

"Yes, and he does get his change of scene on market- days. He is out the whole day long on Wednesdays, while it seems to me we should never get out at all at this rate. Anyhow, there is Coombe to help him today – though I suppose by next Sunday he will be gone too."

"Whether he is or not," said Jimmy, "I vote we stick to this plan. It's impossible to go on seven whole days a week! If he can't do just the mid-day work alone, well – he'll have to get somebody else, or let us have Saturday off instead.

"You'll never get that into a farmer's head!" I replied. And indeed, I never have, then or since, got any farmer to see that the man who did the necessary Sunday work should have an afternoon to himself in the week. It might involve a certain amount of thinking, to arrange for someone else to take over the work in his absence. But in 'cases of necessity' it always is done, and if taken as a matter of course, it would not be at all impossible to arrange. The absolute slavery that farm-work entails to those who have charge of cattle is really almost unbelievable. I remember talking to a shepherd once who was telling me about his son, and how he had refused to go on with the shepherding – chiefly on account of the incessant Sunday work.

"But do you never get a holiday?" I asked in my innocence.

"Well, I 'ad a week-end once since I bin 'ere'" he replied, "an' that's nine years ago!"

A turn of the road, and our grumbles dispersed. The farm and the work, the shippen and the stables, dropped out of our thoughts as the familiar fields were left behind. Before us instead lay nothing but the great clean line of the moor sweeping across the west.

Fields and farms, copses and winding lanes soon disappeared altogether, and we found ourselves in the open, climbing up the first great shoulder of the moor with the

'After a hard day's work on the farm, the woman worker experiences with delight the cleansing and soothing properties of Vinolia.' An advertisement from Landswoman magazine, 1918.

An Olive Hockin watercolour, almost certainly of Dartmoor, and dating from her stay there c.1917. It depicts a hawk hovering over one of the moorland valleys with a typical tor in the foreground. It measures approximately 30x52cm.

exhilaration of explorers about to reach the land of the unknown. What is it that makes the intense fascination of those great open spaces, those long, flowing, clean-cut lines unchequered by fields – lines, subtly flowing, rounded with the beauty of a woman's shoulder, or rippling like the muscles of a man's forearm? Dartmoor is a country all by itself; the very formation of the land is unlike anything else in England; it has a grandeur of its own that does not vie with the grandeur of mountains, yet is almost more beautiful; and to come upon it after agricultural country is like some big, simple, soul-stirring strain of music ringing out above the complexity of an orchestra.

From the top of that first shoulder we could see, rolling away from us, wave after wave of moor; bronze and green and dusky purple at our feet, passing on into deeper blues and greys, till away by Tavistock the pale, blue hills met the paler sky. Over the nearest hill a winding, white, ribbon-like road wound its way, disappearing at the top of the curve, but showing again as it leaped the further wave of down.

Here and there sheep could be seen, much the colour of the granite boulders; and just below a group of little ponies, shaggy-coated, with trailing tails and tangled manes, stood for a moment watching us with a laughable mixture of resentment, curiosity and fear. One movement on our part, and the latter came uppermost. Swinging round, they trotted off with a wild and beautiful motion, their ragged manes streaming out in the breeze.

We climbed on over smooth-cropped turf, through scrubby gorse and stunted heather, on past deserted foundations of hut-circles, and past the scattered granite tor at the summit; then down, till we reached in a sheltered hollow one of those brown-gold streams that, tinkling and gurgling and scattering over the rocks, make the chief burden of the music of the moor.

We established ourselves under a rock in the sunshine – the sunshine of early spring, clear and glinting, invigorating, but warming only in sheltered nooks. And we ate our bread-and-cheese, and we drank from the bubbling, busy stream, and we wrote some letters and read our books, and for a couple of hours we lay and refreshed ourselves, absorbing the spirit of the great bare spaces and listening to the sounds in the silence. Out of the silence, close behind our rock, rang out the cheery voice of the little meadow-pipit – "Please! Please! Please!" he would say, as he hung fluttering in air, and then, with

a rapid descending accelerando: " Please – please-please-pleasepleaseplease!" as he swung himself down from the blue, a sheer and giddy drop that swerved out in a lovely curve when he righted himself and got upon the wing once more. Again and again this little play went on, till we ceased to notice him and heard only the haunting cry of the curlew circling over the bog below, or the hoot of a barn-owl from down a distant valley.

"Cows, Jimmy!" I said, rousing myself.

"Darn the cows!" sleepily, from out her book.

"It's getting jolly cold, anyhow," I remarked, shivering. For the sun was passing behind the hill and leaving our corner in a cold March shadow.

"Oh dear! Come on, then," says Jimmy, rolling over and picking up her rug.

And like Zarathustra the Preacher we turned our backs on the mountain, and went down to work among men.

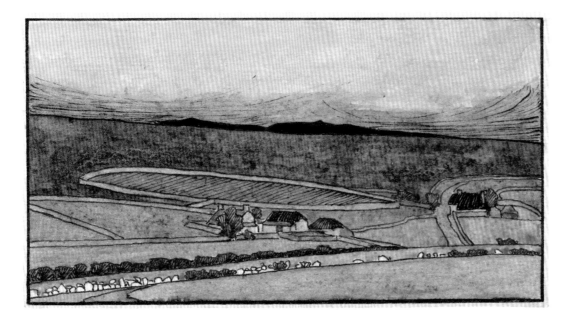

An evening view over the moor towards Dunnabridge Pound, a watercolour by T.A. Falcon.

V. OUR COTTAGE
April

The Missus 'must and would get her house clean.'

THE Missus had come to the end of her patience. She simply could not stand such a houseful. Not that she objected to any of us individually, but visitors were expected for Easter and she must and would get her house clean. The boy had vanished for the last time over the garden wall; Coombe had departed – I myself drove him and his bag to the station and saw him off; and now that the snow had gone and spring was on its way, Jimmy and I were to set up in a cottage to ourselves about five minutes' walk from the farm.

Needless to say, the prospect was by no means unpleasing, for though comfortable enough on the whole, there were many minor trials in a household such as we had been living in. Chiefly, I think, the shut-up atmosphere of the house – what a terror of draughts country people do live in, to be sure! That frowsty kitchen! The Missus at times would have mercy on us and open a crack of window, and then Maester would shiver and turn up his collar and put on his hat, till out of compassion we were forced to give in. Another minor infliction was the weekly table-cloth, a rumpled affair at the best of times, which

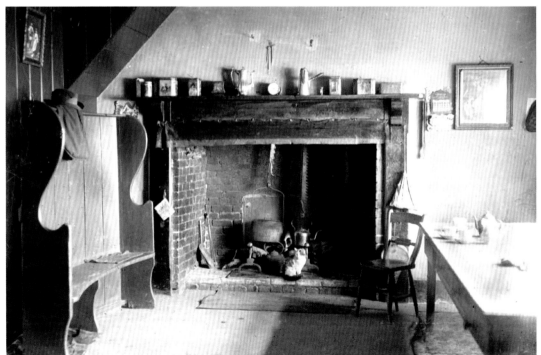

A cat warms itself beside the open fire in this Dartmoor farm kitchen c.1910. The 'Maester's' hat and coat are perched above the back of the settle and tea cups are laid out on the table.

began life more or less white at dinner-time on Sunday, but re-appeared thereafter meal after meal, regardless of stains and wear and a dripping tea-pot. I have visions now of Miss Minton, standing up, her cheeks stuffed with bread-and-butter, one hand doing something at the stove and the other, with sleeve rolled back from a fire-scorched arm, pouring out cups of tea, and the unfortunate cloth being liberally baptised the while. But nobody minded. We did once remark how nice it looked to have meals laid on a plain wooden table that could be washed over every day, but this was considered quite the lowest depths of squalor, " No!" says Maester, "we don't want to pig it like that. I do like to 'ave my food decent-like on a nice table-cloth."

They were minor trials, after all, but the idea of having a corner to ourselves with our own furniture and household goods, where we could eat with windows open, away from our kind but loquacious hostess's unceasing chatter, was one that we felt would very well make up for the extra work that a separate menage entailed. We spent one of our precious Sundays at the cottage, scrubbing the floors and lighting fires, and then as soon as the spring corn was in and the horses could be spared, Maester and I were to set off with the waggon to fetch over my furniture, which had been left behind in the country where I was working before, fifteen miles or so over a shoulder of the moor.

But there was always something imperatively needing the horses, and we had a pretty full week, preparing the ground, drilling the corn and harrowing it in. The day before we started, I remember I harrowed over ten acres, beside shifting the harrows in a cart from one field to another, and bringing in extra loads of mangolds to last the following day. But at last there did come a momentary breathing-space, and we could take the day away.

Leaving the farm, with the stock and the whole day's work on Jimmy's capable shoulders, Maester, with Prince in the waggon, and Bob and I with the carry, set off in the early morning, over the long moorland road and down to the valley beyond.

We loaded the goods ourselves, Maester and I – beds and bookcases, tables, chairs, chests of drawers, pictures and all, stacked with all an artist's care in the waggons – and then by about four o'clock, after cider and refreshments at the house of the farmer there, we started on our home-ward way.

Spring cleaning at a Dartmoor cottage c.1915. Olive's reference to fetching her furniture 'left behind in the country where I was working before, fifteen miles or so over the shoulder of the moor,' suggests Cornwall as the place of her previous farmwork. Also her father's native home too.

Never shall I forget that endless journey back! The anxious descent down the long steep hills to the valley, the long pull up that interminable moorland hill, the continual stopping to ease the horses, while the night came gradually upon us; and finally the jogging along mile after mile in the starlight, sitting balanced on the shaft whenever the way was level, and trudging, hands in pockets, at the horse's head when the road climbed up still higher. Sitting, for hours as it seemed, half-asleep on the shaft, listening to the rhythmic, tired pacing of the horse, I remember feeling as though my whole life must have been passed to that monotonous measure – on and on under the stars, with the dark hedges swinging slowly by and the darkness ever closing nearer a life with neither shape nor purpose, nor beginning, nor end, nor even an incident to –

"Ahoy! Sammy!" came a lusty yell from behind. And lo! while I dreamed and fancied, a buzzing motor-car beside itself with indignation, was hooting in my wake. So I leapt from my perch and pulled Bob out of the road, while the snorting car fled by and was swallowed like a meteor in the darkness. Eventually we pulled into the yard about nine or ten that night.

* * * *

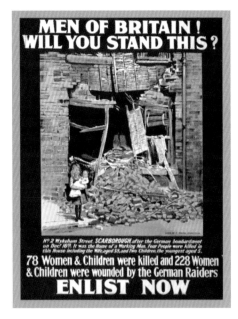

**MEN OF BRITAIN!
WILL YOU STAND THIS?**

Nº 2 Wykeham Street, SCARBOROUGH after the German bombardment on Dec! 16th. It was the Home of a Working Man. Four People were killed in this House including the Wife, aged 58, and Two Children, the youngest aged 5.

78 Women & Children were killed and 228 Women & Children were wounded by the German Raiders

ENLIST NOW

At the outbreak of the war the militant WSPU put aside their claims for equality, with Emmeline Pankhurst stating that the 'German Peril' outweighed the need for women's suffrage. 'When the time comes we will renew the fight. But for the present we must all do our best to fight a common foe.' Olive makes plain (opposite) her thoughts on the inequalities of labour.

And now our housekeeping trials began – from the time when we unstacked the furniture next day and found that most of it refused to be got up the narrow stairway, to the final day when it refused to come down again!

But the chief problem, of course, that beset us – since not the smallest corner was left in our busy day for cooking and cleaning – was the finding of a "cottage wife" to come and take care of us. And this is a problem that is never, it would seem, given due consideration by those concerned with woman's work and wages. There is a theory current among some (I myself was deluded by it at one time) that a man needs higher wages because he "supports" his wife!

But "supports" forsooth! In our troubled experiences it was made abundantly clear to us how impossible it is for a working man to live without a wife to support him. And it was also brought home to us what a thoroughly sound thing man did for himself (for his working self, at any rate) when he designed the marriage-bond. For unless she were irretrievably bound to him by law and convention, what woman would ever do the work of a working man's wife? And for no more reward than a bare subsistence and the roof over her head! When complicated by a houseful of children the question seems to me wholly superhuman, for even without them the round of work is sufficiently staggering to those who attempt to do it. A working man's wife must cook his dinner and clean his rooms; she draws the water herself from a well, fetches in coal, chops the wood and lights the fires; she washes his shirts and his sheets and his tablecloths, she mends and buys his clothes. Often she must walk some miles every week to buy provisions: she housekeeps and saves, and often puts by – and to earn a little money for herself will, in addition, go out to work for other people, or take in washing, or a lodger. This is the normal minimum – for there are many who do more, such as baking their own bread, or working in the garden and seeing to pigs and poultry. But in return for all this a man is considered by popular opinion to be an exceptionally good husband if he brings home his money of a Saturday evening and hands her enough for the purchase of his own food, no account ever being suggested of all the unpaid service that is lavished upon him!

For all this necessary service must a woman worker pay out of her earnings, not only by providing her housekeeper with ample food and a roof, but by wages as well. In addition to this she must see to her own clothes and mending, or pay a second person to do them; pay a third one to wash both her own and her maid's, and herself supervise the housekeeping and marketing. Often her "housekeeper" will require a weekly charwoman as well to scrub out the kitchens, making a fourth individual to be paid.

Let no more be said about the vexed question of "equal pay for equal work." If either sex needs higher wages it is obviously the woman; for without the marriage convention that binds to a man an unpaid servant for life, no labourer could ever have lived in a house of his own on the pre-war wage of fifteen shillings a week.

Well, Jimmy and I had to set ourselves to the solving of this problem as of many others. As there was no one at hand who could come in, even for an hour or two in the day, and as our wages did not permit of a paid housekeeper, we had to light on someone who would come either for love or for patriotism, and we racked our brains and wrote letters by the score, and were almost reduced to the last resort of advertising in the *Matrimonial Times*.

However, in the midst of our blank despair, while a permanent wife was still unfound, there dropped upon us one day – Jimmy's sister.

Like a light from another world she came, rolling up in a cloud of pots and pans and

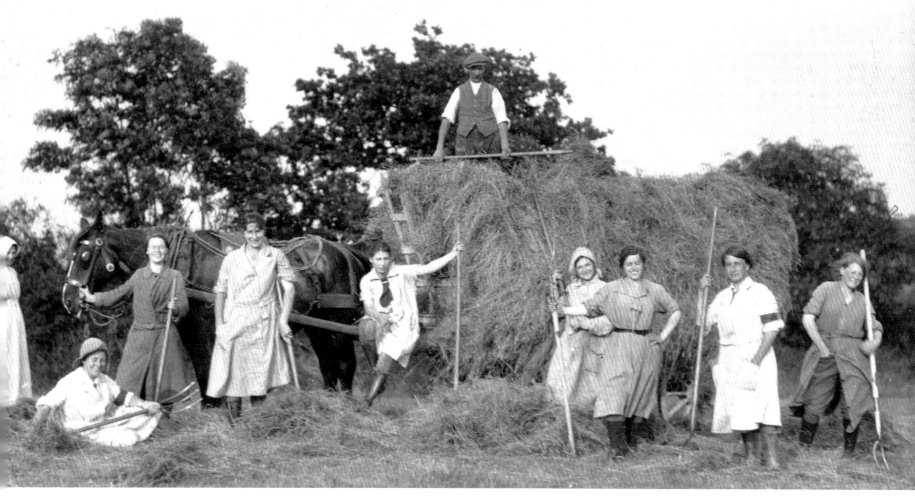

dusters, egg-whisks and tea-trays and garden-rollers, and every conceivable household requisite. With magic hand she set us straight, and she cooked and scrubbed and cleaned and polished, and even dug the garden. In fact, she would do every mortal thing – but stay.

The cottage was close on the road, trim and square, with whitewashed walls and a slated roof. Straight from the roadway, through its prim little porch, one entered the kitchen, and on the left was the front kitchen or parlour, a room with unpapered walls and a stone floor, dark and cool in summer, and very cosy in winter.

Across the roadway lay our garden, a crooked rectangular patch, divided from the road by an old moss-grown stone wall over which our nasturtiums romped in summer. A little broken gate led into it, and round its further boundary was a luxuriant, towering hedge of plum and hawthorn. Beyond this ran the same little brown-gold brook of rushing water that we had dabbled in that Sunday on the moor.

There, screened among the hawthorn and overhanging ash trees, was a pool just deep enough to bathe in on summer evenings or on a Sunday morning. But the household water supply, much to the lamentations of our successive housewives, was only to be obtained with difficulty. For every drop one needs must cross the road with a bucket,

Women proving themselves the equal of men. WLA members undertook training at Seale Hayne College in South Devon from March 1916 to be instructed in milking, calf and pig rearing and field work. By December the local press were reporting that of the seventy women trained at the College for agricultural duties, only four had proved unsatisfactory and where farmers gave women a fair trial they were 'doing very well'. Women joining the course had to agree to work on a farm for a period of at least three months after the training, and in this way to help to take the place of men that had been called up.

Farming people were often obliged travel considerable distances to reach the nearest store, although most villages had a shop which stocked essentials. This Devon store, Goodings of High Bickington, is fairly typical of a small general store around the time Olive was living on Dartmoor, selling everything from sweets and biscuits to aspirin and hacksaw blades. For those not willing to travel there was always the local roundsman who, with horse and cart, laden with lamp oil, lard and linoleum, would follow the same route on specific days delivering goods against orders taken the previous week.

descend three slippery stone steps, stand in a pool of running water, open a door, and dip from an over-flowing well – proceeding with picturesque possibilities, but not conducive, as one and all declared, to the ease and despatch of housekeeping.

The vicissitudes of housekeeping, indeed, were many. They began even before we left the farm, in our first attempt to order in some stores. There seemed to be never a moment when we could talk over our needs together, and at the last moment at breakfast I tried desperately to write an order to a grocer.

"Tea, coffee, sugar," I murmured, writing.

"Of course, you'll get Clarkson's Cleanser, Sammy, won't you?" broke in the Missus, who cannot tolerate the sound of anyone's voice unaccompanied by her own.

"Oh yes," I replied absently. " Coffee, sugar, tea. What else, Jimmy?"

"Matches, candles," puts in Jimmy.

"Matches," I write.

"You must get half a dozen dusters; you can get them all at Beare's," suggested the Missus. "I've got dusters. Matches, candles – I went on writing it down. "What else?"

"I advise you to get Brunter's boot-polish, Sammy. It's much the best. Some people like Neville's, but I don't recommend it."

"We shall never have time to clean boots. We must get necessaries first. Do we want flour, Jimmy?" I went on desperately.

"Oh yes," chimes in the Missus,unabashed, "of course; be sure and get Samson flour; and if you mix it with – "

"I shan't get any flour," I exclaimed wildly. " There's the postman's knock, and this will have to go as it is."

Such was the way we began. But somehow things muddled along and settled down, and, thanks to the efforts of a succession of friends and relations, we somehow got fed in spite of all.

Our twice-daily walk to the farm and back by sunrise and sunset, in the heat of midday or the darkness at night, was a joy which never palled. As we left the farmyard gates three roads branched off; one, steep and narrow, climbed between high banks to the upper fields; another, overhung by holly and hazel, dropped steeply down to the mill; while ours, the most attractive of all, passed round the slope of the hill, with a steep slope down to the river on one side, and a flower-spangled bank on the other. All the year through that valley passed from glory to greater glory. In spring, when the trees were bare, the brook could be seen between their boughs, sparkling and chattering merrily down from the moor, but as the first green veil spread over them, his flashets sparkled less, though his homely voice was always heard, rushing and whispering, or rising to a welcoming uproar as we turned the last bend near home and scented the fragrant whiff of wood-smoke from our fire. Barely the first spring flush had come upon the boughs when a wealth of blossom, of blackthorn, cherry and wild plum, apple, pear and hawthorn, one after the other, foamed over the valley like a breaking wave. And when the warm rains of spring came blowing from the west, dismantling the blossom in heedless disarray, then the boughs of the fruit trees took on their clothes of green, the gold of the young oaks turned alike to green, and to harder and deader green as the drought of summer came upon us. Harder and deader and greyer still till harvest was over, colourless, tired and waiting – and then, in a sudden burst of pomp and splendour, autumn was there and let loose her fire. . . .

Flames of gold and copper and bronze ran rioting over the hill; each tree was caught, turned scarlet or crimson, or orange or gold, burning in the sunlight, glowing in the dawn, brighter and ever brighter, till in that onslaught of colour, the whole valley flamed up like a funeral pyre.

But the blue mists crept under, slowly and remorselessly working their will, slowly but surely quenching the crimson and gold; and at last, fighting ever as with the glow of dying embers, the cold grey hues of winter, beautiful even in their dark severity, once more prevailed.

We saw the seasons through in that little wayside cottage. I came on it first, desolate amidst the untrodden snow, and in the snow we left it. Who lives there now? Often we wonder, and whether our garden is dug or cared for, and how the rose has grown that we found all choked with grass and that we pruned and trained with – well, I confess, with but intermittent care.

VI. SPRING TILLAGE
May

FOR truly it was a desperate time as regards the work. Coombe, and the boy also, had left, and for an interval before another more capable one arrived upon the scene, our inadequate feminine hands constituted all the labour our farmer could command.

Some thirty or forty bullocks there were on the place – using the word in the local sense to include cows and calves as well; over one hundred sheep and lambs; four horses and a pony; pigs and all. All of them must be fed, and most of them individually and differently. All the work was backward from the prolonged snow – if only the grass would grow we knew things might get easier, for the hungry mouths could then find something to eat for themselves. But it was still too early for cattle and horses to be put at night, and the round of feeding seemed never finished.

Added to this – for these were, after all, considered only morning and evening duties – there was all the real spring work to be done in the fields. Even the ploughing was not finished, and for every crop there was the land to prepare and the seed to till.

To our intense relief we had seen the last of the potato crop, but only to find that with the new season's planting the work began all over again! Ten acres of potatoes the farm had borne the year before, but the consequent labour they entailed had hung up the rest of the work the winter through, and this season, like many another farmer frightened at the scarcity of labour, our "Maester" was not prepared to risk it again, and four was the most he would undertake.

Our planting days were during a spell of warm spring weather. The new boy – a lad of seventeen – had just arrived, and all hands were at work. Not all hands, however, for Jimmy, I remember, at this time was enduring an interminable penance of thistle-weeding in the young green corn.

The potato-field was on one of the steepest slopes of the farm, wellnigh precipitous in one part, with a continual outcrop of granite at the brow. It had been my work a short time before to gather up those slabs of rock in the cart and tip them away into a corner, but every time the plough or harrows went over the field, more loose pieces appeared.

We went out in the morning with the cart, with bags of seed and bags of artificial manure, and dropped them along the top and bottom hedges; and then with a pair of horses and the plough, Maester valiantly stormed the hill, turning up a furrow in which we followed, planting the seed. Tom the second passed on first, scattering the dusty manure out of a pan held under one arm; and I followed after, enveloped in a voluminous apron of Maester's in which I carried the potatoes, dropping them as I went at regular intervals into the trench.

As we went up the hill, down came Maester and his charging pair, ploughing up another furrow for us to follow down. Two rounds to our one the plough must do, to cover up the seed before opening the next line, and during his second round we found a moment for a welcome pause and a little gossip before making our next assault upon the hill.

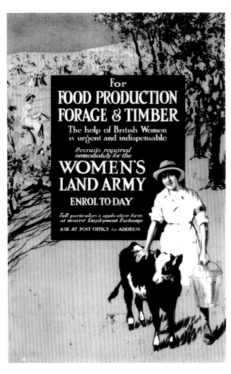

Devon men were slow to respond to Kitchener's appeal for volunteers but in January 1916 conscription was introduced targeting men aged between 18 and 41. Local Military Service Tribunals were set up to hear appeals from those who felt they should be exempted, including Conscientious Objectors, many of whom were incarcerated in Dartmoor's notorious prison at Princetown. As more men were called up so farmers relied increasingly on women to fill their places.

A merry lad was Tom the second, different as could be from poor little Tom the first, who shirked the snow. Garrulous, cheery, quick-tempered but magnanimous, he was quite an addition to the personnel of the farm; always singing or cracking jokes, arguing or imparting information as to everything in the world and about horsemanship in particular. At home his delight was a gramophone, on which he spent most of his pocket-money; and every evening, as we brushed down our horses, the stable would re-echo to the latest thing in soldier's songs learnt from his last-bought record. "Keep the home-fires burning," "Pack your troubles in your old kit-bag" – all the songs of that year came up to the stable, and to me those tunes will for ever bring back the sight and smell of the place: the lantern swinging from the roof gleaming on the horses' quarters, the smell of straw and hay – and horse, and the sound of steady munching from the mangers where their heads disappeared into the shadows.

For all his self-confidence, however, Tom had not the makings of a horseman. The Powers grant he may never read this record, for many a stormy scene did we have upon the subject. "What do you know about 'arses?" he would say in withering contempt. "Yu ain't bin drivin' 'arses so long as I 'ave!"

I might reply with truth that I had driven horses before he was born, but I failed to convince him. For, in common with other Devonshire men that I came across, the first and last idea in his head was to make an animal fear him, the height of horsemanship in their eyes being to be able to "knock an 'orse down!" No distinction could they see in an animal's mind between deliberate perversity and nervous fear, and never could I get anyone to see my contention that to punish an animal for what was merely the result of nervousness was to make it inevitably more intractable than before.

"I'll soon make 'e understand! I'll learn 'e to be frightened' I'll knock 'e down if 'e doan't be'ave!"

Such is the attitude. A case in point was Topsy, the black mare who lived in the loose-box. She had not done much work during the winter, chiefly because of her uncertain habit of kicking out when least expected; and even Coombe declared that "two horses were quite enough for him to see after, and he was not going to be bothered with Topsy." So she was at that time used mostly as a saddle-horse, and I looked after her in the stable. She did once swing round on me and present her heels, pinning me in the furthest corner of the loose-box; but it was only because, while brushing her down, I had surprised her by passing carelessly round to the other side and touching her without warning. Tom would have at once wanted to punish her for "wickedness," but of course it was only nervousness, and I was resolved to make her trust me and to try and tame her in my own way.

I had my reward, too, later on, when her foal was born. It was summer then, and for months Maester had been worrying, looking at Topsy and saying: "I don't believe her's in foal, after all! What do you think, Sammy?" I thought he probably knew better than I did, so I ventured no opinion. But as time went on he began to be more hopeful, and the day came when I went up on the hill one morning, and discovered her with a new-born foal, a lanky little beggar, black as herself, staggering unsteadily on his long thin legs. She walked down to the gate as usual, so I let them come in to drink in the yard as she did each day, meaning to turn her out to grass again.

But circumstances had changed, thought Topsy, and having different ideas of her own, she made a straight course for the stable, and once inside would allow no one to approach,

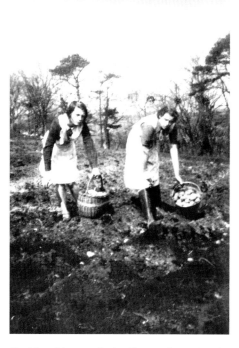

Backbreaking work planting seed potatoes by hand on a Westcountry farm.

Sam Scarr, farmhand at Foxworthy Farm on Dartmoor, feeding a foal from an enamel bowl held between his legs c.1920.

nor would anything induce her to leave it. There she stayed in her loose-box, laying back her ears and showing her heels as soon as anyone came to the door.

Maester was in a great state of mind, scolding me for having brought them in, saying the colt would "catch 'is death o' cold" lying on the stone, and he wouldn't lose it for a hundred pounds, but he was "frightened to death to go near her himself."

"But I know as it's I as 'll 'ave to get that 'alter on," he declared, ramping about – "there's nobody else won't do it."

Tom was for climbing round the wall and driving her out with a whip – a proceeding which would only have alarmed her more, for one could see that it was only fear for the safety of her colt that was the trouble.

After persuasion and whips and other means had failed, I told Maester that I believed I could go up to her with a handful of corn, if he would only keep quiet and let me try.

"Well, you can try, Sammy, if you like; I'm sure I'll be only too pleased – I'm frightened to death of her myself!"

So, entering the loose-box quietly, and holding out my hand as I had often done before, I was rejoiced to find that my experiment had answered. Topsy recognised me, and though she stood palpitating, her black eyes full of fear and ready to swing round at the least surprise, she let me come near and nibbled some corn from my hands.

"Catch 'old now! Catch 'er!" says Tom excitedly in the background. " Don't 'ee let 'er go now!"

But I wanted her to trust me and to feel she was free to go whenever she wished, so without any hurry I took some more corn from my pocket, and then quietly, and without any struggle, slipped the halter over her head.

Then with her jolly little black baby trotting at her heels, I led her down in triumph to the meadow.

I must say for Tom, however, there was not much that he was afraid of, and he knew many valuable tips and ways, and imparted to me much farming lore while we worked together. There was one day when Teddy, the Dartmoor pony, had unlatched the meadow-

Sale of Dartmoor Ponies at South Brent Fair 1919. Well into the twentieth century, the native Dartmoor breed of pony was considered part of the farmer's stock. Though ranging 'wild' upon the open moor, each animal was branded as belonging to a particular farmer and annually these would be rounded up at a 'drift' and sorted ready for market. These small but hardy animals were popular for riding but their value lay largely in their use as pit ponies, many being taken from such fairs as this by rail to the coal mines of South Wales.

gate and escaped to the moor. We rode out to hunt for him on a Sunday morning, Maester and I riding Topsy and Bob, and Tom following on his bicycle.

After a jolly breezy ride, climbing up to the tor and inspecting all the groups of ponies within range, Teddy was descried at last, looking very smart and sleek among the ragged little gipsy-like moor-ponies, and a good chase he gave us before we could separate him from the rest.

But then came the problem of catching him! Time and again he would come, diffidently sidling up to Bob, staying for a while for a sniff and a moment's chat, and then, before I could slip off and get near, away he had whisked with tossing head and flying tail, to join his raggle-taggle comrades. It was obviously friendship versus freedom, and poor Ted was torn in two. Tom it was at last who got hold of him while I offered some corn, and he held on hard by his nose and his neck, while Teddy struggled and jumped and did all he could to get away.

But Teddy was not nervous, not a sign of it. He was thoroughly confiding and cheeky and inquisitive. There was hardly a latch on the farm that he could not undo, and if it were secured by string he would set to work to undo the knot! Often as we were milking in the shippen a step would be heard outside, the door would fly open, and in would march – who but Master Teddy, inquisitive little grey nose and fat little black back, as much at home as you please! In he would walk, strolling coolly up to a cow's stall to see if there was anything interesting to eat in the manger. If the door happened to be locked he would stay outside and knock, deluding us into thinking some rightful person was waiting to come in, and often making us get up off our stools to open it. One night he surpassed himself. He lifted the latch of two gates from the yard where he was shut in, opened the shippen door, let out the calves that were loose inside, shut the doors on them again, and usurped their quarters for the night!

Provoking little beggar! But he did me a good turn once, and obtained for me several weeks of most welcome holiday. It was right in the middle of the corn harvest; we were exceptionally busy, and no thought of a holiday could possibly have been entertained just then, though we were both pretty well fagged out with the summer's work. Maester sent me out one day to round up the sheep and to take them up over the hill. To save my tired feet he told me, as he often did, that I could take the pony and ride with them. So being (as usual) in a hurry, I caught Teddy, but did not stop to put the saddle on, and started, cantering gaily round the field to head off the sheep. The dog was barking at his nose, I remember, which worried us both. Anyhow, whether it were Shag or a rabbit-hole I never knew, but in the middle of his canter Teddy skipped into the air, his slippery, fat, round back somehow ceased to support me, and down I came on the ground. And a broken finger, with a badly sprained hand, obtained for me inevitably the much-desired respite.

Damaged hands were certainly the fashion that summer, for Jimmy likewise achieved a holiday, by poisoning her hand with blackthorn prickles – the result of a week of hedge-trimming. And some time before Tom's hand also was in the wars, badly burnt when pitch-marking the sheep.

But summer's work must wait for another chapter. We were now in the middle of spring, tilling potatoes. After the potatoes, one after another each crop had to go in. Corn, potatoes, mangolds, swedes, turnips, clover, and rape – each occupied us in turn. Each in turn the fields were ploughed and harrowed, rolled, and harrowed again before the seed

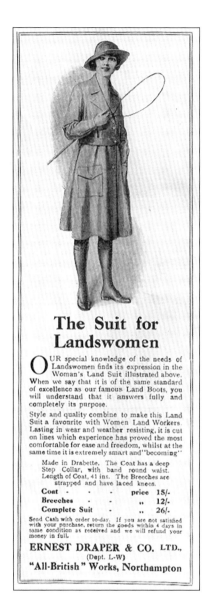

Cecil Aldin's 1918 painting, 'A Land Girl Ploughing' – a somewhat idealised portrayal when set against Olive's descriptions.

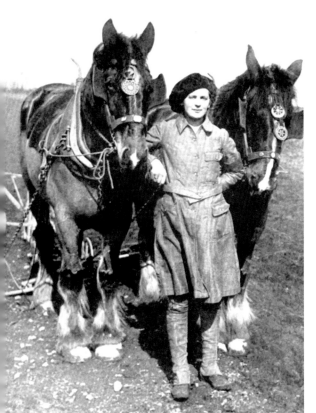

A Westcountry Land Girl with a pair of workhorses pulling a harrow.

was sown, and many a mile I tramped with my horses over the heavy ground. Usually Maester and Tom worked the drill, the latter leading Prince in the shafts while Maester trudged behind, watching the seed as it fell through the six little funnels. Topsy, Bob and I came after with the harrows, covering the seed and leaving the fields all smooth and tidy. And Jimmy – where was Jimmy? Why, I suppose she was still at that interminable thistling. Yes, I remember a glimpse of her over the hedge, little green tunic and orange silk handkerchief round her head, like a big, yellow dandelion flowering in the corn.

It was uncertain but beautiful weather. We seemed to have a whole month of thunderstorms and rainbows. That month remains now in my mind summed up in one vivid memory – a rolling hill-top meeting the sky, and falling away on either side to the thundery blue of distant hills; gigantic clouds piled up everywhere; local rainstorms stalking like ghosts across the valley, and overhead a triumphant rainbow arch, through which my plunging horses charged with the harrows. The very top of the world. Sunlight, glinting across the blue: now blotted out by rain, now piercing and flooding the mist with gold; veils clearing filmily from the hills; and rainbows – always rainbows flickering over the valley.

Literally plunging horses I drove, for those upper heights seemed to go to their heads even as they did to mine. Prince and Topsy and Captain all together I had sometimes, and a most obstreperous trio they were. Prince would kick at the chains whenever the whippens bumped his heels; Topsy delighted at any moment to stand on her head and let fly at the rainbow; while all three at times would start with a mutual impulse, tearing off in the wrong direction, while I followed as best I might, digging my heels in the ground and lying back with all my weight on the reins to hold them.

It was my one score over Tom – and I could always bring it up when he was particularly crushing about my horsemanship – that at any rate I had never let those three get away. For that is what happened the first time he had them out himself. From the hill where we were working, Jimmy and I could see him with the harrows below. He seemed to be in difficulties with the horses for some time, for their course was impetuous and distinctly crooked, and at last they got right away. We watched his charging zig-zag career across the field,, and held our breath as the galloping horses neared the lower hedge. It was low on the field side, but dropped steep and high into the narrow lane. And – as the boy told

afterwards in excited tones – they were all but over it in their rush had not old Captain had the sense to hang back. At the last moment, instead of crashing over the hedge, he swung the others round, and they pulled up a little further on by the gate which, mercifully, was closed. It was a long time before Tom would drive the mare again!

Those excitements on the hill-top with the horses and the rainbows I thoroughly enjoyed, but there was one really bad moment I had once when out with Prince. It happened on a day when Tom was away, and there being no one else to drive him, I was for the first time promoted to take him out in the cart. (From this you observe that Tom was head-carter – I was only second!) Up to now Maester had been rather wary about letting me drive him, for though we could not come to much harm in the open fields, it was a different matter with a cart on the road. Prince was young, big, and full of fun; also impatient and inclined to make mountains out of mole-hills when his nerves were at all upset. He had once run away in the cart with Coombe, though I don't think Maester was ever aware of it. And one memorable day in the hay-field he had bolted with an empty waggon, and jumped a gate with the waggon behind him.

The reality of ploughing steep moorland fields. Land Girl Miss Collett working under instruction at Foxworthy Farm on Dartmoor c.1917.

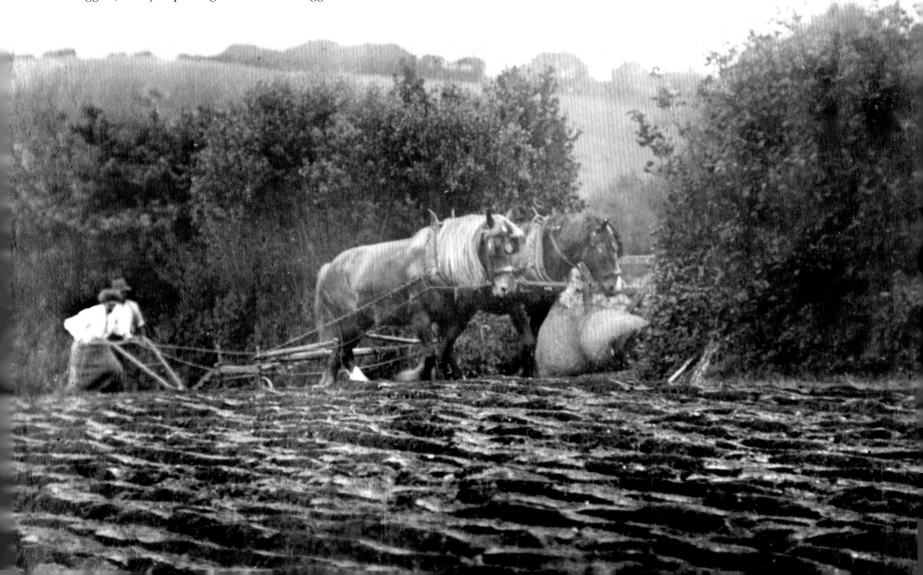

With all this against him, I felt very much honoured by my new responsibility, as he and I started up the hill together with a load of turnips for the sheep. He was really a darling to drive, so podgy and round and sleek, with soft padding footsteps like a cat. Not hard and jerky in his movements, like Bob, but soft and sinuous, with a beautiful mouth, tender as velvet.

At those upper fields were all the narrowest gateways, but we got safely through two – rather with my heart in my mouth, for the bank was steep and the stone posts leant so perilously near the wheel... The third, however, was really a problem. It was in the corner of a field leading out into another. The gate would not open straight – a hedge at right angles was in the way – and it had to be taken on the skew. Taking Prince firmly by the head I made a shot at it – but crash! we stuck, wheel wedged hard against one post.

"Bless my soul!" said Prince, "what's this? Who's this has the impertinence to hang me up?" And he plunged forward to clear himself of the annoying hindrance. But the gate held fast. The cart slanted across the opening, wedged on each side, and nothing short of removing posts and all could release it.

"My goodness gracious me!" said Prince. "My corn and whiskers!" he went on in growing indignation, and he kicked out hard behind. That only hurt his heels against the

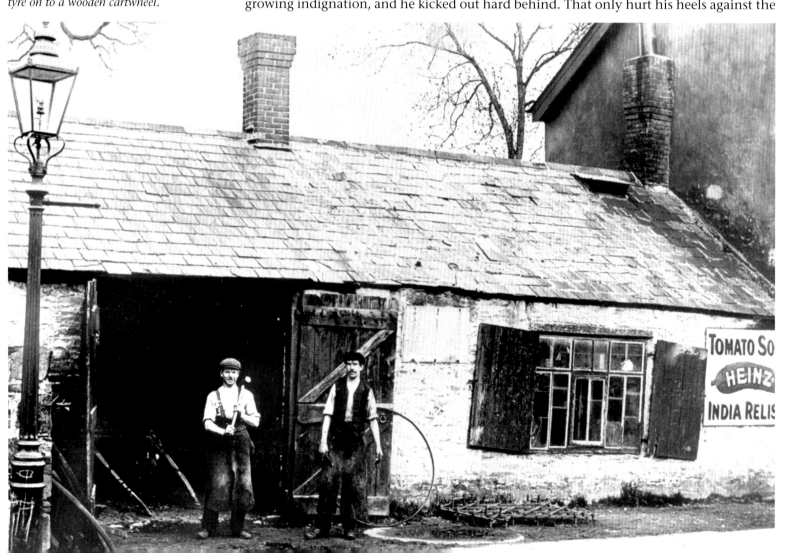

What couldn't be repaired on the farm would be taken to the local smithy where the blacksmith often also served as wheelwright. This is the smith's shop at South Tawton, north Dartmoor c.1910. The iron hoop of a cartwheel tyre stands against the smithy door above a circular ring of granite – the wheelwright's stone – used when fitting a red-hot tyre on to a wooden cartwheel.

TOMATO SO
HEINZ
INDIA RELIS

cart, and his indignation turning to fright, he lashed out harder than ever. But neither cart nor posts would give, so he plunged and kicked with increasing vigour.

"What did you do?" asked Jimmy breathlessly: when I recounted all this that evening.

"Do?" I replied, "what could I do? I just waited till he'd done!"

Of course I know what I really should have done, according to Coombe's instructions. That is to seize firmly hold of his head, give the bit a vicious jerk, and roar out "Damnee! Where be goin'?" But I have to confess that my presence of mind had fled, and for the moment I could recall no instructions that would meet the case.

But all excitements have their ending. At last the belly-band burst, a tug-chain came loose, and poor old Prince in an agony of terror leapt out of harness, cart and all, and swung himself round to look at it, held fast still by just one tug-chain. Now that he could survey the obstruction he waited, trembling, for me to come to his aid.

I was not very keen on coming within reach of his heels, so I had to climb over the hedge and crawl along the bank before I got to his shoulder and could undo the chain. After that we abandoned the cart, with its load of turnips and its cracking shafts, and dejectedly and rather ashamedly betook our way homewards. Going down the lane, over the hedge popped Maester's face, round with wonder. He was setting rabbit gins.

"What's amiss, Sammy?" says he. "Anything 'appened?"

"I'm awfully sorry, Maester," I said in a voice that still sounded scared and trembly. " But I left the cart behind 'cos I'm afraid we've broken the shafts." And I related the adventure.

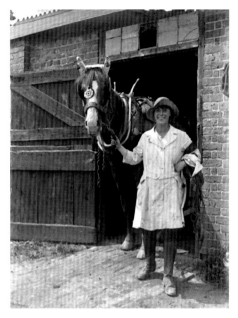

First World War Land Girl with her horse ready for work.

"There! You see!" said Maester, very much upset. "That's what I 'ave to contend with!' That's just where it comes tu – employing women! You want to drive the 'arses, and this is what 'appens when I let you! Dear, dear," etc., etc.

I did not think it the right moment to remind him how many times the boy had broken the plough, though he was a superior male, so I offered to pay for the mending of the cart, and that took the wind out of his anger and pacified him, more or less.

It was not such a very bad job after all, for when we went up together to look at it, and took my staid old Bob along to fetch it down, the cart was still in usable order. But my biggest fear throughout the adventure was lest that boy should ever get to know. I implored Maester not to tell him, for I knew I should never hear the last of it from Tom, And Maester rose to the occasion with great generosity, and told many a fib to turn him off the scent.

Finally I took the cart in with Bob to the wheelwright – a humorous little man, who looked at the cart, and then at me, with a knowing twinkle.

"What," says he, "'ave ye bin lettin' the 'arses run away, then?"

And Maester forgave me in the end, and so did Prince, and we did many a day's work together afterwards, carting turnips in the closing of the year.

VII. RAIN
May

THE rain was driving across the hills, drenching woods and fields and roads with that fine, thoroughgoing persistency that Dartmoor knows so well. The skies lay close upon us, dark and heavy, resting their weight upon the tree-tops and smothering us with a thick, grey, dripping blanket.

In hobnailed boots and leggings we splashed our way up to the farm in the early morning, bowing our heads before the lash of the wind, while a trickle of raindrops slid and slithered round our hat-brims, pattering on to our oilskin coats in a never-ending stream.

"Think we'll be out in this?" asked Jimmy, quite prepared to face whatever might come.

"Oh no," I replied, "probably not. Don't suppose we can do anything out on the land while it's in this state. More likely to be cleaning out pigsties, I should think!"

"How awful! Sammy, do you really think so?"

"Shouldn't wonder," I replied. " You finished all the calves' houses last week, didn't you?"

"Yes. And I suppose the pigsties will have to be done some time. And the longer they're left the worse they'll be. But I'm not enjoying the prospect!"

"Nor I. Perhaps, though, Maester will take it into his head to start thrashing. Then we shall be playing about with the engine most of the morning."

"Well, I hope to goodness it will be that," said Jimmy. "Those pigs'-houses are a holy terror. They've not been turned out once since we came."

At the yard gate we separated, and I went on to the stables, whence a low rumbling whinny greeted my footstep. Having satisfied the appetites of those inside, I came round to help with the milking, and we were half through by the time Maester appeared, having wisely, as often happened on uninviting mornings, overslept himself. As we went on milking we could hear his passage through the yard – the click of the gate and the greeting of each kitten in turn: "Eh, Pussy! O-o-oh? 'Oo's my little sweet 'eart? Eh?" Then the slam of the barn-door as he went inside, with a jibe at the fowls who persisted in entering too; and soon after, the heavy footsteps crossing the yard in our direction.

"Morning, Maester!" we said as he came round the corner into the shippen. "What's on to-day?"

"Oh! Good-morning, Samuel!" came the answer, as it did each day, with an air of there being some huge joke unexplained, while he rubbed his hands and beamed upon us.

"What's on to-day?" he repeated. "Well now, Sammy, I think we might as well get some o' that there corn thrashed out. So when you've 'ad your lunch you can come an' 'elp me in the barn. And Jimmy, I shall want you too as soon as the engine gets started. But till then I think you'd better get on wi' clearin' out they pigs' 'ouses."

Poor Jimmy! – the blow had fallen! But though she could make a face at her cow where

she sat behind it in a dark corner, her philosophic answer, "All right, Maester!" rang out as sturdily as ever.

"Anyhow," she said to me afterwards, "the place will be all the better for getting it done. And after that I shall jolly well keep them clean, instead of letting them get into this awful state for want of turning out."

Maester went off to his indoor breakfast at nine, and Jimmy and I climbed with our lunch and thermos flasks to the loft, where, among the loose piles of hay or straw that had been tossed up there after the last thrashing, we could curl ourselves up in a nest, keeping watch at the same time on all that went on in the yard beneath.

It was a snug and sociable little meal. The sheep-dog, Shag – a nondescript creature with a Jaeger-coloured coat – generally joined us, and Laddie also, the collie – a more ornamental but less intelligent member of the species. The two would sit together in front of us, with tails flapping heavily and expectantly on the boards and eager eyes watching each mouthful, restrained from active assault only by the strong sense of politeness that all nice-mannered dogs possess. Black Or-rgan showed no such scruples; the little thief would tip-toe over the straw on to our shoulders, and whisk a piece of bread from our very lips. Luckily his thundering purr was something of a warning. Billy Muggins also sometimes sauntered up, blinking inquiringly, and waiting curled up by my side until some legitimate tit-bit came his way; and others also hovered around at times. Billy was almost my favourite, I think, though he was an ugly puss really – just a common, short-haired tabby, with no particularly showy points; but he had so much dignity, such quiet independent ways, and such wondrous soft fur and gentle movements that one could not but love him.

"Oh, so you've got plinty o' company, I see!" said Maester, returning again through the yard-gate, beaming more than ever after his dish of eggs and bacon.

"Oh dear. How quick you've been," we exclaimed, longing for another five minutes in the straw.

"Only 'alf an hour, Jimmy, by the clock!" he said, going towards the barn. "Now, Sammy, as soon as you've finished you come along an' 'elp me yur."

Reluctantly we packed up our basket, shook the straw out of our clothes and descended. Jimmy went off to fetch barrow and prong for her assault upon the pigstye, and I joined Maester in the engine-house.

Maester, admittedly, was not an engineer, and nor even could I, by any stretch of my habitual self-confidence, consider myself one. And the old engine who inhabited that dusky cell in the barn was quite aware of the fact and thoroughly took advantage of us. It was generally an hour or two before we could induce it even to begin to work, an hour of wrestling with wheels and taps and screws, and as the time went on we used to get more and more heated and exasperated with the world and each other.

To open the proceedings, Maester began by pouring oil liberally into every hole and crevice, while I did the same to the thresher, climbing about in the roof on perilous beams and exploring every wheel for an oil-hole. Then descending, I swept up the floor underneath, tidied away numerous old bags and buckets, and put things ready to begin.

The barn was a lofty, old-fashioned building that had been recently adapted for modern use. The engine-house was enclosed out of one end, with a loft above for stacking away the thrashed-out straw, and zinc granaries for the corn. In the main part of the building was the thrashing- machine, with corn-sheaves by its side, piled from the floor up to the

Sheepdog resting in a Dartmoor farm doorway. Interesting that Olive should describe the By-the-Way sheepdog 'Shag' as having a Jaeger-coloured coat as generally reference to anything German at the time was discouraged. 'Jaeger' refers to a hunter in German, and more specifically to a type of German infantryman. This was the period when the German Shepherd breed of dog was renamed Alsation in order to remove the stigma associated with Britain's enemy.

vaulted roof, and behind, a platform on which the operator could stand to feed it. A low dusty window illumined the ground part and a couple of sky-lights let in some daylight from above, and the effect of large masses of criss-crossing shadows, with bars of light falling across old worn beams, and a roof festooned with dusty cobwebs – here in brilliant light and there receding into gloomy depths of shadow – made the place a sufficiently pleasing scene for work on a rainy day.

It would have made a jolly picture from where I stood, halfway up the ladder, and I was thinking what a subject it would be for Stott, or Clausen – and thinking too, if the truth were told, that I could have made a better job of it than either of them if only I had the time – when – "Damn they old fowls!" rang out from down below – "(that ever I shu'd say so!) Sammy, you've left that door open again, an' the fowls be all inside! Shoo! Shoo! I'd like to ring the necks of the lot of 'em, that I would!"

By this I knew that the engine had got out of bed the wrong side this morning, and was venting its temper on Maester, who reacted on the fowls. Hurriedly I descended to help to wage war upon them. Fowls, being the property of the Missus, are a source of strife on most farms, I believe. They certainly were on ours, and they were also the one set of creatures that we thoroughly disliked. No sooner in the mornings had Jimmy tidied up her shippen, than the fowls hopped down through the hay-racks and scratched it all about again. If the stable door were open for one moment the place would be full of them, eating out of mangers and scratching in the dung for undigested corn; and as for the barn – well, they knew quite well that that was the heart of the Food Supply Department, and a group of anxious, chorking birds was ever hanging round the door, waiting their chance to slip inside.

As we came to the door a pungent smell gripped our noses, nearly knocking us backward. It cried unto the heavens, and the whole yard was full of it. In the midst was Jimmy, with prong in hand – head tied up tight in a handkerchief and a sack swathed round her waist – making heroic attacks upon the interior of the largest pigsty.

Lord! How it reeked! Even Maester looked compassionate.

"Yur, Jimmy!" he called out. " Come over yur a minute an' 'ave one o' my cigarettes. That'll 'elp yu!"

Jimmy let out her breath with a gasp and came over with relief, while Maester pulled out of his breast-pocket and handed to her a wondrous yellow packet' "My Darlings," I believe they were – which I had been commissioned to buy for him last time I was down at the station, sixpennyworth at a time.

Whatever they were made of, Jimmy accepted them with gratitude, and lighting up, returned courageously to her work while Maester and I meanly retreated, having had quite enough of her performances from the barn-door.

"Just come inside now, Sammy, and see if yu can turn the wheel for me," said Maester, as we returned to the grimy little engine-room.

The scene inside really almost vied with what we had experienced in the yard. Never have I seen such a den as that engine-house! Just now it reeked with paraffin and oil and smoke. Sticky smoke was coiling out of the door, and the dark window, already hung with cobwebs, was curtained again with smoke. The engine itself was permanently coated and clogged with oily dust, and to me it seemed small wonder that, stabled in such an atmosphere, it vent its resentment upon us and refused to work.

A wad of tow was burning and sputtering gaily in its little chamber, and this heating of

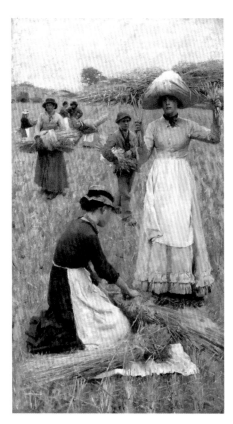

'The Gleaners' by George Clausen (1852– 1944). Olive, with her Slade training, would be familiar with the works of both Clausen and William Stott whose allegorical paintings often portrayed scenes from rural life. It's likely that Olive's real-life experience of farming led her to believe she would indeed have made a better job of portraying life on a farm. It certainly implies a confidence in her own artistic skills.

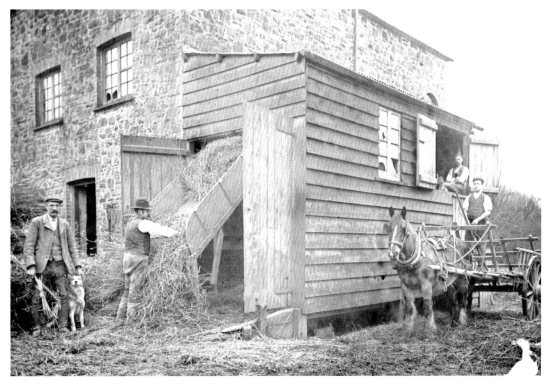

Threshing in a barn in North Devon in 1920. This would be the scene much as Olive describes it, with a threshing machine kept inside the barn along with a paraffin-fuelled stationary engine that drove the thresher via a canvas belt. Here the corn is being brought in from the ricks by the horse and wagon, then pitched up through the side of the barn where it is fed into the thresher. The grain is shaken out and the straw ejected down the shute where it will be carried back to build a new rick.

its nose at one end, combined with the turning of the wheel at the other, was supposed to set the thing in motion. I went to the big wheel and, using all my strength, succeeded in revolving it slowly, while Maester fumbled with taps and screws, and began lavishly to oil it all over again. But in spite of all our efforts, the creature remained dumb and lifeless.

I know nothing whatever about engines or machinery myself, and all I could think of suggesting was that it might perhaps go better for being cleaned. But that suggestion seeming not to go down very well, I held my peace and henceforth only did what I was told.

"Now, Sammy," said Maester, having turned all the taps and screws he could find, "I'll turn the wheel. You just come yur now, and pour the paraffin into this yur little 'ole – steady, now, not too much!"

Rather alarmed – except that I had had to do this before and had come out unscathed – I took the bottle and let the paraffin drip in a gentle stream on to the burning tow, while Maester wrestled with the wheel.

Flames began shooting all about, seeking what they might devour, and, finding nothing but oil and metal, licked hungrily around, as if one's clothes, or even some straw, would have been much more to their taste.

The wheel went crashing on, the burning tow sputtered and roared, something clicked and the engine began to throb. Maester worked the wheel more vigorously than ever whilst I still poured oil upon the troubled flames, and at last, with a snort and a violent explosion that sent the horses (when they happened to be near) careering round the yard, the engine caught on – the wheel revolved of its own accord, the big bands moved, the

wheels in the roof caught the infection, and with a rumbling and banging and snorting and puffing the place was alive at last.

"Run and tell Jimmy we're ready!" shouted Maester above the rattle of the wheels; "and find Tom too – we shall want 'em both." And I sped into the outer air, glad to get out of that choking den.

I released Jimmy from her unsavoury occupation and sent her in to help, and then found Tom, who was carting away the muck she had thrown out. He put Prince back into the stable and helped me to bring the big waggon across to the door of the barn, ready for piling up with straw. That done, we returned to the barn, to find that the thrashing-machine had been connected and was adding its booming rumble to the rest of the chorus.

Once the engine starts, the work goes forward merrily. Each one falls into his place – Tom on top of the rick, throwing down the sheaves to Maester, where he stands by the mouth of the thresher; Jimmy above in the loft; and I below, waiting for the straw. With a whirr and a burrh each sheaf was caught in the toils, whirred and beaten and pummelled inside, and finally disgorged. At my feet came pouring out the corn; at the back, the "doust" piles itself up in a dusty house of its own; and over my head came down the unending stream of straw. That was my chief work – to gather up the straw on my prong, and hand it up to Jimmy as she waited in the loft above, or stood outside on the waggon ready to receive it and stack it away.

From my position, besides throwing up the straw I had to keep my eye on the corn, and push it aside as the heap accumulated; then run round to the "doust" house and scrape that back when, in its turn, it threatened to choke up the machine; and again rush back lest my pile of straw should have grown overwhelming in the interval.

The work went on, breathlessly and without a pause, unless a belt happened to slip.

Threshing outdoors on small westcountry farms was a more usual practice than working in a barn as it avoided the expense of owning and maintaining a threshing machine and, in this case, a steam traction engine required to drive it. These 'sets' of machinery would be taken from farm to farm with its own crew of workmen, the farmer providing local labour in order to speed up what was a labour-intensive process.

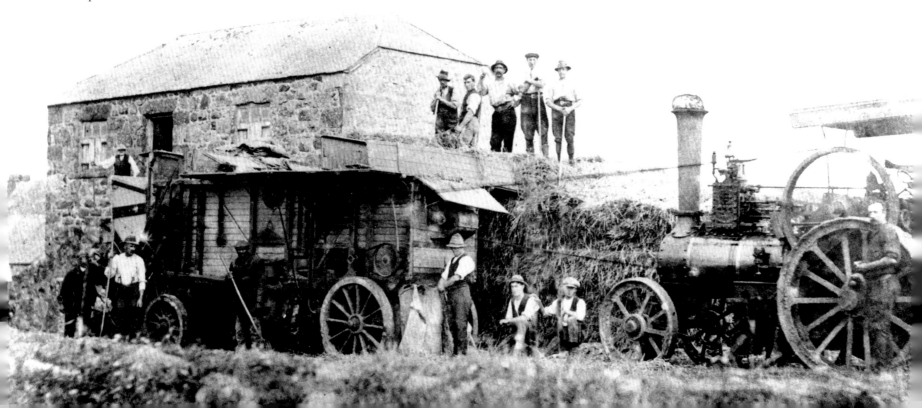

Sometimes there were more slips than threshing, and those were weary mornings of argument with the engine and the machinery. But today, once we were started, all went straight ahead. Unceasingly we worked, while the thresher buzzed and boomed, the engine spat and coughed and exploded, and the wheels rumbled overhead. Dust from the corn floated thickly over the scene, making silvery stairways where the daylight glinted down through the skylights, but choking our throats and nostrils and begriming our heated faces. The loft was full and the waggon already loaded high when, looking round, I caught sight of the Missus beckoning to me from the door.

"Sammy!" she said pathetically, as I came up to her, "*do* tell Maester that it's nearly two o'clock and his dinner is spoiling! I've been waiting ever so long hoping to hear the engine stop. Isn't he *ever* coming in?"

I laughed, put down my prong, wiped my face, and climbing up on the platform, shouted the message above the booming of the machinery.

"Oh, is she? Right you are, then, Sammy," he shouted back. "Just run up in the loft and pull the lever, and you can tell the Missus we'll stop right away."

I pulled the wooden bar that disconnects the machine, and the wheels and the thresher ceased from rumbling.

Maester stopped the engine, and a wondrous peace descended upon the world.

Coming out into the still gently falling rain was like reaching the country in the old days when the smoky London Underground was running.

"Well!" said Jimmy emphatically, "I'd as soon work out in the rain anyday as go through another morning like that again! And that blessed pigs'-house is still unfinished!"

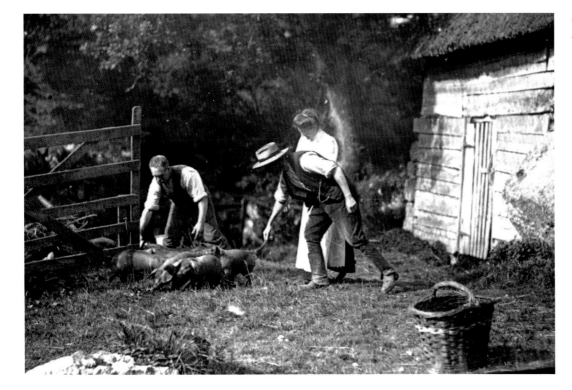

Coaxing piglets back to the pigs'-house at Foxworthy Farm on Dartmoor.

VIII. HAY-TIME
June

THE month of rainbows and rainstorms had passed, and the days that followed were brilliant with fierce June sunshine flashing straight through the clean-washed air. Leaves and flowers stretched themselves, shook the rain off their petals, and held up their heads to the sun. The grass that had lain flattened with the weight of rain once more stood up, while the birds in our wooded valley, and the larks above in the blue, filled all the world with song.

The fields, one by one, had now been tilled, and the chessboard patterns that chequered the slopes around us were changing rapidly from brown squares to green. Every day the transformation was more apparent; potato-patches showed a rich luxuriant green, and the fields of young clover were emerald. Blue-green patterns of wheat vied with the yellow green of the oats, a flush of still yellower green showed where the young mangolds were springing, and squares of brilliant yellow shone out where charlock was flowering over the corn. Every little farm around showed its set of coloured squares, and from our upper fields the country dimpled about us like a patchwork quilt.

The grass was springing rapidly after the last month of rain, growing up rich and luxuriant in every hedgerow; and the banks along our cottage-lane were all bejewelled with blue and yellow, pink and white – bird's-eye, lady's- fingers, lady's-bedstraw, starwort, pink crane's-bill, and all the lovely little hedgerow flowers set in a matrix of brilliant green.

Looking from Cornwood towards the uplands of Dartmoor in early summer. The hay has been cut and raked into 'cocks' for drying, prior to being gathered for the rick.

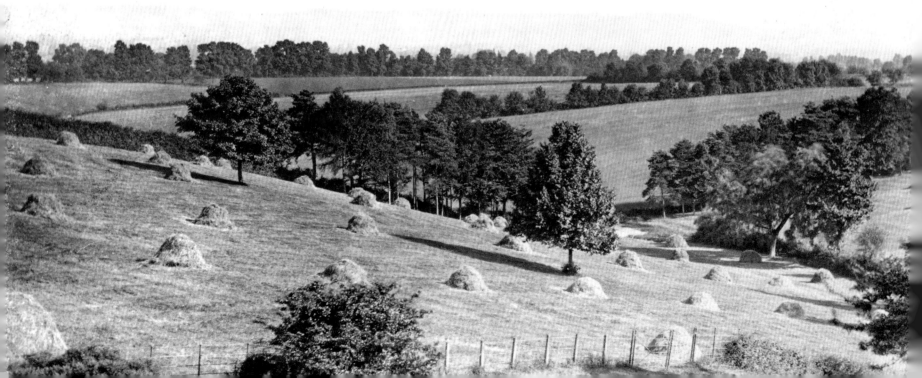

June roses, pure and tender in colour, rambled everywhere, and here and there were early trails of honeysuckle. Green was spreading, flushing over the hedges and over the fields, and for a long time now the horses as well as the cows and yearlings had been turned out for the night to eat their fill of the summer grass.

Most of our free time – now we were released from evening work at the farm – was spent in our own garden, weeding onions, planting out beetroot, training scarlet-runners or checking the rampant growth of grass and hedge.

Indeed it was a strenuous life, for the few minutes which we could squeeze out of the day for ourselves were clamoured for in so many directions. Any ordinary civilities of life, such as reading, writing letters, seeing one's friends or exploring any of the country beyond our own few fields, we found were simply out of the question. It is small wonder that a labourer has no interests outside his work – indeed, it is merciful for him that he has not, for the home garden alone needs all and more of the hours he has to spare.

Certainly we very soon found an answer to the oft-heard charge against country-people – that they are unenterprising and ignorant of anything outside their immediate sphere. It is a true charge, admittedly, but as things are it is inevitable, for until the work is lightened or the hours lessened, the farm-worker must find his interests solely in his work or cease to be interested in anything.

Mercifully for him, work on the land is, in itself, wholesome, healthy, and interesting, or the country labourer would be a very different man from the fine, primitive craftsman that he is.

Those who make such criticisms, and whose own work permits of leisured afternoons, or who arrive at the evening with energy left, and time even, to dress for dinner – with mind comparatively fresh and a body not aching at every joint – cannot have any conception of the exacting nature of a labourer's work.

By dint of eliminating all amusements, and all occupations but the barest elementary necessities, we found existence possible, and by this time also our original difficulty had solved itself – for a less temporary wife had come to take care of us.

With her we were now more or less at ease as to our housekeeping affairs, and we settled down to a comfortable life of routine. Wife – Elsie is the name we remember her by, a staunch and faithful friend in need, unfailingly kind to her two tired boys who appeared at intervals clamouring for food, and who, having fed – eating all they could lay their hands on and generally clamouring for more – disappeared again to the outside world, or to the upper regions to bed. It was a lonely life, I often think, for a cottage wife, for it was little enough companionship she got out of us, and no one without abundant reserves in herself or a great fund of kindness and good-nature would have stood it, voluntarily, for so long. There was plenty to do, certainly – but apparently to so little purpose! The morning's labour, the carefully prepared meals, were gone in such a flash. And then there was nothing for it but to wash up the dishes and prepare one all over again.

Our routine began each day at half-past five – which this year, of course, thanks to the Daylight Saving scheme, was actually at half-past four. The arrangement may have been excellent for people in towns who begin their work at the comfortable hour of nine, but it had little regard for the feelings of workers on farms. Just as we had got through the six or seven months of struggling miserably into our clothes in the dark, and were rejoicing in being awakened by daylight instead of unnaturally by the alarm, on goes the clock, plunging us ruthlessly again into darkness and despair! Really, it was one of the cruellest

War artist Randolph Schwabe's drawing 'The Shepherdess'. She wears an armband of the WLA.

WLA armband, worn as part of the uniform by Land Army personnel during the First World War.

blows of the war! There was no compensation for us in the extra hour of daylight which was the raison d'etre of the change. No one who has to get up at half-past five wants to work on till nine or ten at night, and the discomfort of getting up in the dark is only equalled by that of trying to go to sleep before the sun. How we hated that tiring, never-ending daylight! We used to leave our garden in the full flood of sunlight, and go to bed, pull down our blinds – shutting out all the beauty of the summer's evening – and, lighting a candle, try to read ourselves to sleep in order to get enough rest to carry through the next day's work.

The farmers, of course, might just as well have changed their hours and begun work at the nominal hour of half-past seven instead of half-past six. But such a calculation as that threw poor old Maester's wits into a dreadful turmoil. He would have had to have dinner at two instead of at one, which' though owing to his unpunctuality it often was at two' must always be nominally at one, or the skies would fall.

The animals, of course, resented the change as much as we did, for the chickens would not go to bed at night, and the cows refused to get up in the morning!

But there was no mercy, and at half-past four, or, as the Parliament decided to call it, at half-past five, our alarums went off, and within five minutes whichever was the least sleepy would run down to put the kettle and porridge on the oil stove, so that it came to the boil while we dressed. At six we took a cup of tea to our still sleeping wife, and sat down ourselves to breakfast. At twenty past we pulled on boots and leggings – painfully stiff and heavy at that hour in the morning – and by half-past six were on our way, I to the upper fields for the horses, and Jimmy to the meadows for the cows.

After all, when the struggle of leaving one's bed was over, and breakfast with porridge and nice hot tea had made one's inside comfortable, we were really glad to be out. For the joy of those fresh, early mornings, with the sun rays slanting over the hill and the long grass crusted with dew, was worth a good deal of discomfort.

When the grass was plentiful the horses would be away at the top of the hill, browsing quietly as they watched me climb to them. It was like climbing to the top of the world – the earth so small and the sky so big, a vast open dome of translucent blue all over me, shimmering into white and gold as it fell sheer to the sunrise, and all round, ringing the horizon, the deep blue line of hills and moor.

Sometimes I would catch one horse to ride, and drive the others on ahead, or sometimes they would come of themselves, thundering down the slope with a flick of their heels at the sunrise. Prince particularly, the biggest and heaviest of all, delighted in this little play, as if he loved to show off his beauty all untrammelled by harness and bridle. Perpetual games went on all along the road – Bobby teasing Captain, yet terrified of Prince, Prince defending Captain and nibbling or lashing out at Bob. Then at the last corner, as the cows were seen trooping up the lane, together they would break into a trot and go clattering into the yard, each one into his own stall.

From six o'clock till about half-past nine, when we sat down to eat our lunch on the shady side of a hedge, those summer days were all pure joy and beauty. The mornings were cool and we were fresh, and the weariness that grows with the day had not yet begun to tell on us. But never have I known the time stand still as it did between the hours of ten and one. By that time we would be out in the fields hoeing mangolds. Tom and I had probably gone out about eight, and Jimmy would join us as soon as she had finished in the yard. The hour or so before lunch-time was rather pleasant than otherwise, working

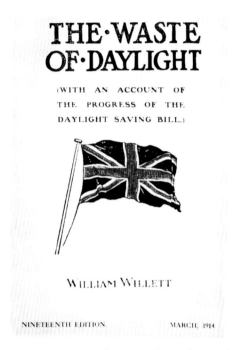

THE·WASTE OF·DAYLIGHT

(WITH AN ACCOUNT OF THE PROGRESS OF THE DAYLIGHT SAVING BILL.)

WILLIAM WILLETT

NINETEENTH EDITION. MARCH, 1914

Businessman William Willet advocated Daylight Saving after he saw how much of the potential working day was lost during the summer months. It was introduced in 1916, but universally disliked by farmers for it disrupted the natural patterns of the year, as Olive describes. The practice was abandoned soon after the end of the war.

up and down the rows, knocking out the weeds and deciding on the best little plants to leave; but after lunch, as the day grew hotter, the hours just crawled along, and – well, for sheer intolerable boredom and paralysing monotony, commend me to the season for hoeing roots.

But while still half way through the hoeing the hay-harvest was upon us, and when the grass is ripe and the weather promising everything else must give way.

Our hoes were put aside, the mowers brought out, knives were sharpened, forks and rakes collected, and, best of all, extra hands were roped in to help us through the work.

Hay-time seems always the culminating point of the year – the time of longest days and of hardest work, when everyone's nerves and muscles are strained to breaking- point; a time of anxiety for the farmer, who may lose hundreds of pounds by a change of weather, or by false calculations of seasons, or any other slip of mismanagement. For the men, the anxiety is less; yet it weighs on them, and the extra hours overtime tax all their resources of strength. Everyone's nerves and tempers are on edge – so much so that, among harvesters, "hay-fever " has a different meaning from the sense accepted by townspeople! Yet, in spite of all, the concerted work – the feeling of mutual endeavour, of each one doing his share in a big thing, of every man and every muscle taxed to the uttermost while the work is on, and all the time the anxious watching of the elements, the race against rain – all give the time something of more intense, psychological value than any other period of the year.

The pleasures of haymaking. Here at Foxworthy on Dartmoor in the years prior to the outbreak of war.

Greatly the actual pleasure of hay-making lies in the fact of getting on to grass after working in the mud or dust of tillage fields. What a rest the green grass is – a rest for one's

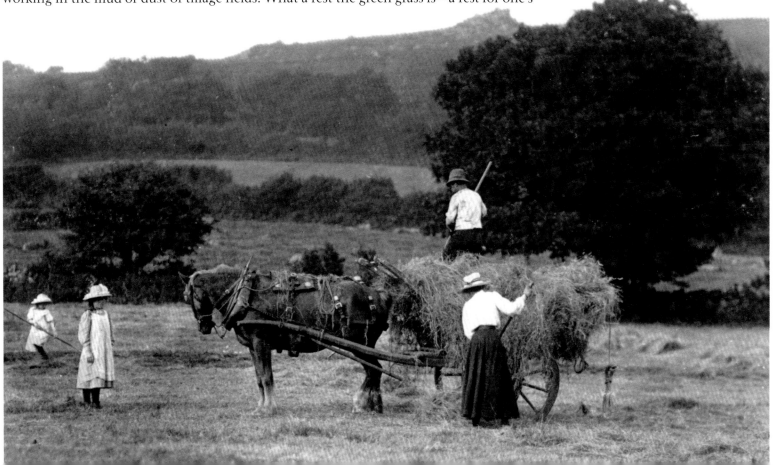

feet to walk on, for one's eyes to look at, and altogether to work in! The time in the hay-field was work I never grudged, however long the day, for with the flowery grass and the glorious June sunshine sparkling down from the blue, piercing leafy shadows, glinting on the water and touching all the world with magic, every moment of it was beautiful.

Does not the sound of the cutter, even the thought of it, bring back summer all the world over? One may not be able to "hold a fire in one's hand by thinking on the frosty Caucasus"; but one can at any time, when sitting by a winter fire, just bring up in memory that particular rattle coming down upon the wind in rhythmic waves of sound – and at once the whole scene is with us! Blue skies, warm air, the singing of bees, the scent of new-mown grass, cool dresses and sunburnt faces, sunlight permeating everything; and it is as real for the moment as if no bleak winds were raging in the grey outside.

What a wealth of flower was in those luscious hay-fields?

"What a 'wallage' there is of it!" as Maester said indeed. The long rich clover, purple and crimson and mauve and white, with all the little sparkles of yellow and orange and gold, and the fierce shafts of sunlight throwing stripes and streaks and splashes of light and shadow all in among the colour.

As I drove my machine through it, what a slaughter was there! The horses, plunging remorselessly onwards, laid low swath after swath of flower. Evenly they lay, with bent and lowly heads, the colour fading rapidly and the live green turning to brown. Row after row I clattered round, plunging first through the deep grass by the hedgerow, and winding round and round the fields, leaving quaint rectangular patterns, until, at the end of the day, all is cut but a small square standing in the centre.

Cutting hay with a two-horse team, exactly as Olive describes it.

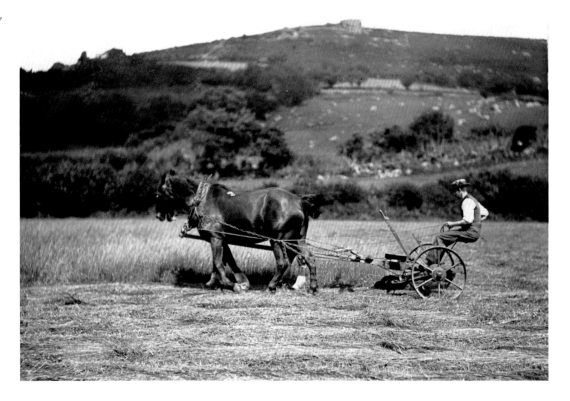

Then comes the worst of the work as one nears the end, for that is where the rabbits gather – poor little frightened souls, driven nearer and nearer to the centre, until they find themselves completely cut off from their homes by a terrifying open space, occupied by enemies. And as the brutal knives travel onwards many a poor bunny comes to grief.

That was, I think, the most nervy work I ever had to do on a farm, and many a nightmare I had afterwards thinking of the poor maimed beasties who suffered under my knives. There was a brooding pheasant once, who lay quite quiet on her nest, thinking that so I should miss her. But I could not see her where she lay until, with a shriek and a whirr, she flew right up from the knives, leaving a nest wrecked and overturned, smashed-up eggs, and, alas! two dainty, delicate little legs, cut right off her body.

That is what we do – riding roughshod through Nature. To man's inventions all must give way, or suffer. And all is right and legitimate so long as man's own need is served! Even the laws only condemn "unnecessary" cruelty – not cruelty. It makes one wonder at times in what way we really are the superior species and the "crowning glory of Nature" when our boasted inventions bring such cruelty and desolation. In Nature, herself so beautiful, whose means and ends seem so wonderfully inter-adapted, it would often seem as though man alone were the jarring note. Wherever he comes, comes also death, cruelty, destruction, and ugliness. He kills, not only for his own essential need, as do the hawk and the wolf, but for pleasure in the name of Sport or Science. In the name of "Liberty, Justice, and Honour" he kills off the best even of the human race, and in the name of Medicine and Progress he keeps alive those who naturally would die, leaving the world the better and the healthier for their loss.

Everywhere is natural beauty and order, and a beautiful interchange of usefulness – of plant feeding animal and animal feeding plant – changed under his hand into disorder and dislocation, dirt, refuse, and rubbish. Even his houses, instead of making part of the whole scheme of the landscape as do the houses of birds and beasts – even they are incongruous and ugly, and the scar that a city makes on the face of the earth takes Nature some centuries of work and growth to efface.

Will the time ever come when we can regain our lost place in Nature – when we shall come back to some sense of proportion as to what is important and what is not?

For all our boasted gains, how much have we lost? One has but to watch a plover on the wing rejoicing in his powers of flight, or listen to the lark filling the world with song, to wonder what there is in human life that can compare with the joy that is obviously theirs. For Mankind, crowded cinemas, sensuality and lust, laboratories for vivisection, battle, and murder in the name of Sport! Such are the joys and achievements on which we pride ourselves, and for which we have sold our birthright.

Yet, individually, how can one escape? It seems impossible, for one is tied and bound to the unwieldy machine, and the huge juggernaut-car of civilisation rolls on its way, crushing out beauty, unswayed by any individual effort. If I had got off the mower and thrown up my murderous job, someone more ruthless than I would have taken it on. And I, at least, could get down as we neared the end and turn out the creatures that were huddled in that last patch of standing grass...

To the men and boys it was rare sport, this reaching of the centre of the field. And later when the corn was cut, it became a festive gathering for the villagers, who came with dogs and guns, eager to see which could bag the most, shouting with glee as each frightened rabbit came out and shot across the open to the distant hedgerow.

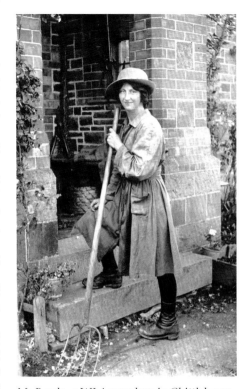

Ms Rawle, a WLA members in Chittlehampton, North Devon. She is holding a 'prong', the ubiquitous farm tool described by Olive. WLA wages were set by the Agricultural Wages Board. The wage for someone in the WLA over the age of 18 was a little over £1 a week after deductions had been made for lodgings and food. There was an agreed maximum working week – 50 hours in the summer and 48 hours in the winter. A normal week would consist of five and a half days working with Saturday afternoon and Sunday off.

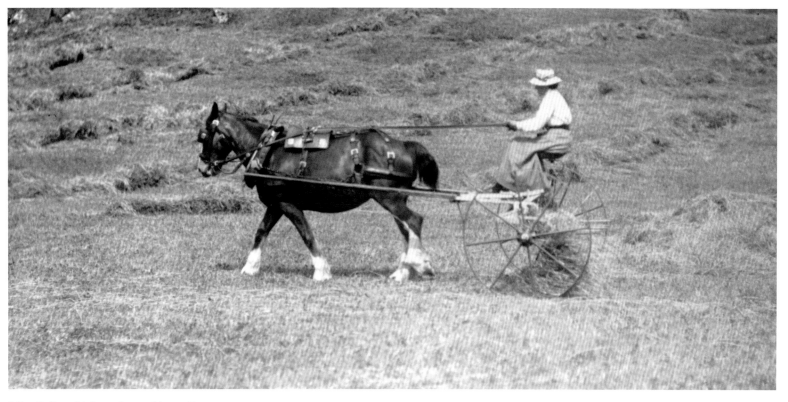

Miss Collett driving a hay tedder at Foxworthy Farm. The curved steel tines of the tedder picked up and laid the cut hay in rows, turning it in order to aid it drying.

*　　　*　　　*　　　*

"Now listen to me, Sammy," said Maester a morning or two later, coming into the stable where I was buckling up the halters while the horses nosed impatiently at their corn. "That there front clover-field will be ready to carry to-morrow, but it wants a bit o' shakin' up first. Yu jest get up on Barb, an' ride over to Mr. Simmons' an' see if 'e'll kindly lend me 'is tedder.

"All right, Maester," I replied, proceeding with my vigorous grooming of Bob's grey coat. "Take the cart 'arness along with yu, an' mind and be quick back, for it'll be a good day's work to turn it, and maybe he'll be wantin' the machine himself. But you'd better ask 'ow long 'e can spare it, and then we'll get all the fields turned while we can."

"All right, Maester," I repeated, and presently, having fixed up the harness, with pad and breechin' hung across the saddle, I swung myself up on his back and Bob and I set off over the hill.

It was weeks since I had been outside the farm, or seen other hedgerows than our own, and those occasional jaunts into distant lands were memorable breaks in the routine. The country was teeming and rioting with summer, the air with the song of birds, and even the hedges were alive with little beasties, half invisible, darting about under the leaves. I rode over the hill, down and on towards the moor, off a narrow by-lane whose luxuriant hedges, romped over with dog-roses, almost met above my head, then out into the open

with the long moor lines sweeping all about me, and on again through farming country where everyone was out in the hayfields and the whirr and rattle of the cutter resounded on all sides.

I rode into the yard and delivered my message, and the generous Mr. Simmons, having finished with the tedder himself, was quite willing for Bob and me to bear it away. In this way there is some sort of a rough-and-ready co-operation among Dartmoor farmers, but it does not work out very satisfactorily, the give and take being generally one on each side instead of upon both. A thrifty and foresighted farmer will have all the machines he wants himself, and the one who is generous enough to lend is more often than not averse to borrowing; while the man who will borrow freely as a rule has little to lend. Some system of joint buying might be made to work in small farms that lie near together, but the fact that the machines are almost always wanted by each one at the same time seems to me an insuperable difficulty, almost inevitably leading to discord.

"Yu'll come inside and have a glass o' milk, Miss, won't you?" said Mrs. Simmons, appearing at the doorway with her round and pleasant face smiling a welcome.

The last load of the day at Foxworthy – a photograph taken prior to the First World War. The rick on the left has been thatched, possibly a survivor from the previous year. The new ricks stand behind. The woman holds a wooden rake, used to sweep up any hay that has fallen to the ground. Little was wasted.

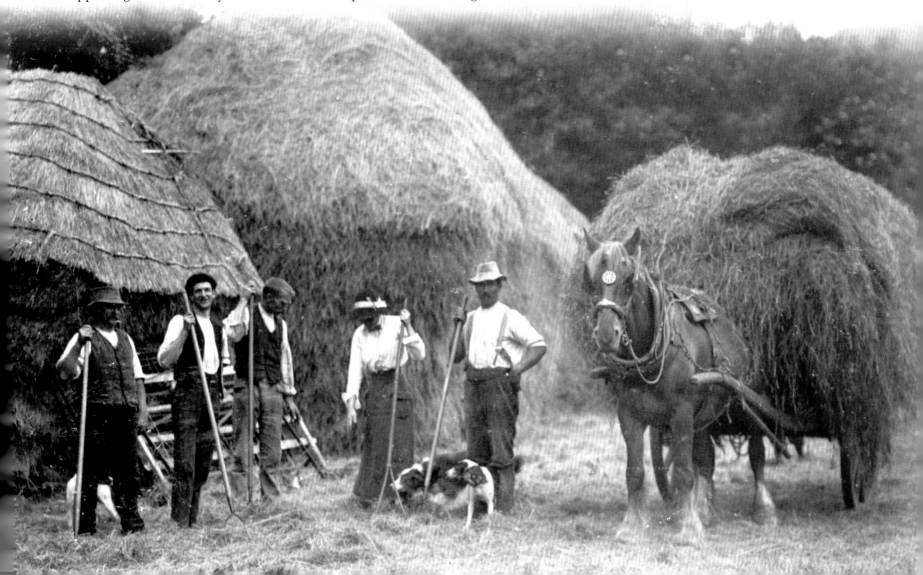

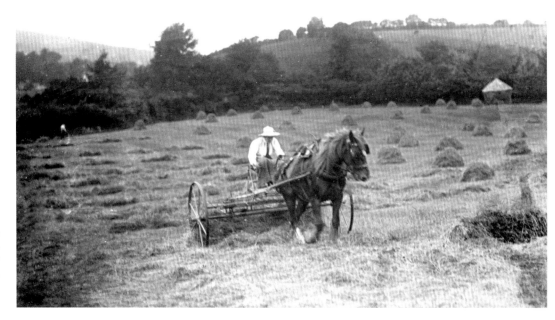

"All the afternoon we jingled up and down with a fountain of sweet smelling grass flying out behind us..." A women driving a hay tedder at Foxworthy on Dartmoor. Note the rows of hay in the background, the small dome-shaped haycocks and the rick in the field's corner.

But much as I should have liked to – for I loved seeing into other people's farms and noting how they each managed their work, and yarning with them about the good old days and the decadence of present ones – yet I remembered those acres awaiting me, and refused heroically.

Climbing up on the quaint little iron perch, I rattled off with Bob and the tedder, and it was ten o'clock that night before we had finished the field. All the afternoon we jingled up and down with a fountain of sweet-smelling grass flying out behind us. Pleasant work, and comparatively easy, even though a springless iron seat without any back is not the most luxurious of couches to joggle about on for many hours at a time.

Certainly, however, the horsemen do have the easiest part of it at this season, riding round on cutter or rake or tedder, instead of plunging over the heavy land with plough and harrows, as I had been doing all through the spring. "Sammy's Pram," as Jimmy dubbed my horse-rake when we were carting the hay, and she watched me tooling about the fields in a leisurely manner, scratching the loose stuff up into rows. I did not wonder that she looked a little envious and scornful from her post on top of the loaded waggon, for certainly hers was most unenviable work. All day long she was up there, placing the hay as it was thrown up to her by the men below, lifting great bundles of it on her fork, floundering in the deep springy stuff, climbing always on top of it only to be buried again by the next pitch, joggled and flung about by the cart as it moved on.

"'Old 'ard!" sings out Maester. And the horse, knowing the signal, starts ahead, with Jimmy staggering perilously at one corner. The only amusing part of her game was perhaps the shute from top to bottom when the load was full – a proceeding quite alarming when first one launches out into mid-air, and finds the ground is such a long way down below!

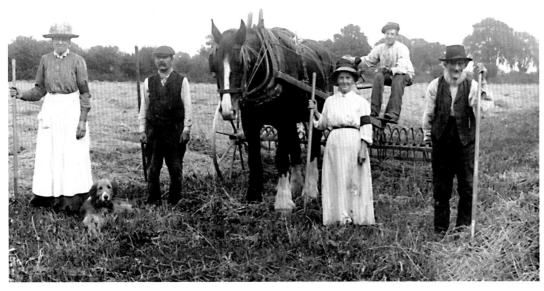

Though not in Devon, this photograph shows the curved tines of the tedder which ran just above the surface of the ground picking up the hay. When a good quantity was gathered, a lever could be pulled, raising the tines and releasing the load of hay. A skilled driver would ensure the gathered hay lay in neat rows so that those loading the hay wagon could travel along them. The boy sits high up on the metal seat, 'not the most luxurious of couches', as Olive relates. The women in the photograph are wearing WLA armbands. By no means were all women working on the land 'girls' – many were elderly even though not always officially WLA recruits. Olive herself was in her mid thirties at the time she wrote Two Girls on the Land.

Loading a waggon is a surprisingly scientific process. On Dartmoor farms we use waggons with no sides, but with big 'lades' at the ends, which, though simpler than the plain ones, have yet to be built up with a good deal of cunning. But when it comes to one which has sides all round a foot or so in height, and upon them a load some eight or ten feet high is to be balanced without any lades, it needs to be extraordinarily careful and deliberate work if one is not to see the load slipping off as it crosses the field, or overbalancing round some steep turning.

DIAGRAM OF WAGGON (GROUND PLAN).

Olive's sketch showing the correct sequence in loading a wagon with hay.

Women loading a wagon on a Westcountry Farm c.1919.

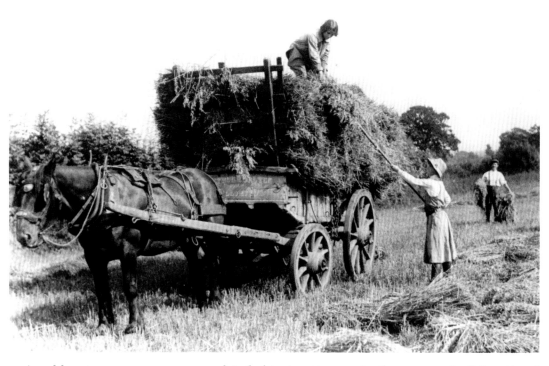

An old carter once gave me very detailed instructions as to the process, building it not so much in flat layers, as we used at first to do, but in definite blocks. The first mistake that the beginner makes is, of course, to be afraid of building the lower layers wide enough. But to plan out a wide foundation well over the edge of the cart is the first secret of getting up a steady load. The blocks are placed one after another, each a good pitchforkful, as much as a man can comfortably lift. First of all two on the back corners, for the back part is always kept the highest; and then a third sitting between them, overlapping and binding them together; Nos. 4 and 5 come next, one along each side; and 6 and 7, placed as in the diagram, bind the whole lot together. Those last two are the key-stones of the structure, and my humorous old instructor told me that if anyone watched me place them correctly they would think that I really did know something about my job. " But," he added, "best not let on as ye knows too much, or ye'll always be put to do it!"

After No. 1, one turns oneself about in the waggon and repeats the process at the other end, finally piling up the middle, more or less to the same level, and beginning all over again at corner No. 1. The sides and ends are always kept a little higher than the middle in every layer, so as to keep the hay from sliding off. Waggon-loading in fact, like most things that look simple just because they are deftly done, is almost as particular an art as rick-building, and a load of hay can be an ungainly sight, not to say dangerous, if badly put up.

The rick-builder – Peter Whidd'n it was in our case – is the most important man in the hay-field, for it is he who more or less directs the whole of the work. By eye alone, without

any measuring or plumbing, he raises his building, steady and square and level; by eye he judges the amount in the field and plans his foundations big enough to contain it; he stands on the top of his rick, receiving and placing every prongful as it is passed to him by the man who receives it first from the cart. Working round the sides he places each piece, judging the shape and the right amount of overhanging – or "swimming," as he terms it – that will protect the sides from rain and yet not let the whole thing overbalance. This alone is difficult, for from one's position on the top the tendency is to slope the walls inwards instead of out.

"Do it swim enough, do 'ee think, Maester?" asks Peter from the top, looking down to Maester who passes below.

"Oh ay, Peter. That'll do. That'll do nicely," says he, stopping for a minute and looking at it critically with his head on one side.

Peter Whidd'n was the well-known thatcher who, since all the others had gone to the war, held the local farmers in the hollow of his hand. A most important personage! For if he, by any chance, took offence and would not thatch their ricks, what were they to do? A sorry predicament it would be, after all the labours of the harvest!

At this moment, rambling down the field on my rake, I caught a welcome glimpse from afar of a light-blue dress showing brilliantly against the summer hedges, and an apron flashing white. It must be Miss Minton, this vision with large enamel can in one hand and market-basket

On larger farms, ricks were built with the aid of a pole and grab. Here we see a waggon laden with hay (as Olive relates – vital that this is properly loaded) standing against the side of the rick from which the grab lifts hay to be stacked. A horse-drawn hay rake stands in the right foreground and (left) a flat-bed cart with lades front and back, as Olive describes the type they had at By-the-Way Farm. Rick building was a social occasion which drew friends and neighbours along to help, although in wartime the shortage of young males made the work more onerous for those who were available to lend a hand.

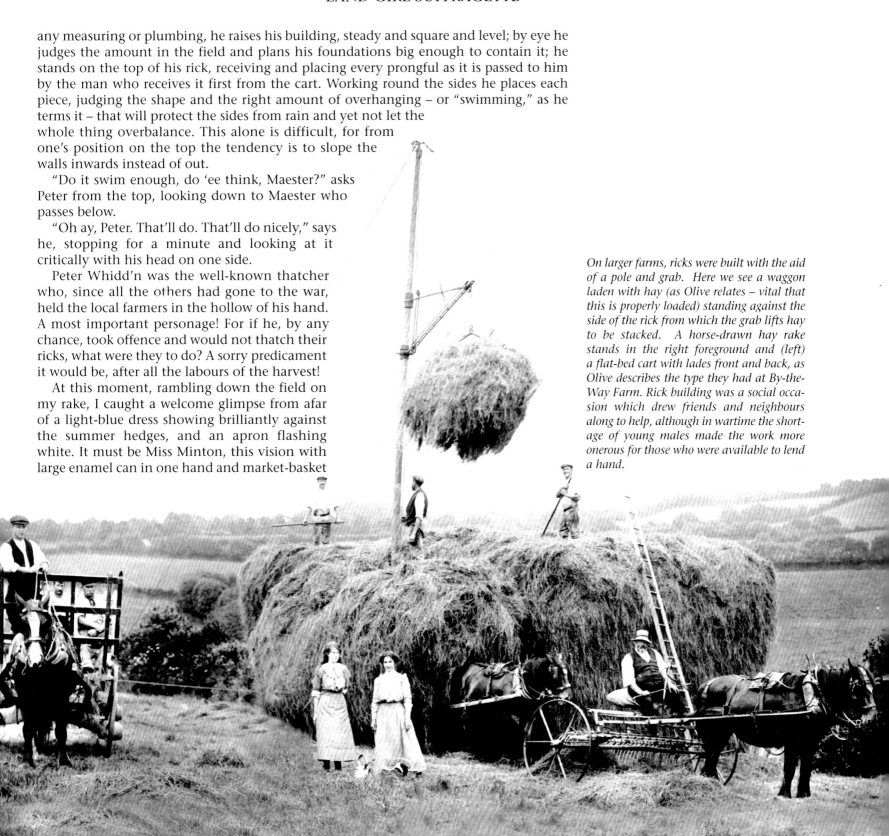

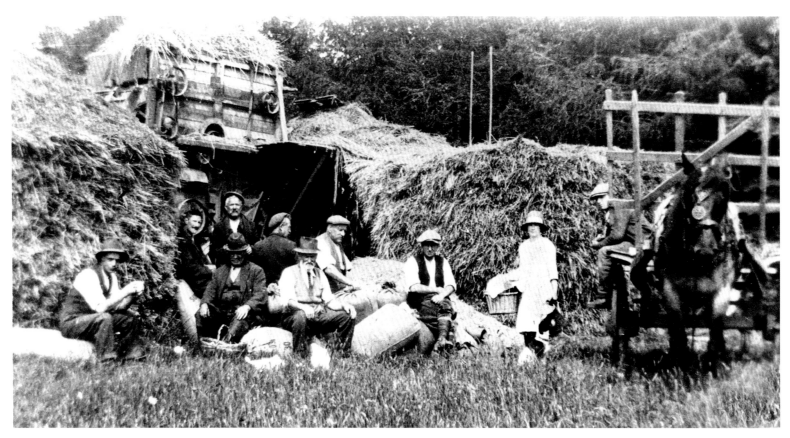

South Tawton, at the edge of Dartmoor, to-wards the end of the war. A young woman delivers 'croust' to the workers in a rick field during threshing. Note the age of the men at a time when the majority of young men were serving in the military.

A gin trap for catching rabbits.

in the other! Welcome, indeed, for great and unappeasable was the thirst that came upon us in those harvest days! We quenched it at intervals during the day with diluted cider, much to the scorn of Peter Whidd'n and the other men, who liked theirs neat – and as strong as they could get it! But one attempt at drinking cider pure on a hot day was quite enough for James and me, and not wishing to disgrace our sex by the consequences we foresaw, we took to sobering it well with water. Nothing, however, comes up to a harvest tea, and the sight of that blue dress in the distance with the white enamel can was the best thing that had happened that day.

I swung my lever and released the line of hay that had gathered under the rake, turned Bob up the hill, and called out the good news to Jimmy as I passed. Bestowing upon Bobby a bundle of new hay for his own refreshment, I left him in a corner by the hedge, and joined the men who were coming down from the rick and gathering in a group in the shade.

Besides the usual members of our staff – Jimmy and I, Maester, and the boy – there were the others who had come in to help us; Peter Whidd'n first, whose aid it had been such an honour to obtain; next 'Arry 'Ickey, a grotesque and crooked little man, half-crazed we always thought, a carpenter by trade, but a handy man who did odd jobs for anyone. Lastly there was Billy Withecombe, the rabbit-trapper – the most charming of men in spite of his ghoulish calling, with the broadest, burriest Devonshire talk I have ever heard. A

good man all-round he was – he had been horseman on a farm for years and understood every branch of farm-work; but he would not go back to it now. "Why, Miss," he said, "I makes as much in one night wi' the trappin' as I did in a week on the varrm!" As a trapper he is his own master, and works when and how he pleases – from early morn till after dark when the weather is open, and the day is his own when the trapping-time is bad.

I had often talked with him about his business, and ventured sometimes to express my sympathy for his victims. But – "Lor' bless yu, Miss!" he would say with a disarming smile, "it doan't 'urt they. They ain't got no feelin's in their legs like! Tain't like yu nor me, Miss!" And so it is by such self-deception, I realised, that quite kind-hearted people spend their lives as torturers.

But *if* being held in a vice by the leg until you die from sheer fright or wrench the limb in half by your struggles to escape is not painful, then how was it, I wondered, that when the traps were laid near home, the Missus could not sleep at night for hearing the rabbits scream?...

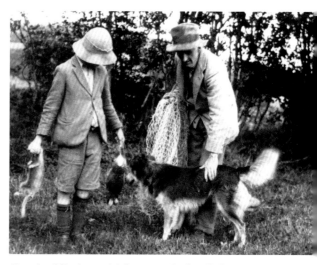

It is a horrible subject, and a very vexed question. Rabbits must be caught, unless we are prepared to go under ourselves, as anyone would realise if they saw a field of young corn half-eaten by their ravages; but yet nothing but these fiendish torturing gins that grip them by the leg can be devised. Wires, they say, are worse, for the choking process takes place so slowly that the eyes are starting from their sockets with terror and agony before the strangling can be accomplished. Billy Withecombe, too, objected to wires, he told me, because the rabbits grew so wary that they could see and would not go into them, whereas the gins can be altogether hidden from sight and scent under sifted dust.* A really expert trapper he was, and while working on our farm he would come in every morning with sixty or eighty corpses slung over his back, the result of his evening's work!

Stiffly now, with his game-leg, he descended from the rick and joined the group at tea, the horrors that hung about him vanishing in the genial sunny atmosphere of the hayfield. Maester and Jimmy came up with the waggon and the basket was unpacked. Our cups were filled from the large bedroom can, slabs of bread-and-butter handed or tossed to each one in turn, with substantial hunks of cake – the produce of the kitchen oven. Baking was a speciality with our Missus, she could beat anyone with her bread and scones or buns or pastry, and those harvest cakes were something really to be remembered.,

"An' what d'ye think o' this yurr warr, Maester? " asked Withecombe, his mouth quite filled with bread-and-jam.

"O-o-oh' ay. . . . Well. . . . They'm *fightin'.'*" is Maester's profound comment.

"They du tell as they Germans be a-sinkin' all our ships," contributed Peter Whidd'n.

"'Tis toime it stopped, that it be," chimed in 'Arry 'Ickey. "Let them as made the war go out and fight, that's what I says. It bain't no workin' man's warr."

"You'm right there," answered Peter Whidd'n. " Let them as wants it goo an' fight."

Despite Olive's sensitivity towards the plight of animals, rabbits were a vital source of protein during the war and had long been regarded by farmers as one of the 'crops' to be nurtured and garnered. In 1919, after rationing had been imposed, Stephen Woods in his book Dartmoor Farm, *records one Widecombe farm sold 905 rabbits at market, caught during a nine month period. Snares (wires) were generally used along with gin traps, but ferreting was considered most effective where rabbits were driven from their burrows by the ferret and into a net. Here a young boy holds two rabbits caught in this way at Foxworthy c.1920.*

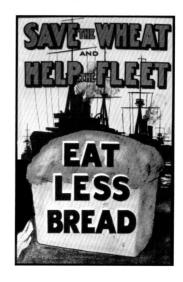

*The Royal Humane Society has, I am told, offered a prize of £100 for a really efficient, humane rabbit-trap. Meanwhile, it recommends the use of a wire, which runs freely on a ring, but is stopped by a knot at about the circumference of the rabbit's neck. This captures but does not strangle the animal, and the theory is that it waits contentedly until the trapper comes to kill it! Certain laws have been passed regulating the use of traps, but these I found to my astonishment are in no wise concerned with the feelings of the victims, but are made merely to protect pheasants and game!

An advertisement for Devonshire Custard, (made in 'Delectaland') that appeared in the Landswomen *of December 1918, the end of the first year of rationing.*

"Is it true, Maester," says Withecombe, "that you beant allowed to sell your wool? Well, well, 'tis time it wur stopped, so it be, interferin' on a man's own farm – ."

Such are the war echoes that reach our Dartmoor up-lands. Verily, until the famous prohibition of wool-selling in 1916, I believe the farmers hardly knew their own country was involved.

"Now, James!" said Maester, all too soon, heaving himself up stiffly from the ground, "ye'd best be goin' after they coos" (I wish I could write the pretty Devonshire way of pronouncing now and cow – "Caooii" is as near as I can get it, the 'u' modified always as in French). "Yu'll have no one to 'elp you to-night, for Sammy must come along o' me with the waggon."

Jimmy departs, carrying with her the can and the empty basket, and the men climb up on the rick again. Higher it grows and higher, until at last, when the architect decides that there is just enough out in the field to form the pitch of the roof, he ceases to build out the sides and starts the "rashers." Layer upon layer he piles them, each one a little narrower than the last; and at last the rick grows so high that Tom in the waggon can no longer reach up to the top with his laden prong. Then a "pitch hole" must be made in the side, and someone balances himself half-way up, catching each bundle and passing it on to Peter up above him.

On goes the work as the sun goes down, and the purple shadows creep about the ricks, throwing them into dark silhouettes against the glowing sky. The figures of the men on the top grow dark and flat, merging into the haystack like gargoyles on a roof.

At last it is finished; the last gleaning from my rake has been tossed up in its place. Dew is falling in the shadows, chilling every grass blade, and the dusk is upon us. I let Bob out of the rake. Prince, Captain, and Topsy are unharnessed from the carts, and climbing each on to a broad and friendly hack, Tom and I with our clumping cavalcade jingle homewards.

By ten o'clock, when the horses have been fed and turned out to grass, we may perhaps get home ourselves, to our supper and our patient wife. Sleep comes upon us almost before we are in bed – and almost as soon as we have rolled in among the bed-clothes, it is time, alas! to roll out again in the morning.

IX. SUMMER
July

A PECULIARITY of farm-work seems to be that one is always working up to a crisis. One goes on at high pressure, putting all else aside, straining every muscle to get something accomplished, with the feeling that when once that particular job is finished things must of necessity get easier. But does the expected respite ever come? We never found it! To us it seemed that, however hard we went, never was any bit of work got through but there was something harder still waiting for us on the other side.

It really did seem as if haymaking, with its strenuous days and long, late evenings, must be at last a culminating point, and that afterwards we might take things easily and prepare ourselves for the next job, the corn-harvest; even the corn-harvest seeming to be something of an anti-climax. But no, at By-the-Way Farm no respite ever came our way, and we finished up our fortnight in the hayfield – having worked many days for fourteen or fifteen hours with only a stop for meals – only to find our energies at once switched on again to turnip-hoeing.

The mangolds, which were choked with charlock, had indeed been hoed twice over, but the swedes were fast overcrowding one another, and the turnips too called upon all hands as urgently as the hay had done.

To make matters worse the weather, so glorious in June when everything was fresh and sparkling, now, as July passed on towards August, had wholly changed its character. Spring had vanished to make room for early summer, and early summer had grown up, and she

Summer haze over Redgate and Merripit Farms on Dartmoor c.1915.

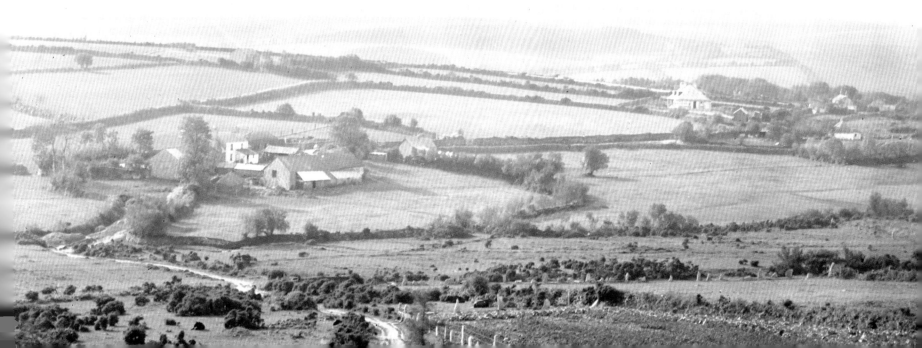

was tired, cynical, and hard. Though outwardly the same – for the skies were blue and the sun still shone – yet a wholly new spirit had come into the land.

All nature seemed to feel it. The leaves, so green and luscious while June was with us, now turned grey and dusty; the grass was yellowing under the glare of the sun; the hedges shrivelled up, and the blue and yellow flowers along our banks had run hopelessly to seed. Even our little rushing brook seemed tired, and circled lazily round his rocks instead of leaping over them. Day after day the sun glared down, cloudless, out of a hazy sky. The colour went out of the land, and one thing after another joined in that same grey monotone of heat.

The horses were turned out to grass – or to pick what grass there was left – and the cows went down to the marsh, where they stood about as if rooted in the deep mud, swinging their tails as the flies swarmed and buzzed about them.

What can be said of ourselves, but that we echoed the prevailing note of Nature? Tired, languid, hot and dusty, yet we laboured on. Day after day we went out to those turnip-fields, and day after day and hour after hour we swung our hoes while the sun burnt down upon us, scorching the earth, blistering our necks, and parching our lips and skin.

All the morning, from eight o'clock onward, the hours dragged slowly by. Ten to eleven was an eternity in itself; eleven to twelve the deadliest of all, for time seemed literally not to move; twelve to one – after twelve, though the minute hand crawled all too slowly still, yet one had turned a corner and dinner-time was in sight. But how many hours really packed themselves away into those, three divisions I would hardly like to say. All the weary time with perspiring faces and bent and aching backs, chopping, chopping, chopping – scraping, scraping, scraping – the same position and the same little movement repeated a hundred thousand times. For all sound, in that great empty solitude of heat, there was the click of the hoe against the stones and the scrape of it through the powdery earth; for all sight, swedes and weeds, weeds and swedes in interminable rows, stretching up the field and stretching down the field, never-ending whichever way one looked; for change of position, only the arriving at the end of one row and the beginning of another; and for all sensation, nothing but an aching back, hands growing stiff, and eyes growing sore with the glare, and in one's mind a numbness and a void – no conscious thought, but an ever-growing yearning for the hour of release to come.

As one o'clock arrived at last, we could straighten our backs – unhitching them, as it were, with a painful jerk – and, wiping the sweat and dust from our brick-red faces, we left our hoes at the gate and made our way home, too hot to talk, too hot almost to eat, longing for nothing but to lie down in the shade and sleep for our remaining days.

The hour was not long enough to relax, far less to feel one whit refreshed, and at two o'clock, when all else in Nature sleeps among cool leaves, once more we climb the hill with the sun blazing more fiercely than ever, and resigned ourselves to the intolerable toil.

Day by day and week after week the same routine went on, each day like a month, each week like a year in length. Sometimes Jimmy and I were alone, sometimes Maester and Tom were with us, all four together working up and down the rows. Even Tom's garrulous nature grew depressed and his songs less frequent, though at times when he was there an inevitable argument broke the monotony. I can almost find it in my heart to feel sorry for poor old Maester now, for he had never had to work so hard himself – and though, with seeing to the sheep and other things, he had more breaks in the day than we did, he

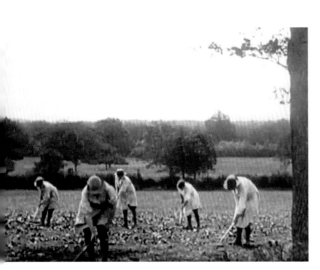

The monotony of hoeing roots. WLA workers in South Devon c.1916.

did come out and work. But at the time we had no pity – for indeed he had none himself. To us he seemed little more than a slave-driver, and we hated him with the dire hatred born of jangled nerves and aching limbs.

Perhaps we were slow, as he often would say, but we honestly gave of our best, and at least we were voluntarily enduring tortures for his advantage, so that it would have been encouraging had that point of view ever occurred to him. But from beginning to end of our time at the farm no word of thanks did it enter his thick old head to express. Far from it, indeed, for from his point of view the paltry seventeen shillings or so a week that he gave us was a magnificent wage, and exonerated him in full from all obligations whatever, even of common gratitude!

Poor old Maester! How we did grumble to be sure! There was one little peculiarity of his, I remember, that annoyed us always, but especially at that hoeing-time. It was the habit he had never to stop doing one thing until it was time to be at another, and consequently of being late for everything all through the day. He was quite under the impression that he had his dinner at one o'clock, and nothing could ever persuade him to see that this was a pure impossibility if one worked in the furthest fields until one. As often as not after that we would put up our hoes, walk back to the farm, feed the horses and perhaps a calf or a pig or two, and then go home to the cottage. An hour for dinner was, of course, our recognised due, but to the end of time Maester would never understand why we could not get our hour and yet be back in the field by two.

This kink in his head, and lack of any sense of the duration of time, was a source of perpetual friction in his own household also. The Missus would provide his nice hot dinner by one o'clock, as requested – until she learnt from experience that he was never ready to begin until half-past. But on the day that she prepared it later, her spouse would of course turn up in time, having perhaps been at work on something near at hand. Then with injured feelings and ruffled temper he would declare that dinner always was at one – always had been and always must be at one, and he'd be hanged if he'd stand being kept waiting, and so on. And the Missus would look pained and hurt until the next day. Then when dinner was ready by one, and there was, as usual, no sign of Maester until half-past, she, of course, had her innings. I wonder if that goes on still!

Jimmy and I, taking the law into our own hands, timed our hour from the moment we left the farm, if it happened that there was work to be done in the yard. But it was nevertheless a continual grievance when that brought us back to work at half-past two, or even a quarter to three.

At other farms, if one has horses to tend, the practice is to leave the fields soon after half-past twelve, but I think poor Maester's hair would have stood on end had we dared to suggest such a proceeding with him! What he really liked, by way of stopping at one, was to begin the last round of whatever we might be doing at one. And when that happened, it was just the final match to our exasperation!

As the time came on for the evening milking the same old struggle came up each day. We were realising at last that there were limits to human endurance, and that the pressure of work never would be relaxed until we made some sort of a stand ourselves. Now that the haymaking time was over, we determined that from six-thirty a.m. to six p.m. was long enough for any human being to work as a regular thing, and we resolved that, come what might,, we would leave the farm at six. Maester's cheery idea, of course, was that all hands worked in the fields till five – and then got finished as best they could.

"Not so I" said James in her determined way. " If he doesn't let me leave the field in time to get the yard-work done by six, I shall just leave it *un*done, and he can finish it afterwards himself!"

Our plan was complicated by the fact that at that time both our watches were out of order, and we were obliged to refer to Maester for the time. That was a fatal thing to do, for to get a straight answer out of him, even about the time, and far less about anything else essentially definite, was almost an impossibility. "Is that too long?" we would ask him – about a rein perhaps. "Well, Sammy, plenty long enough!" was the sort of answer one got – and his various ways of avoiding the direct statement were really ingenious.

Jimmy reckoned up that to get the work through by six she must leave the field no later than half-past four. And after this ultimatum every day she brought out her alarum clock, wound it up to full pitch, and set it in the shade of a turnip.

How we used to jump when that welcome alarum went off! And though he demurred and grumbled, it was the only thing that achieved our purpose – for if there was any way by which our old Maester could squeeze a few minutes extra work out of anybody, or a few extra pennies out of their wages, he would consider it was only doing himself justice to find it. Perhaps all farmers are alike. But he had his good points, and was a good old sort in many ways, and he did at times lend me Topsy on a Sunday– for which, in spite of all our later skirmishes, I shall ever bear him good-will.

The heat-wave continued all that month. When the swedes were finished we went down to the mangolds again, which by this time were big and flourishing – and the weeds likewise.

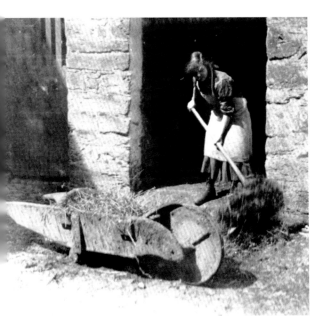

'Yard work' using an 'eevil' to clear dirty straw from a shippen.

"Never did I see such a dirty mess as this 'ere – not since *I* come doonstairs!" was the verdict of 'Arry 'Ickey. And certainly the weeds on that farm were pretty desperate. It was owing to the late ploughing, I believe, that that particular field was so bad, there having been no time properly to clean the land before seed-time arrived. Most land destined for roots is ploughed two or three times over during the winter, but with this I remember it was a scrimmage to get it done at all, and it spent the winter in the form that they call in Devonshire "arishes," or "erishes" – whether the word is supposed to have an 'h' in front of it I have never discovered, and as a designation for "stubble" it seems unknown in other counties.

During our first weeks on the farm we had spent many days "spreading dung," as the process is properly termed, on this particular field; carting the manure first of all from the yard, and tipping it out in heaps – taking great pride, I may say, in the regularity of the heaps and the straightness of the rows, for by that may quickly be discerned a good or a bad carter; then shaking out each heap with an "'eevil" or four-pronged fork. That also, by-the-way, is a word I could discover from nobody how to spell. It might likewise have an "h" for all I know, or it might equally be eavil, oevil, aevil, evil, eavle, eevle, heavle, heevil, etc., etc. Perhaps some Devonian can tell me.

Dung-spreading is by no means such an uninteresting and malodorous a job as might be expected. We used rather to enjoy a limited spell of it, for it is hearty, rhythmic sort of work, swinging out each forkful and shaking it abroad. Jimmy took great pride in the nice square patterns she made, getting exceedingly worried with Maester, I remember, when he came out to help and would make them all crooked! It is magnificent exercise for every muscle one possesses, especially for the back and arms, and might well be recommended by physical culturists. The difficulty comes in only when the stuff is new. Well-rotted

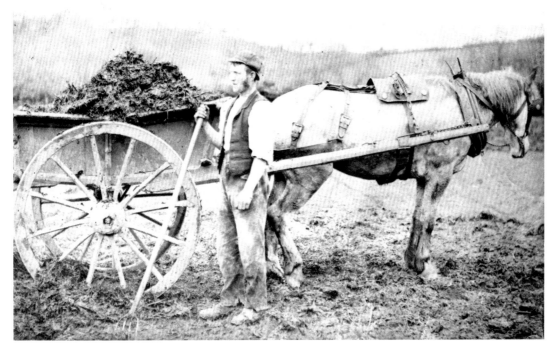

A typical Devon dung cart or butt. Note also the ubiquitous four-tined fork.

manure is a pleasure to shake out, but fresh stuff is the devil. It breaks one's arms to pieces before it will break up itself.

Loading manure into a cart is hard work too, if it is heavy and old and well trodden-down, as it should be. But that also is pleasant exercise chiefly because of the rhythmic swing one can put into it, and because stooping and straightening one's back alternately is worlds easier than anything which necessitates stooping all the time. It is this continual stooping and the impossibility of getting any sort of rhythm or change into it that makes hoeing so particularly trying perhaps. Hoeing is nothing but scratch and chop, scratch and chop, with no satisfaction in the movement whichever way one takes it.

But old 'Arry 'Ickey did not seem to mind. He had stayed on for a time after the harvest, on piece-work. We used to watch him sometimes as he chopped away, hour after hour and day after day, by himself, and we marvelled that the monotony of it did not seem to strike him.

"Oh, it be all the zame to me," says 'Arry, " so long as I gets me money. I likes anything as goes straet on like." And I suppose the deadliness of constant repetition never worried him.

Perhaps it is only because our brains have been artificially stimulated from childhood that they desire such continual exercise, or excitement. For the nightmare that it is to us to have "nothing to think about" apparently never occurs to the farm-labourer. It is quite enough to him that he has to watch each turnip and cut out the weeds around it, his brain can brood peacefully over that and he works on happily, as content as a horse might be plodding quietly along a highroad. But for us, accustomed to work that takes active thought and some concentration of mind, the mental stagnation and emptiness that

The author once shared Olive's bafflement by once being asked by a farmer friend to fetch the 'eevil' from a barn. It was later that it dawned the word, describing the four-prong fork – comes from 'heave-ho', pronounced without the two h's, and in the Devon way. Olive's reference to 'arrishes' indeed describes stubble fields and is a name used more widely than just in Devon.

comes over one becomes almost unendurable. The only safeguard lies in the intense physical fatigue which renders one incapable of thinking, although it does not in itself satisfy the craving to think.

I am not at all sure that this is, in us, such a sign of our "superiority" as is generally supposed, or that the fact of continually needing something to exercise our minds over means necessarily that our thoughts are of any value. Much of it is mere restlessness and craving for excitement. I believe that there is inclined to be altogether too much mental stimulation in our ideas of education, and far too little manual training. The brain is not everything, whatever the scientists may say, and in anything beside brain, civilised man stands by no means at the top of the scale. One has only to compare a man with any wild animal, or even with the more primitive of his own species, such as the Red Indian, to see how dull and inert are all our senses and instincts. A wolf or an Indian will distinguish sounds which are quite inaudible to a civilised man; the wild-deer or the hawk can see form in what to him is only an unmeaning smudge; and in the quick response of body to brain notice any wild thing asleep (if you have been lucky enough to creep so near), and you will see how instantaneous is the change from slumber to an attitude ready, equally, for flight or self-defence. Compare this with the slug-like sleep and awakening of a man, yawning himself into consciousness through drowsy stages!

Is man altogether so superior to the animal? Brain, surely, is not everything? In sexual morality, at any rate, any wild beast can give points to mankind as a race, and one cannot but think that physical beauty, keenness of sense, alertness, health, joy, and mental and physical harmony, have some definite life-value each in its own proportion? Is not the superior animal, the super-man, one who will combine all these in right *proportion* – not one whose brain is developed at the expense of everything else?

It is time surely to realise whither we are tending; for the result of many more generations with brains developed at the expense of their senses will be the evolution of a creature with the aspect of a slug or a tadpole – a thing with a vast and complex brain, perhaps, but with spectacles for eyes, ear-trumpets for ears, electric wheels for legs, living physically inert and powerless in the midst of its own inventions.

The farmworker: "a being whose body and movements are a joy to look upon, who can swing a scythe ten hours a day..."

Games and exercises at school are not enough. We must begin to appreciate physical fitness, and even to give it a market value, before the tendency to development will swing the other way. At present, whilst any anaemic clerk, dwarfed and spectacled, can earn just twice as much per week as a powerful countryman – a being whose body and movements are a joy to look upon, who can swing a scythe ten hours a day or carry two hundred pounds on his back without flinching – so long will the national development tend naturally towards the former type.

Nor is the value and beauty of skilful manual work nearly sufficiently appreciated. There is work that can never be learnt from books, and farm-work is essentially of this class – as much, indeed, as any of the Arts. I know a farmer, of great repute as a farmer, who began in a very small way and who to this day can barely sign his own name. Yet, when he sold his stock a year or so before the war, he was worth £15,000. He had never, I believe, looked inside a book in his life, but he could tell the weight of a fat bullock or of a rick of hay, just by looking at it, pretty well as accurately as by the scales.

Much book-work, in fact, hinders rather than promotes natural observation, as may often be noticed in people, townspeople particularly, when they walk through the country. It is almost laughable to watch how vacantly some people stride along, missing all the

"Scenery! How one hates that word when applied to the country." Olive's sensitivity to the natural world and her artistic abilities are evident in the small number of paintings currently attributed to her. This watercolour of moorland is possibly a record of her time on Dartmoor.

life and wealth of detail on every hand. With eyes dwelling on nothing and thoughts busy with second-hand ideas borrowed, perhaps, from a book or the morning's newspaper, they travel blindly, emerging from vacuity only if something familiar in the shape of a printed notice appears. I always wait for this when I am walking with these people, and am generally right if I wager to myself on its being read aloud, however inane and inappropriate its message may be. And all the while, all the interesting things that are happening in Nature, the myriads of different complex little lives that are about one everywhere, the changes or significance of soil, of season or of weather, the management of fields and hedges, of coppice and wood – all open books to read from if one will – these are ignored as if they were so much painted scenery.

Scenery! How one hates that word applied to the country. The use of it is exactly typical of the type of mind just described. To these, man – oneself – is the centre of the universe, and all else is "scenery"! All else revolves as subserviently and unmeaningly around him as did the sun and the planets in the days of Copernicus. There is no true happiness to be found in Nature, no real comrade-ship, until one can put away that all-important ego, and feel oneself of no more – and perhaps of no less – consequence than just any little toad-stool under a tree. What is man but a mite, on a mite of a planet, revolving around a sun that is after all but one of the lesser stars of the myriads that make up the Milky Way!

How, then, can he be of any more (or less) importance than the midge that dances for a day and a night over the stagnant pool? Why should he stride through the universe

regarding all that is bigger, and all that is smaller than he – just as so much scenery?

To find again that lost sense of unity and comradeship in Nature, the best thing I know of is to sleep out of doors – to sleep alone, away up on the mountains or deep in the heart of woods, far from the influence of houses and the noisy works of men. For then in truth the wild things cease to regard one as an enemy, the woods draw close and wrap one round with wonderful comfort, and one does, in fact, "belong" at last. Then is found a sympathy with Nature and a divine happiness that transcends all that I have ever known.

I thought that in farm-work one would be conscious of this happiness always – that being with Nature, out under the open sky, with everything beautiful round and nothing to jar or disturb one's contentment, it would be possible to combine what one might call a state of religious worship, with work for one's daily bread.

But no! Three seasons of hoeing, with its deadly sameness, its paralysing effect upon the mind, and the intense physical fatigue which renders one insensible to any joy whatever in life except the relief of stopping, have convinced me that it is not in this way the problem is to be solved.

Perhaps it is only in the excessively long hours that lies the hitch. And if so, one cannot but feel, with Tolstoy, that if everyone did their share of "bread-labour" – of producing absolute bed-rock necessities – that possibly the lot of those who are already overburdened might be lightened.

Mercifully, however, there are some who do not mind. Old 'Arry 'Ickey did not mind. He was as contented a character as any I have met. Either then we must allow a few more people to grow up with unstimulated brains, or we must reduce the hours of labour for those whose minds crave more occupation. Possibly, if everyone who devotes so many hours a day to profitless exercise – in playing golf or tennis, or taking walks, or in even more unproductive Swedish exercises so as to keep themselves in health – were to do an hour or two a day of field or garden work, the lot of the labourer might be considerably lightened.

Hickey seemed much puzzled by Jimmy and me. Perhaps he filled his mind as he worked by making up stories about us, even as we did about him. He really was rather sorry for us, I think, being under the impression that we must have had bad luck and come down in the world to be reduced to taking up our present work. Some of the local women were not so generous, for they opined that we ought to be thoroughly ashamed of ourselves for undertaking such dirty work as milking – "going down about in the yard with the men!" One woman I came across, an "assistant" in a farmhouse, when asked to empty something away out of a bucket, refused to do so on the ground that someone might see her carrying a bucket in the yard. If such was the conventional view, it can be readily believed that we, who spent half our time carrying buckets and things about, must indeed hare sunk very low!

As we toiled away in the fields old Hickey, with his queer figure, would often shamble by, and stop with a look of sympathy or a word of encouragement. And one day he came by when I was alone at lunch-time, Jimmy having been kept late in the yard by some obstreperous calf who could not be induced to take its milk. It was nine o'clock, the hour when people in towns, having missed all the freshness of the day, are sleepily coming down to breakfast; and the hour when labourers, having breakfasted at six, sit down to eat their lunch, taking a very welcome half-hour's rest under a shady hedge. I had settled myself in a comfortable corner, where I could see something more refreshing than the

interminable rows of turnips, when I observed 'Arry 'Ickey sidling along in his peculiarly grotesque manner, munching his bread-and-cheese as he came.

Arrived opposite my corner, he stopped and regarded me for a moment in silence. Then suddenly in a loud voice:

"Do'ee sweat, Missy?" he called out.

I knew this was a polite way of asking if one were hot, so I answered, equally politely, that I did, indeed.

"It be fit tu melt anyone, that it be!" he continued, mopping his brow with a handkerchief that once had been red.

"An' ain't 'ee got no friends doon yur along?" he inquired.

I replied that Jimmy would be out very soon to join me. But 'Arry was on some trail of his own, which he pursued.

"Yu'm all alone like, b'an 'ee, Missy? Now I got a nice little 'ome up Exeter way," he informed me – "I keeps it agoin' ever since my old Missus died. But there, it's lonesome up along by myself. I'd as soon be workin' doon yur."

I expressed as well as I could a sympathetic interest.

But – "Well there. Miss," he continued, "yu'm a bit lonesome like yur too. Look 'ee, Miss! If yu ain't got no one tu tak' 'ee oot' I'll tak' 'ee oot!"

My sense of obligation indeed overwhelmed me at this crisis, for I realised suddenly that this was verging on a bonafide proposal.

"I'll tak' 'ee oot, Miss," he repeated appealingly.

I suppose I looked rather at a loss, but stifling my appreciation of the situation until I could let off the humour of it to Jimmy, I managed to convey to him, politely still, but definitely, that I did not think I should need to trouble him, and with that he left me, shambling crookedly back to his work.

Poor forlorn 'Arry! Whether the disappointment was very great I never knew. But I often wonder if he would have been surprised had I accepted his generosity.

Soon after that Jimmy appeared, and we got to work again. But that was destined to be a disturbed day all through. Not many hours had passed before the sheep were seen breaking out into the corn on the opposite hill. And from that day onwards this was a regular occurrence that relieved the monotony of the time.

X. SHEEP
August

THOSE blessed sheep! It seemed that nothing would keep them contented. First they were into the roots, and then they were out in the corn. Twice in a morning, sometimes, one of us would have to go and chase after them. On some days it was a relief to have to turn to something fresh, but at others the extra climb up the steep hill in the heat was just the last straw that broke our backs. Generally the job entailed the fetching of a billhook and heavy spade, and climbing up the hill with them on one's shoulder as well. Curiously, the sheep always seemed to know when they were in a forbidden place, and would scuttle back the way they came without much pressure. But then the gap would have to be found and mended.

The way this was done was merely to cut some sturdy pieces of blackthorn and stuff them into the hedge, or if there was not sufficient hedge to hold them, they were laid along the top of the bank and weighted with turf cut from the bottom with the spade.

A flock of Dartmoor sheep at Sampford Courtenay c.1920.
"There," said Maester always, as he placed each piece, "They won't face they prickles!" But whether or no, they always found some new gap to get through, however well we stopped up the old one.

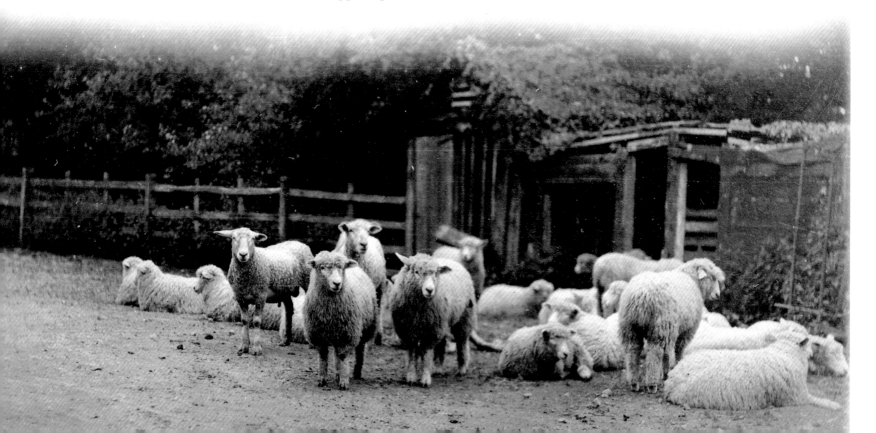

Jimmy and I could never make out why he did not set to and make his hedges sound, as they do in other parts of England. But being on a rented farm this would have been for some other person's advantage, and rather than be so altruistic I believe he preferred to forgo his own! Certainly, hedgemaking as it is practised in the Midlands is an unknown art in Devonshire, the naturally luxuriant growth relieving the farmers of any work beyond trimming the hedges in summer, and possibly cutting them down for fire-wood once every few years in winter. We felt ourselves, in our heated exasperation, that to have thoroughly fenced or wired those fields would have meant less work in the end than spending half one's day chasing the sheep and blocking up gaps.

Sheep really do need one man's undivided attention, especially in summer-time, when flies get into the wool and foot-rot is rife. Every day Maester went out to them with his tar-pot and knife, rounding them up into a corner with the help of Shag, and catching each one that limped. Then came the struggle; seizing it round the neck with one arm and under the body with the other, the sheep was thrown, and lying upside down, submitted, poor beast, to having its toe-nails pared and tarred, and any unclean locks of wool trimmed off.

During the process Shag, with tongue hanging loose and mouth wide open in a grin, would lie by the side, lording it over the flock, immensely proud and important. Sometimes her self-importance went to her head completely, and overdoing her generalship she scattered the sheep out of the corner and dispersed them over the field again.

How exasperated Maester used to get! "Yur! Yur! Yur! Lay doon, Shag!" he would yell, loud enough to deafen any animal within a mile. "Lay doon, Shag! Damn the ol' dog! I do believe 'es 'ard of 'earin'!"

Shag was a trying animal, certainly. She was useful enough at times, and when she felt inclined, she saved us many a tramp after the cows. But to tell the truth she considered that driving cows was somewhat beneath the dignity of a sheep-dog, and as often as not, when sent across the field to bring them in, she would start half-way towards them with great apparent enthusiasm, then stopping suddenly in mid-career, would roll vigorously on her woolly back, change her mind with a shake, and trot happily off in another direction chasing birds or rabbits – real or purely imaginary. Jimmy had then to plunge over the swamp herself and round up the cows, after which, perhaps, Shag would join her and consider her duties conscientiously fulfilled by shooing them with gusto up the lane.

Sheep are powerful beasts to throw and hold, but, like everything else, to do it easily requires knowledge rather than physical strength. Shag and I had a desperate time with them one very hot afternoon when some of ours had got mixed up with a neighbouring flock.

To round them up was a thing Shag thoroughly enjoyed – very different from the ignominy of being sent after cows! Like a streak of lightning she was off down the hill, encircling the field, and woe betide any poor animal who was slow, or independent enough to separate from the flock! Shag would give her just the run of her life; and often, I am sorry to say, in spite of my heroic efforts to emulate Maester's "Yur! Yur! Yur!!" the sheep arrived at the end with a torn or bleeding ear.

When collected, the only corner available for catching them was a slightly obtuse one, with a litter of rock about, which the sheep found very convenient to dodge around. Being

A Land Girl farming at Widecombe-in-the-Moor with her sheep dogs.

a strange flock they were extra wild too, and unused both to Shag and me, and I think we spent an hour or more in and out of that corner. But before my patience was altogether exhausted I managed to catch the half- dozen of ours that were mixed up with the rest – easily distinguishable by their curly Dartmoor coats – and each one I hauled struggling, twenty yards or so, to the boundary-hedge.

Once there, however, the problem became still more acute. The boundary was a bank, five or six feet high, and very steep. Up this, somehow, the ponderous, struggling beast had to be lifted and dropped into his own domain on the other side. 'Arry 'Ickey might well have asked, "Do 'ee sweat, Missy!" had he happened to come by just then.

Verily, our tasks were like those of the old fairy tales, each one more apparently unconquerable than the last. But miraculously, somehow, most of them were accomplished in the end.

One of the most truly gruesome jobs perhaps that I ever had to do was likewise connected with sheep. A half-grown lamb had died – we never knew from what cause they died, as every ailment was invariably put down to "catching cold."

"That's 'ow it is, yu see," said Maester time after time.

"They runs about and gets 'ot, and then they lays doon an' catches cold! That's where it is!" an explanation that always presented to my imagination the ludicrous picture of white woolly lambs racing about getting flushed and purple in the face, like Maester himself when he was called upon to do anything very energetic!

But however it happened or whatever the cause, lambs did occasionally die, and an old sheep had likewise died some time previously, in spite of Jimmy's devoted nursing.

This one the boy had been sent out to bury, but he had done it so inadequately that the dogs resurrected the carcase some weeks later, and for a long time our grief and trouble were great when passing that particular side of the meadow. So when Maester sent me along to bury the lamb, telling me to make a better job of it than the boy had done, I resolved that rather than pass that decaying horror any more, I would have a shot at getting it underground as well.

With pick and shovel I dug a lordly grave, big enough almost to bury myself in too, and in it laid the innocent lamb to rest. And then came the problem of the other one, which by this time had become literally unapproachable. I pondered how it could be done, and bethought me of the plough reins. Fetching the longest ones we had, I made a slip-knot in one end and prepared for the bold adventure. Holding my nose tight with one hand and the rein with the other, I raced to the spot, looped the slip-knot round one leg, and speedily retired to the other end of the line. The next thing was rapidly to drag it to the pit, seize upon the spade, hurriedly heap a few spadefuls of earth upon the disastrous sight, and then one could retire to choke and regain one's breath.

Thereafter it was plain-sailing, and great was the relief on the farm when the deed was accomplished.

After that experience the handling of live sheep was nothing, and many a bout did I have with them at shearing-time, when a friendly shepherd once instructed me in that art. It is work with plenty of scope for deft and delicate use of the hands, as well as needing considerable strength to hold the sheep while standing oneself in a stooping posture.

The fleece is first opened down the side, the victim lying flat, and then with the sheep sitting up on the lower part of its spine, leaning back against one and held firmly between the knees – its head hanging pathetically on one side – all the underpart can be cut away,

Bottle feeding a lamb at Foxworthy Farm, Dartmoor, c.1915.

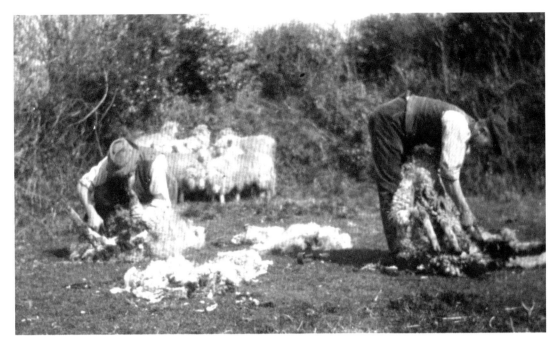

Shearing sheep at Bridestowe on Dartmoor.

and the corners and crannies cleared out round fore and hind legs. Once the corners and legs are clear, the shearer works up the breast and neck, round the head, and then down the back, clipping evenly in horizontal lines. Half-way down the back the hardest part is over, the sheep can lie more comfortably again on its side, and the rest of the fleece comes off in lines cut parallel with the spine, working upwards, one side first and then the other. A quick shearer, if the sheep are caught for him and he can go straight ahead, will clip about thirty in a day. My own first efforts resulted, I believe, in four!

The sheep were wonderfully patient, they hardly flinched, even when sometimes unavoidably their skin was nipped with the shears. But if a struggle did begin there was nothing for it, it seemed to me, but to throw oneself bodily on top of the animal, or away it would go with half the fleece trailing behind like a court train! Newly shorn wool is really delicious stuff when it comes away from the sheep, creamy white and spotlessly clean and pure, as soft and silky as a baby's hair, and rich with sweet-smelling oil like lanoline, that makes one's hands as soft and smooth as if they had been rubbed with cream.

We did not get much chance of shearing at By-the-Way Farm, however – when that time came I remember we were already at work on the mangolds. The principle that ruled there was that, if we could not do a thing sufficiently well to be of use straight off, we were not to waste our Master's time in learning. It was a short-sighted policy rather, for we might have been of much more use in the end if it had not been so blindly adhered to. With Jimmy especially it seemed unfair, since for her first two months she worked for no wages, paying at first even for her board, on the understanding that she was to "learn" something of farm-work! From the first day, however, she was obviously of far more use than the boy who was then living in the house and receiving wages, but no concession from the first arrangement was offered until the full two months were out. Being a willing hand, moreover, she was kept on the go every bit as hard as if receiving wages, and if she

had not made a definite stand about it each day, would never have been allowed even to learn to milk – though that had been expressly stipulated. And then we should have been in a fine predicament later on.

It was a great grief to poor James that she was not allowed to shear her own pet lambs, especially when they appeared to her afterwards, unrecognisable little miseries, baa-ing plaintively, with long bare legs and skinny faces – and she lost sight of them forever among the flock. I used at one time to think that the reputed faculty a shepherd has, of knowing each member of his flock by sight, was a wild exaggeration. But I believe Jimmy knew quite a number of her sheep, especially those she had fed and dosed and handled so often. Maester knew them all, I think, and I found myself that they were much more individual than I had ever supposed – even as human beings are when one ceases to lump them together into the rough divisions of classes and nations.

Sheep do have a trying life. Never, it seems, can they be left to do what they like. All they ask of man is to be left alone, to browse or sleep or wander, and to interfere with nobody. Instead of which they are penned up in small fields, pursued perpetually by a fiendish dog, chivvied, hugger-mugger, along hot and dusty roads, tumbling over each other as they go, and puffing and panting with heat and unwonted exertion, clipped and

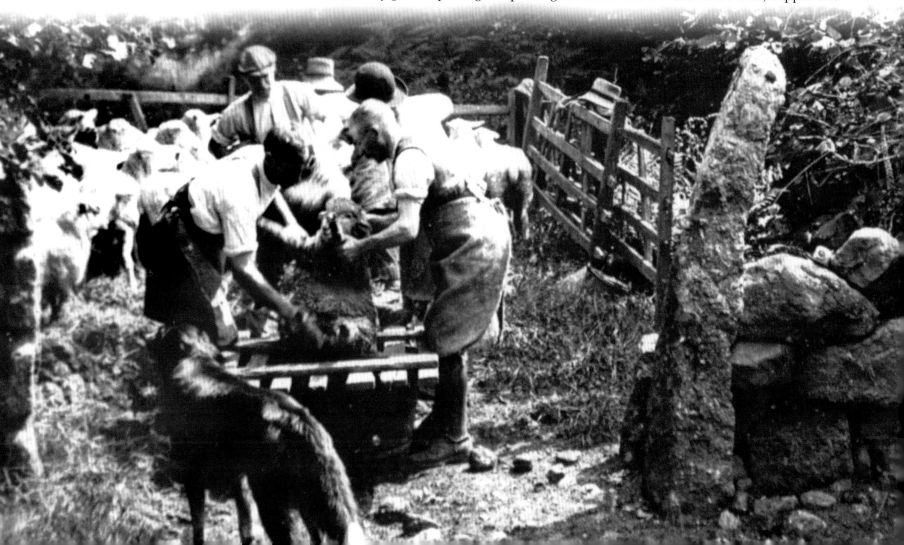

Under the eye of the sheepdog, sheep are being sheared and dipped on this Dartmoor farm in the 1920s.

dipped and thrown about! Yet they resent nothing that is done to them; they have no means of defending themselves – all they can do is just to look pathetic and injured and bored, as if to say, "When will you silly humans finish messing us about and leave us to get on with our own business?"

But from the time when first their tails are cut off to the end of their days, they have no peace. After the shearing comes the dipping, and anything more pathetically miserable than a sheep being dipped I have never beheld.

When the dipping-time arrived we took ours over to a neighbour's farm, where a primitive sort of bath had been knocked together. We did not start till about four in the afternoon, I remember, after having already done eight or nine hours work that day. But that was the light-hearted way things happened at By-the-Way Farm. If I took half-an-hour off to do something necessary in our own household, three halfpence was strictly deducted from my wages at the end of the week, but time and again we might be working on till seven or so at night without any stop for tea; and unless it were haymaking days there was no recognition of overtime. "Oh dear, no!" says Maester. "Yu don't work overtime. It only just 'appened we was a bit late!"

But to return to the sheep, and the evening of the dipping. Maester rode round with the flock, and Tom and I cut across the fields to where the neighbouring farmer was still at work with his own. A wild-looking set of men were there, with dishevelled garb and faces smeared and splashed with red from the atrocious disinfectant prepared for the sheep. But we were all as wild and dirty by the time we had finished, for without exception I think it was the messiest job I had ever had to do.

With the unearthly yells and cries in which it always seems necessary to address sheep, the stranger flock was driven off, and ours let into the pens. I wondered, as I watched them bundle in, if they remembered from former years what horrid process was awaiting them. Whether or no, resignedly and patiently they entered the pens, submitting obediently to whatever might befall.

But first we must fill up the dip, and this, instead of having been made where water was plentiful, was quite a hundred yards from the nearest spring. So the first half-hour was occupied by Tom and me in carrying buckets, while Maester mixed up the lurid poison. The buckets leaked, I remember, which made things slower than ever.

Then the performance began. Seizing each creature in turn, we lifted it bodily and hurled it into the bath. Down it sank, rising again to the surface with blinking eyes and an injured air, paddling round to find an exit. But down it went again, poor beast! – ruthlessly we shoved them under, letting them swim at last to the further end and struggle up the slope into the drying-pen.

Such a splashing and such a mess! How hot and grimy and exhausted we were by the time we had caught and bathed them all. Over one hundred sheep and lambs there were to deal with, and by the time we had finished we were splashed like a set of painted Indians fresh from the prairie.

In this condition, late that evening I mounted Topsy, and collecting the flock, rode off with them round by the road to their home quarters. I did wonder rather at the time why the occasional passer-by smiled at me so interestedly. But when I reached home and was met by wife-Elsie at our cottage-door, I was allowed to wonder no more!

Struggling with a ram at the dip.

XI. A CLIMAX AND A RESPITE
September

THE roots in time grew too big to be hoed any more, and, to our intense relief we could leave them to finish the season on their own, letting them grow until the autumn, when they would again call on us to harvest them.

At intervals of chivvying sheep Jimmy and I now turned our energies to hedge-trimming, to mowing "vearn" and "ryshes," or carting faggots from the wood where Withecombe, on winter days that were unsuitable for enticing rabbits into traps, had put in what time he liked cutting and binding them.

Mowing fern to me was certainly a relief after hoeing, though physically the swinging of a scythe is harder work. Perhaps if I had had to stick to it for as many interminable weeks, I should have come to hate it as much as we hated wielding the hoe; but for the short while I was using a scythe it was rather enjoyable.

Bracken, at any rate, does not grow in straight rows, and one could exercise a modicum of initiative wandering where one liked over the rough uplands of gorse and fern, choosing out the best patches to cut. It is a beautiful swinging movement too, though it is, I admit, a fairly severe strain upon back and arms, the muscles of which force themselves acutely upon one's consciousness next day. It is a disappointing fact that, however much we congratulated ourselves on being in really good physical condition, some slightly new form of exercise would at once find out the weak points, and result in several days of renewed stiffness. I always hoped that in time our every muscle would be kept in such good working order that "stiffness" would be a thing forgotten, left behind with our amateur days; but personally I have never been able to arrive at that happy condition.

Harvesting bracken on Dartmoor c.1915. The dried fern was used for bedding and, in extremis, fodder.

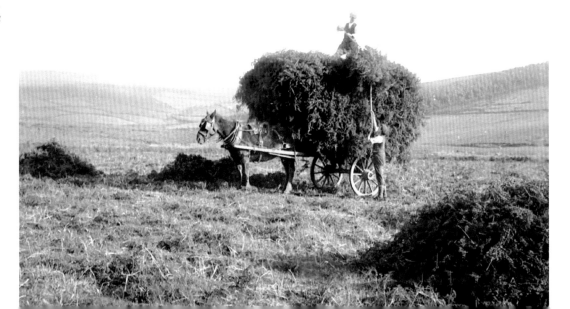

Once, indeed, I remember, as I watched an old cowman lifting hay on his prong, I asked him if he thought I might hope to be as strong in the arm as he when I had worked his number of years!

But, "No, Missy," he replied, shaking his head with the indulgent smile of the superior male; "yu'll begin tu go back now, I shuldna' wonder"– a crushing snub to my modest ambitions! I did receive comfort from a blacksmith, however, once, as I watched him swinging his hammer with such apparent ease the livelong day. For when I asked him if his arms never got stiff and tired, he confessed that they did, often! After that we did not feel guilty of such undue amateurishness when, after a week of hedge-trimming and mowing, our arms and wrists became acutely painful.

I spent about a week up on the hill-top mowing the bracken, alone with my scythe and the birds and a straggly pine-tree or two. It was very pleasant to have left hemmed-in fields for rough, new, untrimmed country. There is something so confining about hedges, even when they are rambling, luxuriant Devonshire ones, and to be for long among right-angled fields and hedge-rows gives me always the feeling of being tied round with string like a parcel. But the joy of release would have been infinitely greater had I only been able to sit down at times, to enjoy the ranging view of hill and moor, and the light-hearted music of the larks drenching the blue with song, instead of swinging my scythe with an aching back, hour after hour. As it was, a cursory impression while I stopped for a pull at my cider-bottle was all I dared take, storing it up as best I might for enjoyment later on – "after the war," perhaps, when once again one may feel at liberty to take a walk or watch a sunset in peace and at one's leisure.

From the hill-top I went down to the meadows, mowing rushes for thatching; and after that we were turned on to hedge-trimming, which is monotonous work – and dull, except in so far as one can take a craftsman's delight in a job neatly done. It delighted me exceedingly when the condescending Tom looked over the hedge one day and surveyed my handiwork.

"Oh – yes!" he volunteered. "You'm adoin' of it very well!" That indeed was praise, coming from such an authority.

There were one or two days at that period when Maester really started out to mend things – the principle that usually prevailed on the farm, with harness, gates, hedges, or any thing else, being to patch it up for the moment with anything that came handy and postpone mending "until there was more time." The consequence, of course, being that harness was everywhere tied up with string, broken panes patched with rags, fences stuffed with loose boughs of thorn, and so on. Often it would have taken very little longer to mend the thing properly at once, as we used to clamour to be allowed to do; and certainly in the end, the continual re-patching wasted far more time. The accumulation of litter everywhere, too, was a source of much trouble to Jimmy's passion for getting things ship-shape. Whenever a thing was no longer of use – whether it were a bottle or tin, or a piece of a cart or plough, or odds and ends of leather or anything else– it was dropped, just where it happened to be, and ever after disregarded. Jimmy I remember, one day, had a regular holocaust of old coats, waistcoats and other garments, which we collected from the yard and various buildings; and I, at the same time, in turning out the harness-room, filled a vast bin with old bottles and tins!

The idea of really going out to mend gates was a pleasure indeed, for the number that were off their hinges or lacking latches caused us continual irritating delays when going

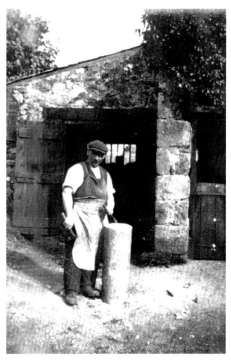

The village blacksmith, Manaton on Dartmoor.

about with the carts. A good many were altogether broken, and a goodly stock of new ones, provided by the landlord, had long been waiting in the yard. By the time we left the farm most of them were waiting there still, and probably are to this day!

Apropos of feminine incapability, I remember a quaint incident connected with those days of gate-mending. There was a broken-down gate at the side of one of the very steep fields about half-way up in the hedge. We had been putting in a new one to a gap at the bottom, and then had to carry another up the steep slope to replace the broken one above. In single file, Maester and I hitched our shoulders under the top rail, caught hold by a lower one, and started with it up the slope. He, I admit, was carrying far the heavier end. But whether it were the heat, or steepness of the hill, or the fact that I had but lately finished a large and satisfying dinner, I cannot say. My knees seemed to dissolve beneath me, my heart stood still, and a feeling of suffocation came upon me with an overwhelming conviction of the impossibility of ever reaching that gateway above.

"Perhaps," I thought to myself," they are, all of them, right after all. Perhaps the work really is too much for a woman. What an inexpressible relief it would be just to admit the fact – and give in!"

Scarcely had this passed through my mind when, with a groan behind, Maester stopped and dropped his end of the weight we were carrying.

"Oh, stop a bit, Sammy!" he called out, puffing and bringing out his large red duster to wipe his redder face.

"Let's 'ave a rest, for 'eaven's sake!"

A revulsion in feeling came over me then, and at the sight of him groaning and pathetically mopping his brow, my strength somehow miraculously returned.

"Here, Maester," I exclaimed, "you've got much the heaviest end! Let *me* have a turn at it!" And thereupon, changing places, we proceeded triumphantly – I with renewed faith in feminine powers – to our destination.

Gathering wood for use in heating the home and for cooking was an essential part of farm work. Not the size of the faggot stack on the right of this photograph taken of a cottage in Ilsington, Dartmoor c.1910.

After the gate-mending, an occasional expedition to the woods for faggots enlivened the season. That was adventurous, partly for the different surroundings we travelled into, and partly because of the wild and rugged places we had to take the cart down. We set off one morning, Jimmy and Bob and I, with the "carry" to bring in some loads. The first turning off the road led into a steep field shelving precipitously down to the river, a place worn into horizontal ridges where sheep and cattle had traversed the hill.

From the gateway we drove down a narrow, precipitous place like a rocky, uneven staircase. Bob achieved this safely, though he did look somewhat surprised at the jumping and bumping of the carry behind him; and then, after zig-zagging down the grassy slope, there was the river to ford, and a rocky bank to ascend beyond.

The river passage was exciting, for the bed was of hidden rocks and stones, and Bobby's incorrigible habit of tearing along at the top of his speed as soon as any difficulty occurred behind did not tend to make things easier. From rock to sunken rock we bounded, swishing through the water, one wheel sunk in a gravel-bed while the other whirled in the air as it rebounded from a crag; then up the further bank, where the roadway was indistinguishable from heather-covered rocks, Bobby crashing on while we sat wildly helpless, clutching whatever we might to steady ourselves.

At By-the-Way Farm, as may be noticed, no job seemed ever to be calm and straightforward, as one expects on the well-ordered estates in other countries. Either the ground, or the implements, or the weather, was always against us! Always we seemed to be fighting the elements or overcoming natural obstacles in a way undreamt of on the level farms of the Midlands. But the general rough-and-tumble added greatly to the picturesqueness of our life, as well as to the fatigue, so everything that came along must needs be greeted as a fresh adventure.

We arrived at the top of that perilous hill with necks unbroken, though somewhat jarred, and made our way down through the tangled wood.

It was a self-grown jungle, thick and very varied, with queer gnarled oaks, almost effaced in their overcoats of moss, groping with lichened arms towards the light; under them dark thickets of hawthorn blocked the ways; and here and there a soaring cherry, with already a hint of autumn in its leaves, splashed the green roof-tracery with a tinge of red. Here

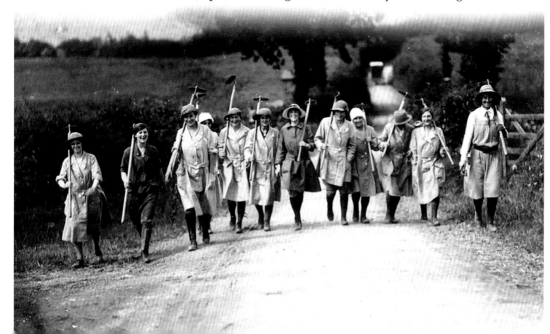

A group of WLA trainees on their way to work – South Devon c.1917.

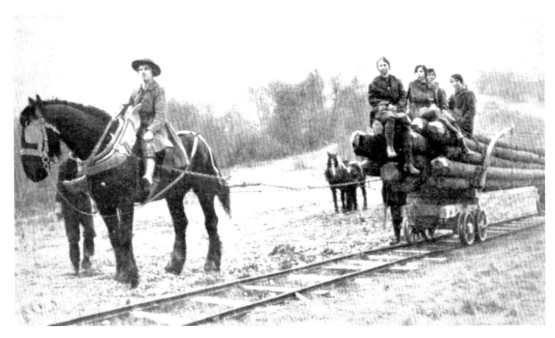

In January 1918 the WLA were divided into three sections: Agriculture, Timber cutting and Forage. After a six week training course the Timber Corps women were taking on the tasks of felling and transporting timber. Here they are hauling felled tree trunks along a light railway from a forest on the edge of Dartmoor.

again, a graceful ash, swinging her supple stem up through her close-set neighbours, swayed, hesitating, like a slender maiden captured by a band of rugged ancients. Her companions, a group of saplings beyond, poised as if in flight, swept bending towards the river, where matter-of-fact alders held their own in a sturdy wealth of green, and pale young birches, interspersed with holly, crowded close.

Jimmy had often explored these thickets – buffalo-hunting, as she put it, in the early mornings. For here the cows at times wandered in the night, eating the young boughs, cooling their feet in the river, and hiding themselves away in the thick undergrowth. They had queer fancies about coming in to be milked. Very often they waited impatiently in a group at the gate, and at other times, loth, to come in, they entrenched themselves in these fastnesses beyond the river, and responded neither to Shag's bark nor Jimmy's call.

Work in the woodlands – and work with wood – has something in it more fascinating than almost any other department of agriculture. Perhaps it appeals to the primitive arboreal instincts latent in most of us. There is a warmness and a feeling of kinship in trees more sympathetic than anything else in Nature, and the handling even of a dry faggot has a comfortable homeliness about it, quite different from the cold and unfriendly turnip. Creeping about in that thick undergrowth we felt wonderfully at home – as if we had escaped from school and the workaday world, and had come back to the haunts of romance and faerie.

The exquisite mottled carpet we moved upon was in itself a universe of life and colour, with its complex patterning of moss and overlapping leaves – dead leaves, sienna-coloured, amber-coloured, brown, maroon, crimson, and purple, all lying interlaced and interwoven as if arranged for show by some loving hand on a "fairy-cupped, elf-needled mat of moss." Golden-brown chips from the wood-cutter's axe gleamed out from the rest, and fallen logs, grown over with lichen and moss, littered the ground. Perhaps for

colouring and intricate patterning there is nothing to equal a moss-grown log' a log that has lain from season to season among damp undergrowth. Grey lichen rambling over it in foaming rings and wreaths, warring with the soft, thick blanket of moss that wraps it close; frilly toad-stools gathering about the roots like busy chatterboxes, and hints of red and orange fungus in the cracks – it was with a tragic sorrow that I learnt that all these lovely forms of life are but disease attacking a dying tree. One of the great beauties of a wood has always seemed to me that wealth of colour in fungus and lichen and moss. And these, after all, I am told, are but signs of disease and death! When all life preys upon life, where can one discriminate in one's affections? It is the problem of the rabbit versus the corn all over again, and the enigma for those who love all life is indeed difficult!

Difficult, yet not insoluble – for as I write it comes to me how the explanation bears out what is to be noticed always in Nature : that all is beautiful if only left to go her way. Death she allows – when a tree has had its day; and disease – to weed out the weaklings. But see how in her bounty she will beautify death itself! Immediately, new forms of life take hold upon the corpse, and while it lies rotting into the ground, they, while their day lasts, may flourish and give joy in their turn.

It is the privilege of an artist to love beauty wherever it may be, and what form soever it may take, regardless of significance or potential human utility. To an artist a tree does not gain in value because he can use it for timber, and a fungus is none the less beautiful

'On the Plym at Shaugh Bridge (1912)' an oil painting by John Barlow. Typical of the lower reaches of Devon's river valleys, the rock-strewn stream is bounded by dense woodland of oak, ash and birch.

WLA Timber Corps workers 1918.

because it may not be edible – even as a dew-drop flashing in the sun is equal in value to any diamond sparkling at a woman's throat. And so, as an artist, one may love the little striped and frilly fungus clustering at the roots of trees, the orange coral growing in the pinewoods, the comic halfpenny buns and pancakes, or the white-spotted, scarlet fairy's umbrellas, even though, as an agriculturist or a timber-grower, one must needs wage a ruthless war upon them.

The same emotional conflict rages at weeding-time, when one sees that the glorious flush of poppies in the corn is to 'Arry 'Ickey and his kind, but one more "dirty mess," significant of nothing but bad farming.

Truly an artist's place in life is perplexing, for he, like other mortals, needs corn to make his bread, and timber for his house-roof. Yet permanency in beauty perhaps means very little. It is enough once to have seen a field of poppies, and afterwards the farmer can work his will upon them, for the joy of that revelation is in one's possession for ever.

So will the memory of that wood be with me always – Jimmy, in her green tunic, piling faggots upon the cart; Bobby, with his dappled coat, pulling at the boughs above; sun and shadow speckling everything, and the criss-cross of boughs vanishing into avenues and arcades whichever way one looked; the moorland stream pursuing its reckless course over rocks and logs, whispering, gurgling and burbling as it went – all was a wonderful break after our long toil in the open, unshaded fields.

We could have stayed down there all day playing with the river and exploring the little rabbit-paths and cattle-alleys, only that the thought of that exacting twopence half-penny and threepence per hour we respectively were earning forever burdened our consciences. Had we only been doing piece-work it would have been worth many threepences to have been able to stop a moment, as in the good old pre-war days of leisure, left such an eternity behind.

Wandering through the undergrowth presently came Bill Withecombe, with axe upon his shoulder, looking like the spirit of the wood incarnate. He might have been an oak-tree walking in the shape of man, with his rugged, wrinkled features, and the scraggy whiskers like a tangle of lichen hanging from his chin. His weather-worn, green-brown corduroys robed his body with the perfect fit that only comes with decades of wear, and the splashes of sunlight moving over him painted them with all the mottled colouring of his surroundings.

Something of the same stern kindliness of the oak-tree shewed in his face as he came up to us, smiling a little at our amateur struggles with the load.

"Yu'll 'ave it all comin' off again. Missy, if yu puts it up like that 'ere!" he said; and, seeing me staggering under a top-heavy faggot, he took the prong from my hand and deftly re-arranged the load, fitting each piece into its place as one knowing the key to a Chinese puzzle.

"Luk 'ee now, Miss, I'll show 'ee 'ow tu twist a bien!" he said, noticing that one of the bundles had come untied.

He sauntered down to the water, and presently returned with a long withy-wand cut from a pollard stump.

Timber was at a premium during the later stages of the war as it was required in vast quantities by the military. This left domestic users falling back on traditional sources of wood to fuel their fires and cooking stoves. On Dartmoor peat was still cut for fuel and faggot bundles were collected and stacked close to dwellings for ease of access in winter. Here Miss Blenkiron of Ilsington on Dartmoor, dressed in her WLA uniform, is photographed with her donkey cart collecting blacksticks, the remains of furze (gorse) bushes after swaling had taken place. These were especially suited to firing bread ovens as they burnt with a fierce if short-lived heat.

Timber and neat bundles of faggots lie in the shadow of an abandoned mine on the banks of the River Tavy near Belstone on Dartmoor c.1915.

"See yur, Miss – you stands on one end, like that 'ere, and ye twists it like a rope. Then yu turns down the thin end fur to mak' the loop like, and twists it again till it 'olds."

Then he laid the twisted bind upon the ground, placed the loose wood upon it, passed the butt end through the loop, knelt upon the bundle to keep it firm, twisted the bind again, and secured it as fast and firm as a knotted rope.

"Now yu'll know how tu do it, won' 'ee, Missy?" he said as he tossed his faggot upon the rest.

"I sh'uld let that bide now," he said; "that'll be enough for old Barb to pull up through that there gaet."

Bobby agreed with him, when we arrived at the gateway after recrossing the adventurous river. He stolidly refused to attempt that rocky stairway, and we found ourselves in the predicament of the donkey in the well, who climbed up one step and fell back two all the time.

"Come along, Bob, now!" I exclaimed. " You're not even trying to pull. 'Tisn't as if you *can't* manage it!"

My usual course when this fancy of Bob's occurred was to walk at his side with the reins, using a timely switch as he began to back. But this time I could not leave his head because of the narrow gateway and the many rocks, and his propensity, once he got started, to crash ahead through everything. But we got through alive in the end – thanks to Jimmy standing with the switch at the precise spot where the backing performance began – and plunging ahead up the rocks, we squeezed safely between the gateposts.

We got up three loads that morning and stacked them in a tidy pile to themselves, ready for the Missus to use for firing as she needed them. A load for ourselves also would have been most acceptable, for our own Missus had to gather by hand all that she wanted, but ideas of that kind never occurred to our employer unprompted – being so generous already, as he considered, over-wages.

Feelings of this kind – unexpressed antagonism flaring occasionally into open revolt – were more or less rife amongst us up till harvest-time, when, through broken bones and other casualties, we both got our much-needed holiday. After the long days in the hay-fields and the long hot hours over the roots, we were both of us by this time thoroughly overworked and tired out, and the apparent hopelessness of counting on any coming respite made things worst. Our feelings of resentment were considerably enhanced when we found our Maester refusing extra help that was offered to him, thinking, apparently, that he was getting on so well as it was that to lengthen his wages bill any further would be unnecessary. Nothing, I am sure, but the feeling of urgent public necessity would have kept us going as we did all through that summer – that, and the thought of soldiers in the trenches.

As regards the last, though, the situation seemed somewhat ironical when, in describing our life to a young officer, I was telling him how the keenest pleasure in life that was left to us was – just to be allowed to sit down! He laughed as he said that that was just what they in France got too much of, and many times he would have given a good deal for a little more exercise, and something to do! Since then, however, his life has been added to the long toll of the country's sacrifice.

* * * *

LAND GIRL SUFFRAGETTE

We had each of us been away for a week-end, back in the spring, but except for that and visits to the dentist, and the alternate free Sunday, which (after much argument and a two days' "strike") had been conceded for a while during the summer, we had hardly had an hour off work since we came to the place in February (Saturday afternoons being, of course, unheard of on a farm). And the long months of continuous and really heavy work was telling on us, body and nerves and tempers. We made up our minds to stick it out, at any rate until the corn was cut and harvested, and then to ask for a week or two away in turn, before facing the work of the winter season.

But circumstances, or the kindly dispensation of Providence, intervened on our behalf, and Jimmy, after a week of hedge-trimming, found her hands in such a state from blackthorn poisoning that, when the rash showed no signs of abating, but rather increased as time went on, she went off one morning to get medical advice.

Women employed in a Devon timber yard near Bideford in 1916, prior to the 1918 establishment of the Timber Corps within the WLA.

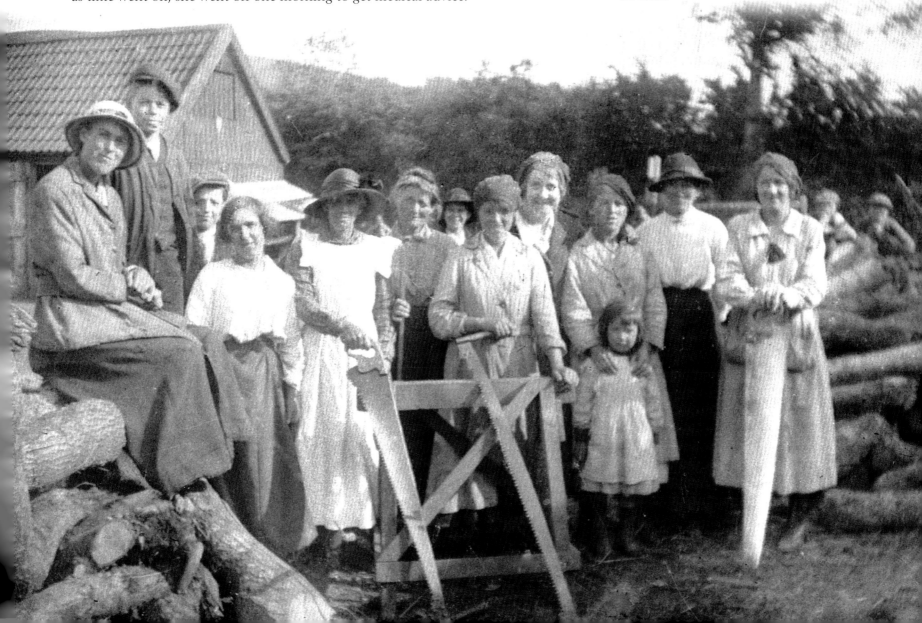

The River Dart in flood, washing out the road near Dartmeet.

Thence she never returned, and we saw her no more in the harvest-field, for she was promptly wrapped up in wadding and put to bed by anxious relatives and a family doctor.

Meanwhile we carried on as best we might. But disasters never come alone; the corn was cut and standing in sheaves when the weather broke and down came the rain.

Day after day it rained, persistent and ruthless, drenching the fields and ruining the harvest. The hayricks were still unthatched, and poor Maester's spirits sunk as low as my own.

The prospect looked more and more melancholy. Bach day the corn-sheaves grew more sodden, the fields ran with water, and the steep hill-roads became running torrents.

We did what we could – carted the wood that was cut and stacked it ready for use; we tidied up the yard, white-washed the stables and the shippen, cleaned even the engine and the thrashing-machine; sawed up firewood, and repolished and oiled the harness. There was plenty to be done, and the hours of work were no less – but none of it saved the corn.

Whenever a dry day came we were out in the fields turning the stocks and setting them up again, so as to give the soaked insides a chance to dry. In many the grain was already sprouting, with little white root filaments groping about in the wet straw, feeling for some earth to grow in.

It was at the most critical time of all – when Jimmy had not yet been able to return, when the sun shone again and dry weather returned, and all hands were needed in the fields – that my own accident happened in such an unforeseen and unnecessary manner.

I stayed a day or two thinking that one arm might be of more use than none, since Withecombe was magnanimous enough to say he'd "rather 'ave Missy with one 'and, than many a boy with two!" But the handicap of a broken finger-bone and a sprained hand was too great. I found myself funking everything, nervous even of the horses and the cows; so at last, leaving poor old Maester – brutally, as it seemed – to get what help he could out of Withecombe and Hickey and such haphazard people, I departed – flung to the winds all thought of duties and work and wars and harvests, and joined some camping friends for a glorious, wild, free life on the moor.

XII. IN CHARGE
October

THE autumn saw us reunited, with tempers restored and muscles and minds once more in tune.

The fields of corn that before our holiday had waved and rippled like the sea when the wind swept over them, now looked as shorn as a close-cropped head. Except for potatoes and roots, the harvesting days were over; hayricks were thatched, corn had all been carted and safely stacked; and early in October, when the pressure of work did for once seem to relax, Maester and the Missus resolved that even they would be able to get away for a few days' holiday.

Jimmy and I were quite confident that we could run the farm on our own, and we urged them to leave everything to us, and to get off and stay away as long as they liked.

"Oh, yes – I'm not afraid like!" said Maester. "Yu can manage all right. I knows as 'ow I can trust you!" says he. It was the first time since they came to the place, five or six years before, that they had both felt able to take a holiday – indeed, except for a Sunday now and again, I don't think Maester had ever been away at all. so we felt all the more important and flattered at the confidence he showed.

For a month past the Missus had been poring over fashion-books and conversing mysteriously with Miss Minton concerning muslins and millinery – rather to the latter's contempt, really, for she thought secretly (and behind her back said openly), that her mistress would have been better employed if helping somewhat with the work.

But that was not at all the point of view of the Missus. "You don't pay other people to do the work yourself" was the way her particular philosophy was always expressed. And to see her "assistant" toiling incessantly from early dawn till ten o'clock at night, while she lay in bed herself till eight or nine, and after cooking the dinner had finished her work for the day, did not at all upset the good lady's sense of fair play.

So now, for many an afternoon we had seen her through the window, sitting at a table heaped with needlework, busily getting her holiday trousseau into shape. Brand-new cardboard boxes had arrived from her Torquay tailor; and even the Maester had been measured for some new green riding-breeches with an expansive check. These last Jimmy and I had also been consulted over – but, needless to say, our advice was not followed!

The immediate hitch seemed to be Priscilla, whose calf was awaited every day but had not yet arrived. It was our one dread, with the cows, that this would happen on a market-day, or when we were alone in charge; and once, indeed, soon after we came to the farm, we did have the experience to ourselves while Maester was away at market.

Our anxiety was great, for to see an animal in pain was a thing neither Jimmy nor I could stand at any time. Fearful lest all might not be well, Jimmy flew across the fields to Farmer Endacott, our nearest neighbour, while I stayed at hand ready to offer assistance if needed. Farmer Endacott was out, but his wife was there, and she listened with

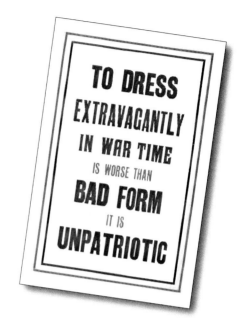

A National War Savings Committee poster produced in 1915.

From the Landswoman *magazine* 1918.

sympathy to the harrowing tale. She reassured Jimmy, however, and the latter returned to me comforted with the report that the symptoms were quite correct and orthodox ; and by the time she got back a limp, sticky, little drenched animal had come into the world, and was struggling with its first quaint staggering effort to stand. His mother very soon forgot her troubles in her surprise at its appearance, and proceeded to interest herself in licking it dry, so that by the time Maester returned that evening they were as bonny a pair as we could wish to show.

To our relief Priscilla's calf did appear in time, and all being well with her, the long-expected day arrived.

It was market-morning; Maester and Missus were taking in the butter and eggs as they went off, and I was to walk down later to the station to bring back Bobby and the trap.

The "pleasure trap" was brought out – I had cleaned and polished it especially for the occasion, and Bobby's harness and brass mountings glittered, as Maester declared, "fit to make 'im run away!"

Maester was striding about the yard, looking superb in the new green breeches and his crimson handworked waistcoat and Homburg hat. All over again he gave us the last final instructions as to the feeding of each individual animal, and showed me for the hundredth time the different little pans of cake and corn that were to be measured out each day.

"Now, Sammy – doan't 'ee forget tu shut up they then little pigs at night. And be sure not to leave any gaets open! Mind that pony doan't go gettin' out! Now yu know what ye 'ave to do, doan't yu?"

"All right, Maester!" I replied. "You'll miss that train if you don't get off! It's nearly half-past – ."

The ownership of a 'pleasure trap' sets Olive's farmer and his wife somewhat above the social standing of many farming people on the moor at the time.

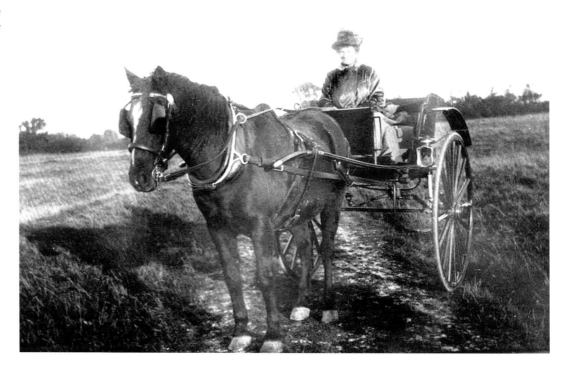

"Just run in and tell the Missus, then, there's a good gal, Sammy."

"Now come along, me dear I" he continued, as the Missus at that moment came round the corner from the house. "We mun get off or we'll be late!"

"Why, John," said the Missus, in her injured, pathetic tone, "I've been ready and waiting for you for ages! I *can't* carry out all the things myself."

Here Jimmy appeared, staggering under the heavy basket of eggs, and followed by Miss Minton with a hand-bag.

"Why, bless the woman!" cried Maester, "I thought I'd put up enough baggage for ten people. Let's 'ave that, Jimmy, my boy!" and taking the eggs from her he swung them up into their place, while the Missus climbed in on the other side.

I stood waiting all this time, groomlike, at Bobby's head, immensely enjoying the scene. The Missus had really surpassed herself, with her neat blue hat tipped across one eye, and the white veil covering it. Under her chin, at the collar of her travelling coat, rested the most coquettish little knot of coloured ribbons, upon which I could not resist congratulating her.

"*Thank* you, Sammy!" she replied, bridling and smiling in a way that reminded me of my first arrival, when I was not yet a farm-boy but an honoured stranger. "I'm sure it must be all right, if an artist says so! And do you know, this coat I've had five years, and it's only just been cleaned and turned; and the hat – ."

"Now, Missus!" interrupted Maester good-humouredly. "No time for all that!" he says as he climbs up on to the box-seat.

"Now, John, you never do let me speak "

"You're talkin' all the time, Missus! You just let me begin for once! All right, Sammy!" he cried, gathering up the reins.

I let go of Bob's head, stood aside and touched my cap with a grin.

"Good-bye, Maester!" we cried together as they rattled out of the yard, swaying round the corner into the lane.

"Mind you enjoy yourselves!"

"Good-bye, Sammy! Good-bye, James! Mind an' be guid boiees, now!"

And the cart is gone, the wheels rumble down the road, and Jimmy and I are left on our own.

"Well, Sammy!" said James, " I suppose you know what to do! I've been told so often that I don't know whether I'm on my head or my heels. I shall probably start milking the pigs first thing!"

"Same here!" said I. But as by this time we knew pretty well what had to be done without being told, we were not particularly worried. Without more words we proceeded with the usual round of milking and separating, feeding and clearing up, and after the cows and calves had been turned down to the meadows, the pigs out into the copse, and the sheep inspected, we went out to work in the fields.

By this time the chief work of the season had come to be potato digging, and for the first time in the history of that particular field we had reason to be grateful for its steep slope. When potatoes are not ploughed up, the hand-digger they use in Devonshire is something between a fork and a large hoe – turned at an acute angle to the stick like a hoe, but with flat prongs instead of the iron blade. In pulling it towards one the potatoes are raked out, and the steeper the hill before us, of course, the less (to our joy), we had to stoop.

Egg subsitute was among a number of new foods introduced during the First World War at a time when few had access to 'basketsful' of eggs. The Win the War Cookery Book *contained recipes aimed at reducing the use of staple foods in preference to items in plentiful supply. This led to recipes for Carrot Rissoles, Scalloped Parsnips and Stewed Nettles.*

But we had come back from our holiday with greatly renewed vigour, feeling really sound and alive once more, and we found we were able to tackle even that eternal potato-field more or less with pleasure. A fact which shows that, given more frequent opportunity of refreshment, there is no reason why farm-work should not be made endurable!

There was a good deal of potato disease about that year all over the country – it was the famous year when, later on, potatoes soared in price from their normal £16 or £18 to over £50 per truck (of four tons) – and for a month or two the subject was the topic of interest from the Prime Minister downwards. Farmers were accused of holding them up. But if all farms were like ours, and had, owing to shortage of labour, reduced their potato acreage to less than half, and with disease rampant in addition, it is little wonder that there was a scarcity.

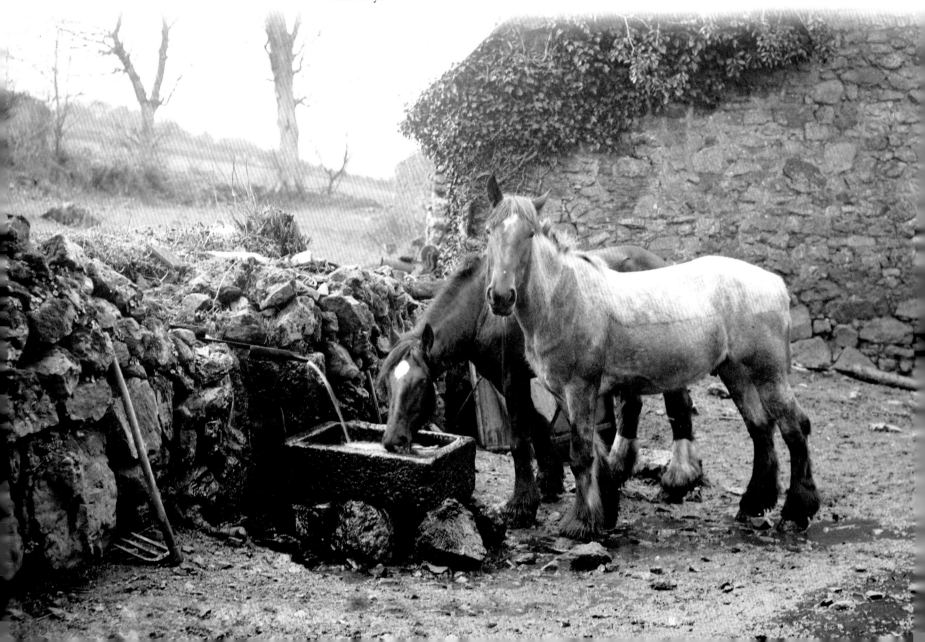

Working horses on a Dartmoor farm drink from a granite trough fed by a constantly flowing spring. An example of the 'hand-digger' used for potatoes, and described by Olive, stands against the wall.

A quaint instance of the farmer's method of reckoning profit and loss was shown me in this connection. Driving his cart, a neighbouring farmer overtook me trudging back to the cottage and offered me a lift – a welcome idea even for that little distance, so I scrambled up beside him. We fell, of course, into the current enthralling topic of conversation – the price of potatoes – and he informed me with a, serious face that he had just sold a truck. Yes, and he'd lost £10 over it, too! On inquiring further, I found that, although he would in the previous year have been very well pleased to get £18, he had sold them now for £40, thinking he had made a very good bargain. A week later the price rose again, topping £50 or £53 a truck! And now, instead of having made £22 of entirely unlooked-for profit, he considers himself to have lost £10!

Frankly I did not feel very sympathetic, when I thought how many people depend on potatoes for the mainstay of their meals.

The disease that spread over the land during the wet growing days had spared ours no more than our neighbours, and it was very grievous to find how many roots came up with just a few rotten or half-grown potatoes clinging to them. But there was one strip of the field where we had put in "Arran Chief" from seed secured direct from Scotland, and here they were robust and healthy, and it was a delight to pull out the large, smooth, golden-brown tubers. Our baskets were filled with miraculous ease when we got on to this patch.

From the bottom of the hill we worked upwards, side by side, taking five or six rows each. Between us were set three large baskets, ready for sorting the sizes as we went along. One was for the good marketable part of the crop; the next for smaller sizes, which are kept for next year's seed; and last, the one for the "scruff" – rotten ones, diseased ones, or those too small even for seed. These last make valuable food for the pigs during the winter, before recourse is had to the precious mangold.

As we worked on up the hill the baskets must be moved on with us, step by step; and as soon as they were filled, together we carried them down to the caves, tipping the scruff into a bag which Bobby would presently come out to carry home.

At the top of the field was Tom – on "piece-work" now! earning so much per yard that he dug, a "yard" in this instance being a patch sixteen feet square; and by working pretty hard from seven to five he could earn about four and six a day, instead of his usual three shillings for the same number of hours. The fact that he was thus disposed of was a decided relief to our minds, for though we were fairly confident as to the management of the animals, the control or supervision of Tom was quite another matter! Personally I had resolved to leave him in any case to go his own way entirely as he liked.

The time was fairly varied while we were alone, for the innumerable things there were to see to broke up the day very pleasantly.

There were the sheep first of all, for they required continual attention. The "yaws" and "little 'ogs" were still on grass, eating the fresh green aftermath, and they must be changed from field to field each day, while the wether-lambs and others that were being fattened were now penned between hurdles in the turnips.

For these we had to carry down a weighty bag of cake and corn each day, and count them over to see that all were well. Every other day or so the hurdles must be moved to enclose a fresh patch of roots, and if this were not done soon enough to please them the insistent creatures very soon let us know. However strongly we hammered in the hurdles, they would find some way of pushing through, or of wriggling under or over the wire that bounded the top-side. In fact, one young ewe used calmly to leap the hurdles when

Building a potato cave or clamp at Fox-worthy on Dartmoor. The pit is lined with bracken or straw on which the potatoes are laid. The whole is then covered with rushes or more straw and piled with earth to protect the crop from frost and to preserve it over winter.

she liked, browse among the fresh green roots, and then return when she had had enough! We were only glad that she did not impart her accomplishment to the rest of the flock.

The hurdles were not the picturesque wattled ones that one sees in other counties, and which are looped to a stake, but were those known as "gate-hurdles": stout wooden ones with pointed uprights, which were hammered in with an iron bar – a bar that was agonising to the touch on frosty mornings. We had some deluging experiences in that field with the sheep, moving hurdles in pelting rain, and later on in the grip of the frost, handling wire-netting and iron with aching, frozen fingers.

Even setting up hurdles is a job that a good farm-worker takes some pride over ; keeping the pens, as far as he can, neat and straight and square. A turnip-field can look a most ramshackly affair if penned badly, with hurdles ranging this way and that, and the roots gnawed in crooked patches.

"Mind you sets 'em straet!" Maester said to us the first time we put them up, "else someone'll be lookin' over the 'edge and sayin', 'That's 'ow they there women does their work'!" So for the credit of our sex we naturally saw to it that our field should have the air of being ruled with a ruler – nothing less!

That dread of "someone looking over the hedge" amused us enormously always, for we had not realised before how much farming is done on the "shop-window" principle. As long as it is out of sight from the road the farmer makes no bones about a crooked piece of ploughing, or a bare strip in the corn where the drill has wavered and "missed." But if it should be near to the road it is quite a different matter!

"There!" said Maester disgustedly one day when he was looking over a gate with a friend who had strolled by. Straight in front of them in the young green corn was the ineffaceable mark of a hopeless wobble on the part of the drill. "There," he said, "to think that that should 'a come just there! I do believe it's the only bit in the field as I missed!" (But it wasn't, for I had been all over that field, harrowing in the clover-seed, and there were plenty more – out of sight).

I remember, too, on the first farm where I began trimming hedges, I started off inside the field, and when, having finished, I moved out into the road to cut the other side, it was only to be very soon bundled back again by the bailiff, so that the show side could be done by a more expert hand!

After the sheep had been attended to each day, there was a load of turnips to be pulled and carted and piled away in the shippen for the cows and calves. Hay also had to be cut from the rick, loaded upon the carry, and brought into the loft for use. Then we carted rushes from the swamp – the rushes I had mown a long while back – and took them up to the potato-field ready for covering the caves. Tom, of course, being on piece-work, expected everything of this sort done for him; and our own caves, too, must be covered, since in October there is always the possibility of an early frost. All this we saw to ourselves. Withecombe had long since gone off trapping on another farm, and 'Arry 'Ickey had, I suppose, returned to his carpentering and his forlorn "little 'ome up Exeter way." Perhaps by this time he had found some more responsive lady to occupy it with him.

But alas for poor Maester's holiday! After the first day or two, a spell of bitterly cold, wet weather came upon us, and we heard afterwards that he had developed a running cold and did little but sit indoors and smoke. It may have been a rest, but having no resources of his own he cannot have enjoyed it very much. The Missus fared better, for she could sit with her hostess and talk fashion and frocks and domesticities for the hour

Pulling swedes for sheep feed on Dartmoor.

together – with no sense of boredom herself, if only her tongue might go! The rain of course put an end to our potato digging, for when they come up soaked and clogged with mud, besides being almost impossible to dig they are less likely to keep well in the caves.

We went down to the sheep and changed the hurdles, while torrents of rain streamed across the field, and after that set ourselves to clearing out the yard.

I had put Bob into his cart, and was just backing him into the pit, when what was our amusement to see the merry-faced Tom come strolling in. Being stopped in his piece-work job, he came along asking us for orders! Should he go rolling the "seeds," did we think, or should he come "drae-in' dung"?

We decided on the latter, and were naturally glad of his help, for we could keep the two carts going all day. Bob and Prince went each in the shafts and Captain came on as forehorse, hitched on to each in turn to help them up the hill.

Jimmy, who seemed always fated to have the worst jobs, spent the day in the dung-pit, loading, while Tom and I alternately helped to load and went out with our carts to the field. It was a mucky job all round, but yet when one came to do it, not nearly so bad as it looked. Before ever I had attempted such work myself, I remember seeing a soldier who was temporarily employed at the farm, spending his time, day after day, on a heap of dung in about the filthiest open yard I have ever come across. It was paved with broken cobbles, full of holes and irregularities, and over one's ankles in muck and filth and stagnant pools of drainage from the heap. For days together he had been standing there, loading up his cart and taking it out himself, but when I, overwhelmed with compassion, enquired one day if he weren't about sick of it – "Oh! no!" he replied cheerily, "I always did like this yur job!"

Well, thought I to myself, indeed tastes differ! But it was not so bad, we found, when it came to the point. Even the smell (except when it is pigsties, or fresh from the houses) has a wholesome countrified tang about it. Infinitely preferable, I always think, to the nauseous stink of scent or papier poudre that women in London carry about on their noses and clothes and infuse into the already overladen atmosphere.

Certainly we could hardly have been accused of looking like London ladies those wet days! Tom and I, who were in and out of the rain, were wearing, as usual, the ubiquitous farm-yard bag, apron-like, to keep our knees dry, with another over our shoulders labelling us to the world, in large letters, THREE X SUPERFINE BASIC...

When worn as a cape or an apron the bag does not impart an air of distinction, but it is consolingly picturesque, and really more comfortable to work in than a coat which hampers the arms, and becomes hot and humid as soon as one makes any violent exertion. Besides, in such an intensely muddy job it was as well to have some sort of shield for one's clothing, dirty though it was already, for what with the rain and the mud and the sticky fields, and, worst of all, clasping the tail-board of the cart each time after we tipped out a load, we were all of us covered from head to foot with muck by the time we had done. But baths were possible at the end – and it is wholesome dirt, anyhow!

The fierce dash of the pelting rain outside was very invigorating after the staleness of the covered yard, and I felt sorry for Jimmy sticking it so valiantly all day. But Jimmy had a theory that she was nervous of horses. It was quite untrue really, at any rate so far as Bob was concerned. But as she insisted that she was more at home among her cows and calves and baby lambs and seeing that I was "never so 'appy as out with a 'arse," we neither of us quarrelled with our jobs, but worked together very comfortably.

Not Dartmoor, Norfolk, but showing the universal use of sacking in keeping the worst of the muck of the clothes when field working. Mary Alcock was the county's oldest member of the WLA.

LAND GIRL SUFFRAGETTE

Olive describes the perils of working on steep ground where two horses were necessary. The field here, and that behind it on the left (already under the plough) are typical of the tight, steep fields found on Dartmoor. Many farmers continued to use horses even after tractors became more widely used elsewhere, not only due to the dangers of overturning, but where the multitude of hidden boulders lurking beneath the surface could cause serious damage both to plough and tractor.

The field where we were dumping the manure sloped steeply up above our lane; we were preparing it, I think, for mangolds for the following season. It was a queer-shaped field, with a crooked corner running out at the top, and I remember hearing hot and incomprehensible arguments between Maester and Coombe about "vours" and "vor'eads" and "lands" back in the spring when they were planning it out with the plough. It was indeed little wonder that Maester did not set much store by *our* amateur work, for when he did have a thoroughly competent man he was never satisfied, even with him.

It was a steep pull up the field, even for two horses, and quite an intricate job to bring the cart round exactly to the right spot for tipping the heap. Two horses at a time with the cart were always rather adventurous to handle, especially two who were so dissimilar as Captain and Bob. Poor Captain was a bony old wreck – not really old, however, but he had been ill-used when young, and was very stiff and rheumatic in the joints and very slow to start. Bob, on the contrary, was only too quick at starting. It was always a problem to hold him back while Captain got under way, for when he got off first and found the whole weight of the cart on his own shoulders, he was as quick to stop and begin to back. By that time Captain had started, and he in his turn, feeling not only the weight of the cart but the weight of the retiring Bob as well, he would stop also. And so we went on – or rather, that was just what we did *not* do.

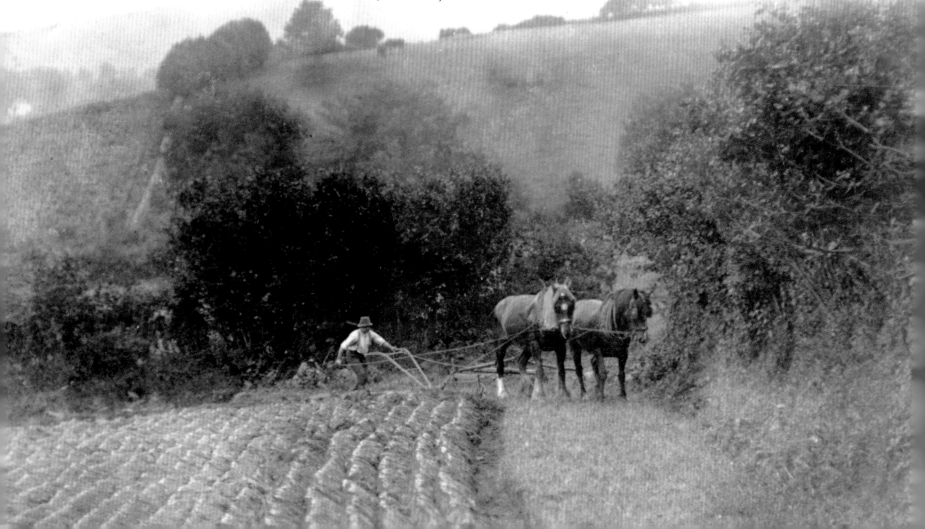

My first efforts at driving two horses were beset with many dangers – driving, in farming language, meaning to walk by the side, with the fore-horse reins in the left hand, and one's right at the mouth of the other. We were carting some bought mangolds from a village two or three miles away, and on my first entry into the village the ordeal of swinging the horses round through a gateway with a crowd of men, women, and children assembled to watch the performance, and equally ready to applaud or to deride, was a somewhat nerve-racking proceeding! By a supreme effort of concentration, aided by fortune who favours the reckless, I managed to swing old Captain round with one hand, steering his awkward career to the centre of the gate-way, and to restrain Bobby's ardour with the other – and by a happy fluke we cleared both gate-posts in triumph. After that the narrow, twisting lane with its many rocks and corners, though intricate, was at least secluded.

<p style="text-align:center">* * * *</p>

Landswoman magazine advertisement for *the Farmer Giles' smock.*

In the afternoon of that drenching day, whilst working away at the pile of manure that we were so glad to see growing less, a stray clergyman with a pony cart drove into the yard, asking if he might shelter from the rain. Coming suddenly face to face with a man of his level – of the class one had always taken for granted in the old days as forming the centre of the universe and the backbone of society – was a novelty that came as a curious shock! We had associated for so long with farm-labourers and farmers, that an "educated" voice sounded to me almost mincing and affected. I suppose that, to the working-people, our speech does sound affected, but I had never realised it before. We are so accustomed ourselves to making a joke of the broad accent and the absence of the "h" in country or cockney dialects, that it is unexpected to find that the tables can very well be turned, and that to others our precise insistence upon the "h" is just as humorous an affectation as the absence of it is to us. We drop the "h" in hour, they drop it in 'orse. To say horse sounds to them, I suppose, as far-fetched as to us it would to say *h*our or *h*onest!

To have the chance of seeing ourselves "as ithers see us" is always a privilege, and I think that the glimpse I got of life and society from the labourer's point of view were one of the things that made those years of work worth while. Before I had worked with him, eaten my dinner under a hedge with him, received my Saturday's wages side by side with him and shared his hunger and fatigue, the workman was to me a very much less important piece in the fabric of human society than I realise him to be now. Whether I was unusually snobbish or exceptional in taking my own class for granted, I do not know. Perhaps not, for even now I find it very difficult to get people to see my point. People of the comparatively leisured middle classes do still seem to think of themselves as "the nation," while the lower classes they tolerate as being put there by Providence, to make things and move things and clean things, and generally to minister to their needs.

To the labourer this is reversed. It is he and his class that constitute the backbone of society. He does the work that matters; it is his work, as he sees, that produces food and drink and clothing, that builds dwellings, digs for coals, and conveys necessaries from where they are made to where they are needed; it is he who, like Atlas, bears the world upon his shoulders. Against the leisured folk, as he sees them riding by or wandering with golf clubs over the moor, he has no grudge – but they simply do not matter. He is not in the least impressed with our clean and well-cut clothes or our refined accents. And the

interests and games and occupations that we work so hard at, he contemplates without envy, and often without contempt, accepting the fact that those who are not capable of serious work should need something else to occupy them.

For all this, or possibly because of this, the appearance of the clergyman and his pony-trap that day in the yard was something of a red-letter event to us. After all, for old association's sake if for nothing else, the tongue of one's forbears has a familiar and comfortable ring about it! ...

He himself looked somewhat bewildered at finding in a dung-pit two young women in breeches, loading the heavy black, reeking stuff into a cart! We did not converse much – a few remarks about the weather, the war, and the country – but to us in our rural seclusion, even that momentary contact with a mind that could conceive of things behind and outside the objects in front of his senses was like – was perhaps like coming upon a passage in English, when reading a book in some only half-known tongue.

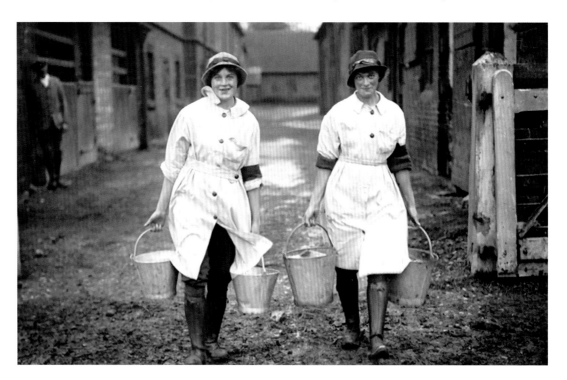

WLA workers milking on a large farm. By the war's end 250 000 women had served on the land along with 84 000 disabled servicemen and 30 000 prisoners of war.

XIII. ROOTS AND AN AUTUMN MORNING
November

ON Maester's return the most urgent matter to tackle was the root-harvest; mangolds, turnips, swedes – and the potatoes to finish as well.

Mangolds claimed our attention first, for they above all things hate the frost, and a very little will turn them black when stored for the winter.

Working down the field side by side, taking three lines each, we pulled them and twisted off the rich green leaves, leaving, as we went a tidy line of roots alternating with lines of leaves, and transforming the field from a flat expanse of green to a striped carpet of brown and green and red. The rich juice in the leaves cuts and stains the cracks in one's hands till they look as creased and wrinkled as an old man's – so much so that at that time of the year, when men congregate in the market, those that have been at mangold-pulling are known at once, they say, by their hands.

As the mangolds lie, streaking the field with bright-coloured rows, come Prince and Bob with their carts, and we load up the roots, stooping and tossing, stooping and tossing, watching them spin in the air with ridiculous glee as they tumble into the cart. With Captain to help across the rough ground, they are taken over to the root-house or the cave, tipped as far back on to the heap as possible, and thrown up again by hand.

Harvesting mangolds at Foxworthy on Dartmoor in the years prior to the First World War.

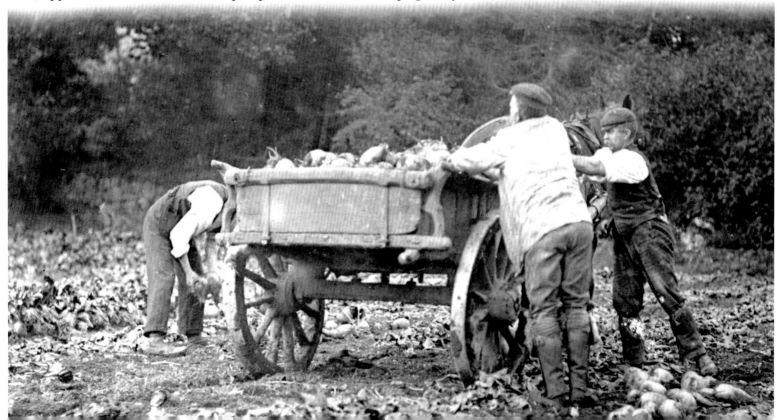

"Now yu puts your wheel just *yur*!" says Tom the condescending, making a mark for me on the ground, "an' then yu'll be just right." So according to his instructions, Bobby is backed correctly, the tilt-pin released, and over goes the load.

To remember to replace the tilt-pin is advisable, for if forgotten the cart travels sedately so long as one is sitting up in front, but if for any reason one walks over to the back or begins loading up the roots again, as soon as sufficient weight accumulates, over it goes, strewing the mangolds once more upon the ground. Tom's joy was immense when he saw this happen to my load' I think his only regret was that I had not been up in the cart myself!

We filled up the root-house in the yard and another shed outside, and the rest made a goodly "cave" under the lee of a sheltering hedge. These, in due time, were covered with rotting hedge-trimmings and dry "stroil" grass, which had been harrowed out of the stubble and which Bob and I brought down in the cart. Finally, after leaving them a week or two to "sweat" and dry, they are banked down with earth as well.

And so to the turnips. Usually these are eaten by the sheep straight off the field, or pulled and given fresh to the cattle. But this year, since frosts were beginning early, we were pulling and pitting half the field. The more we could prolong the life of the turnip into the winter the longer would our mangolds hold out in the spring, and to begin to draw on his mangold reserve, at any rate before Christmas, seems to be an act of sacrilege on the part of the farmer. Tom even informed me that if Bobby ate one before Christmas (as he was longing to do all the time we carted them) he would assuredly die that night!

So for a time now our daily labour took us to the upper turnip-fields. We pulled a patch of convenient size, threw them all to the centre, piled them up tidily and then covered them with earth, marking the field with a diaper pattern of little black mounds.

Our only trouble over that job was the unwieldy Devonshire spade we were given to use – a heavy three-cornered thing with a long slippery handle and no loop at the end, as have all Christian spades we had met before. These outlandish implements treble the difficulty of digging; the only way, as I once was shown, being to rest the handle over the knee and push with the lower part of the femur, a process that naturally produces black-and-blue bruises all over one's leg.

But it was a wise thought on Maester's part, pitting those turnips. For the frost that began so early stayed late that year, and reached an intensity before it left us that has not often been known in this country. The roots that were left out were mostly spoiled before the sheep had reached them.

While Jimmy continued the work, I was generally up and down with Bobby, pulling and carting them for the cows. There is a superstition that cows fed on turnips produce strong, unpleasant-tasting butter. But we never noticed it there. Possibly because in Devonshire butter is always made from fresh cream, thickened only by scalding, instead of being left to turn sour as is done in other counties. The Devonshire housewives to whom I described the process of making butter from sour cream gasped with horror at such an idea, and would not believe that it could possibly be eatable! Certainly Devonshire butter has a peculiarly fresh, delicious flavour of its own.

Of the swedes, also, we were pulling and storing half the crop. And wisely again, for those that were left in the upper fields' those fields where we had spent the long laborious days hoeing, back in the summer – were decimated by rabbits long before the sheep were ready to eat them. So much labour wasted all through the year – for one cause or another!

I suppose that in a moorland farm rabbits are inevitably one of the great enemies. Pheasants, perhaps, are almost as bad, for the way they had attacked the mangolds was pitiful. They were not so numerous as the rabbits, but on a really preserved estate I believe they are a real trouble to be reckoned with. More especially as, until recently, the farmer had no redress. He could not-trap and eat them as he can the rabbits, and even to complain brings him into bad odour with his landlord and may lead to the possibility of being turned out of his farm. Game-preserving does seem to be something of a one-sided pleasure, and is, I suppose, one of the many privileges to receive its death- blow during the war.

Such comic-looking vegetables are swedes! Jimmy used to be always intensely intrigued by them as she pulled them and hacked off roots and green. She loved the smartness of their puce-coloured jackets and their queer naked tummies, their spindly bare legs and shock of green hair! And as we loaded them, sending them spinning up against the sky into the cart they seemed to go chuckling and rolling with laughter, out-doing even the debonaire mangold in topsy-turvy merriment.

The potatoes were still being dug by degrees, and at the top of the field where the ground was more level we ploughed them up – a process that gets through the work more quickly, but is much more monotonous for the pickers. We used to find always, that work which gave one alternating positions – as in digging potatoes, digging and picking alternately; or in loading mangolds, stooping and tossing – was worlds easier than anything which bound one to a single posture the whole day long, especially if it meant eight hours or so continuous stooping, as in hoeing, mangold-pulling, or picking up potatoes after the plough.

One of the particularly wearying jobs that seemed always to fall to Jimmy's share was gleaning over the potato-field after the main part of the crop had been collected – a most depressing piece of work, with no system or satisfaction in it at all, very dirty and very tiring, for the ground was heavy and the basket must be carried with her the whole time. Moreover, as it was only rough stuff for the pigs that she was collecting, we could never

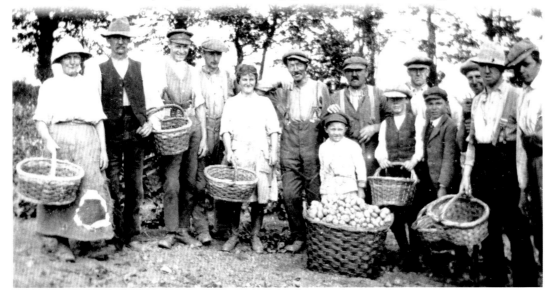

Potato picking on a Westcountry farm during the First World War. The woman standing in the centre is a Land Girl.

119

see why they should not have been turned in to pick for themselves. Perhaps, though, they would have been routing up the caves – that may have been the danger; but if ringed they do not burrow far.

Ringing pigs! That was a job I had feared and dreaded during the whole of my farming career. I had heard it done so often, and the truly agonising squeals and yells of the victims are so harrowing to the nerves, that my one dread was lest I should ever have to assist myself at the direful operation. And at last the day came, and there was no escape.

"Yu come an' 'elp me yur a minute, Sammy. I've got to ring they there little pigs this marnin'." Such was the summons that struck a chill to my heart. For to bring myself deliberately to hurt an animal and cause it all that terrifying agony (if sounds mean anything at all) was infinitely harder to me than to hurt a human being who can understand what one is doing.

Still, if the job had to be done, it was no worse for the little pigs if I did it rather than anyone else, so I steeled myself and made no murmur. After all, to shirk things and look the other way, is of no help to the beasts; it is much better to know exactly how much they do suffer, if they have to suffer.

After all this philosophising to prepare myself for the ordeal, I entered the pigs'-house with Maester and Tom, feeling very much as if I were going to have a tooth out myself.

What was my surprise, therefore, to find that the agonising squeals were, more than anything, pure hysteria at the idea of being caught! Once the little beastie was captured and its ear released, it sat up comfortably on Tom's knees and ceased to whimper, hardly flinching even when the ring was clipped into its leathery little upturned nose! My relief was great, and I stood by holding the rings with comfortably restored equanimity.

But worse even than pig-ringing was the uproar when the large white sow had to be loaded into a cart. That job was Jimmy's especial bug-bear, for she had the brunt of it, while I stood at Prince's head the while. One could not help feeling that it might have been done with a little more consideration for the sow, instead of by pulling her along by a slip-knot round her upper jaw. But the performance all through was about as clumsy as it could be. The cart was backed into the dung-pit, then tipped so that the tailboard touched the ground; and as soon as the animal had somehow been pushed, or inveigled into crossing the threshold (of the cart) I was to move Prince on, and with a heave behind, the cart automatically righted itself. But from beginning to end of the ordeal, the ear-piercing shrieks and yells that followed one upon the other in rising crescendo till you felt the very roof would burst were enough to send the whole farm crazy – pigs, horses, humans and all! The inert dead-weight of a pig is so hopeless – no way in which one can cajole them, or reason with them, or get at them anyhow. Nothing for it apparently but brute force, of which they possess far the larger share. I never could move the horse on at the right moment because I could never hear the signal. The yells and gesticulations that went on all the time covered everything. Sometimes I would move too soon and out the pig would roll again, or sometimes too late and she had edged herself back before the cart tipped up. It was altogether the one job I believe that Jimmy really did hate.

Personally I had a certain amount of affection for that old white sow. She was absurdly stupid and good-natured, and though at the time she could yell the roof off, she was entirely unresentful, however much one pulled her about, and her squeals subsided as quickly as they arose. My affection for her first awoke at the time her litter was expected, when I was installed as masseuse and nurse-extraordinary. Her previous litter had died for

Land Girls feeding pigs c.1917.

want of nourishment, and Maester had a theory that there was a hardness about the breasts that might be removed by massage. Every day, therefore, before the advent of the babies, he and I, with a sticky pot of patent vaseline between us, massaged with scientific care each of her fourteen breasts.

I must say that, when it was first suggested, the thought of touching with my hands that revoltingly large, scaly, pink body fairly made my hair curl. But it is wonderful what one can bring oneself to do when the need arises! I daresay that, in hospitals, nurses are often quite as much revolted by the bodies they have to handle – yes, indeed, thinking it over, I can imagine worse experiences than being mid-wife to a good-natured old sow in a farmyard!

Our trouble was well rewarded too, for, if I remember right, she reared ten little pigs that time out of her litter of eleven, and they grew up to make excellent bacon for the hungry population – "that ever I shu'd say so," as Maester says when he lets slip a word he shouldn't.

For it takes a good deal to reconcile one to the rearing of animals for food. There is something so much more cold-blooded and revolting about the idea of artificially breeding and penning and fattening animals, than of hunting the wild ones in their own domain. In the wilds they have their chance. And it is open to each species, as a whole, to develop its own sagacity or strength or fleetness, or whatever characteristic is most successful in outwitting its enemies. Also the very danger that it lives in continually tends to keep each species at the highest pitch of efficiency and fitness.

The unfortunate "domestic" beast, sheltered and fed and cared for, has sacrificed all claim to respect as an animal – it has lost its own strict code of morals, its intelligence, its vitality, and its healthy immunity from disease. Housed for generations in filthy pens, domestic animals have even lost their natural instinct for cleanliness – though even now a pig will choose the cleanest side of its stye to lie on, and prefers a cool swamp to roll in rather than the "muck" that as a rule is all that is available. Our dependant animals need intelligence no longer; all that is left to them to develop is flesh and fat for human food. In the same way that we bring destruction and desolation every- where else in nature – quarrying into mountains, destroying forests and building our hideous cities over the plains – for our own greed we degrade whole species of naturally fine and independent, self-supporting creatures; and not content with doing so, we turn round now on the beasts we have exploited and say, "Look at this – this inert lump of stupidity! This is an example of the brute creation, created by a beneficent Providence for the use of man! Is not man a superb and intelligent creature by comparison?" – quite forgetting the beauty and intelligence of the wild-creatures who, living their own lives uncontaminated by human influence, are receding from us ever further into the remote places.

When, partly because of my interest in animals, I went to work on a farm, I was under the impression that one could in some way make it up to them by keeping them comfortable and clean and well-fed; that one could keep cows for their milk, living in comfort and ease like luxurious ladies (the ideal of the old anti-suffragists); sheep for their wool, and pigs – not at all. But I was immediately posed by the question as to what I should do with the males, or with a cow when she was past milking! Well, I suppose it certainly is too much to expect a farmer to keep a generation of aging cows eating his grass for nothing, so it is granted – they have to be killed. And if killed, why not eaten – by those who like eating corpses? And if eaten, why not fattened?

A farmer's wife from Widecombe-in-the-Moor feeding a piglet.

If I had a farm myself I should sincerely wish that the last, at any rate, were not necessary. For when I watched and helped to feed a row of nine fat bullocks, chained up in the dark, solidly gorging themselves all day long, eating and sleeping, getting on to their feet only to eat again – mangolds, corn, cake, and hay; cake, corn, and mangolds, as much as they could stuff – never moving from their stalls, never emerging from the foetid, stinking darkness they lived in for three or four whole months, till they came out on market-day, blinded by the glare, terrified and huge and flabby, hardly knowing which way to turn, driven down with shouts and curses to the noisy din of the market' it seemed to me a process so beastly that no beast but a human could ever have conceived it and carried it through.

The sheep, when being fattened, had a slightly more wholesome time, for at any rate they were out of doors and could move about between their hurdles. But it was sad to see our precious lambs – those gay, skippity, long-legged lambs that once romped over the fields in such glee – growing unwieldy and fat and heavy, and to realise that now, in obedience to human needs, no future lay before them but the market, the butcher, and the slaughter-house.

Wednesday by Wednesday now they were ready, and it fell to my lot to escort them each week to the station. Seeing that it had to be faced, I put my feelings in my pocket, switched off my compassion, and let myself enjoy the only redeeming feature of the occasion – which was the weekly ride on Topsy in the early starlit dawn.

By this time the storms and gales of the equinox had subsided, and Autumn was flaring over the country, burning up the summer green in flames. At the end of the month the first hard frost was upon us. Like fiery rain, the leaves loosed their hold upon the boughs and fluttered down, making a carpet on roads and fields as rich as the colours of our wooded valley. Still, sunny, golden days with dewy, mist-laden twilight were followed by nights of frost, sharp and clear. The roads rang under our feet and the stiff grass, each blade outlined with crystals, crunched crisply as we brushed through it in the morning.

"I'll be lettin' you go down with they fat sheep, tomorrow, Sammy," said Maester on the even of market-day. "So yu'd best be round in guid time in the marnin'." That meant turning out of bed at four forty-five in order to be down at the station for the early market-train – and a heroic effort it was, pulling oneself out of the depths of slumber at that hour.

The bliss of waking and dressing by daylight had lasted but a very few months, for in September – long before the clock was put right – it was dark at the so-called hour of five-thirty. In the first week of October there came, indeed, with the change of time, a short but welcome respite from winter darkness. But very short; before the end of the month we looked out of our windows, at getting-up time, into as inky a blackness as one would wish to see; and by November it was still night when, dressed and booted, we plunged from the cottage into the outer world. Night – but not always darkness, for the glory of stars and moonlight in the winter mornings was something I had had no conception of before those days of enforced early rising. Stars in the summer time we never saw at all, the unending daylight becoming almost as tiresome as the darkness; and in winter, a shivery glimpse of them at night, as we run across the road to fill our bucket from the well – leaving inside a glowing hearth and a comfortable well-lit room – is enjoyed more from the knowledge of their beauty than with real keen appreciation of it. "Such a glorious night!" one says with a shiver; and very thankfully shuts it out, to settle down by the fire with a book, feet toasting luxuriously on the hob or aspiring to the mantelpiece.

Olive's dilemma: "When I went to work on a farm, I was under the impression that one could in some way make it up to animals by keeping them comfortable and clean and well-fed; that one could keep cows for their milk, living in comfort and ease like luxurious ladies (the ideal of the old anti-suffragists); sheep for their wool, and pigs – not at all." The photograph shows the end of a pig's days at a farm in Sandford Courtenay.

The time really to appreciate the beauty of the night is in the morning, when one has breakfasted, is warmed and clothed, and ready to set forth all fresh and adventurous, with no lurking thoughts of warmth and a fire at home, but with the knowledge of the dawn to come and sunlight breaking beyond.

Moonlight in the evening lasts such a little while; just for a night or two she shines at a reasonable hour, and then seems to rise so late that we had gone to our rest long before she sailed up over the eastern hill. But in the mornings, day after day, for a week or more at a time it seemed, we stepped out of our door into a great white flood of moonlight.

Those still, brilliant mornings! The trees – heavy, black and motionless, barring the white road with their shadows and blotting out the sky with their tangled tresses, and the thin, clear sound of ever-running water ringing out in the silence! Just as the summer mornings were almost intoxicating in their fresh brilliancy of colouring – the pink and gold and purple of the early hours breaking up the world of green – so were these stern cold mornings of winter inspiriting in their turn, the past summer gaiety of colour and tone wiped out in a relentless black and white, and all but the barely perceptible subtlety of blue and brown drowned in unbroken pools of light and shade.

I left Jimmy still half dressed as I turned out into the quiet starlight on market-morning and made my way up to the farm. From the glimmer of a lantern in the stable I saw that Maester was already about, and I stumbled warily across the dark yard to find him. He had fed Topsy, and she munched her corn eagerly, while together we put on saddle and bridle. Carrying the lantern then we made our way down to the field for the sheep, Topsy following at my shoulder, and Shag running ahead – all alert at the prospect of work to come.

The chill of the frost held everything in its grip, yet for the stillness of the air one was barely conscious of its keenness. In the night and early hours the frost seems never so cutting as just at sunrise, when the first breeze stirs the air and daylight shows its presence.

The sheep were browsing away up the field, hardly distinguishable till Shag brought them down and herded them together in the corner by the gate. Then those we had chosen and marked the day before were separated from the rest and bundled one by one out into the road.

"There are ten of 'em, Sammy, doan' 'ee forget; and see you get 'em all safe into the truck. Yu'll have all the farmers lookin' at ye, mind, so I want you to be proper manly-like!"

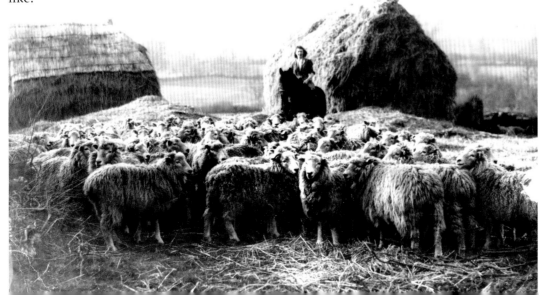

Stephen Woods' evocative photograph of sheep being rounded up on horseback at Great Dunstone Farm, Widecombe-in-the-Moor.

123

With parting words of advice, he held my stirrup and I swung myself up into the saddle, gathered up the reins, called to Shag, and followed the queer grey forms that vanished before me into the darkness.

How solemn and eerie were those cold night journeys! Lest the sheep be hurried, at foot's pace we passed along through the sleeping country, all the landscape shrouded with darkness, hedges and fields and trees and houses indistinguishable each from each, and a silence, broken only by the long weird call of an owl and Topsy's footsteps ringing clear on the frosty road.

Like sharp points of light piercing the blue-black dome, the stars flashed down – Orion with the blazing dogstar setting in the west, Leo and the Crab, those familiar winter signs making angular patterns full before me, the Great Bear balanced upright on his tail and the beautiful Capella in solitary grandeur shining overhead. I had time enough to watch them all and make them out one after another, for Topsy, with the reins hanging loose, pursued her own way quietly, and Shag looked after the sheep, rounding up any that lagged behind and keeping them well in hand.

Slowly, as we travelled on, the deep sky lightened and the stars grew paler, until as I came to the top of the last steep hill above the village and could see the low ring of the horizon beyond, a pale green rim of light was creeping round the earth, putting out the stars and breaking up the flat dark world into hills and trees, roads, hedges, and dwellings, each quietly detaching itself from the great shadow that had overlain them all.

Below me, the grey stone houses nestled in among the trees of the valley, with pillars of smoke rising from every breakfast fire, and here and there a lighted window. On the roads one or two labourers were on their way to work, curious-shaped forms, bent as if always stooping under the burden of their toil; and beyond the village the little terminus could be seen, where already trains were shunting and puffing smoke.

"...and beyond the village the little terminus could be seen, where already trains were shunting and puffing smoke." Lustleigh railway station shortly before the First World War, one of many such halts on the edge of the moor where farmers could take produce for onward transport to market.

As I neared the station the dawn had passed and the earth was alight and coloured, though behind the eastern hills the sun still lay captive, throwing into lace-like tracery the line of trees that fringed their summits.

By the time I was riding back, enjoying the ease of Topsy's long swinging trot, he had burst his bonds and was flooding the world with golden light' a cold world, gleaming white with the frost that I had hardly known was there as I came along in the darkness, but which now, with the breeze of sunrise, made its presence felt as well as seen. A cold, gleaming, silvery world' blue where the shadows caught reflections from the sky, and gold where the sunlight laid its kiss upon it, warming and melting the silver.

Down the village street I had passed with my little flock, the inhabitants standing at their doors to watch, or assisting Shag in rounding the corner at the market square. Most of them knew me by this time, and friendly smiles and greetings flashed along the route. Safely I reached the station and counted over the sheep, amidst the groups of excited farmers who were pursuing their own detachments with howls and shrieks and whistles. If that were to be "proper manly-like" I did not see the force of emulating them, for with just a word to Shag and a shove to the foremost, my sheep had entered the truck quite unflustered and without any yells or excitement at all.

The difference in manners between farmers and the farm labourers is curious. Among the labourers and working men, wherever we went, we were never made to feel uncomfortable, nor did we meet with anything but courtesy and good-manners. The simple, kindly, instinctive courtesy of the countryman equals anything that one finds amongst well-bred people; but with the "superior" farmers, when we saw them sniggering amongst themselves or looking self-conscious and glancing shyly over their shoulders we would become acutely conscious of our breeches and lack of feminine drapery! Where a labourer or a gentleman will be at his ease and instinctively put one at ease oneself, those of the half-way class seem at once to make one uncomfortable. It is curious.

I must say, however, that our old Maester never worried us in that way, he was so exceedingly frank! Nothing that we wore, from a change of suit to a new pocket-handkerchief, ever escaped his notice. If we came up in the morning wearing anything new, were it only a different hair-ribbon, milking-time would not have gone by before he remarked upon it. The cut of our breeks and the colour of our tunics, the handkerchiefs that we wore on our heads, hats, gloves, all came under his notice, and was discussed and approved openly before us by him and the Missus.

He was waiting outside the yard-gate as Topsy and I clattered back up the home lane, standing stick in hand looking down the road, with a wealth of sunshine all about him and golden elm-trees overhead.

"Did 'ee get on all right, Sammy?" he called out.

"Quite all right, thank you, Maester!" I replied, pulling up beside him. "What shall I go on with now?"

"Well, Sammy, now you'm out with the mare you can just ride up over the 'ill an' bring back they bullocks for a bit of 'aie. An' then when you've 'ad yur lunch yu'd better take the cart down and load up they swedes what Jimmy be pullin' down yonder."

XIV. FROST-BOUND
December

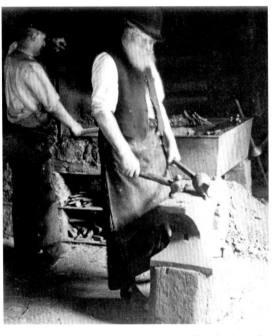

The village blacksmith at Chagford on the north-eastern side of Dartmoor. Getting the horse 'roughed', as Olive describes it, meant nailing additional (sometimes specially hardened) nails at the outside heel of each shoe, the heads protruding slightly to provide extra grip on icy roads. Other devices, such as studs and special shoes were also used - all causing considerable damage to road surfaces and fields if used indiscriminately – hence 'riding roughshod'.

THE frost continued; harder grew the roads, harder the fields, the grass shrank away almost into the ground; and then in December came the snow. Throughout that winter it lay with us almost continuously. Just as it broke away and melted on the warm southern slopes and we began to think that the land would once more be workable, down it came again.

Snow and frost and hills and turnip-carts! The four together make a most perilous combination. Every day, Bob and I and Prince and Tom braved that awful hill, narrow and steep and wellnigh becoming a toboggan run.

"It's goin' up as I minds!" said Tom. "They can come down all right – they don't 'ave to do nought but slide!" But I could not agree with him: coming down fairly put my nerves on edge, for they did indeed "just slide!"

Bob would put his four feet together and let himself go, more or less sitting down all the while. I was only thankful, personally, that it did not fall to me to support Prince. Bob was worried enough – but Prince! Really, the moment anything unusual occurred the state of fuss he got into was more like – like a pre-war army major than anything else I can think of to compare him with.

When the road became quite out of the question we avoided it by going up across the fields. That was plain-sailing at first, for one could tack across the hill to lessen the steepness, but in the middle came a gateway leading from one field to another, steep and slippery as ice. The horses were nearly on their noses as they went up, after which I insisted on throwing down some earth, and then we got on better.

We did get Bobby roughed one day when I happened to be in the village with him, so that the Missus was able to get into market. But the nails do not last very long on those roads – the blacksmith was too far away to have it done repeatedly, and apparently Bob had not the right sort of shoes for us to do it ourselves – so mostly we had just to slide and bear it. Work on the land was out of the question.

A little ploughing had been done, but all had to stand by now while the frost continued, and except sometimes for carting and spreading manure the whole of our energies centred in filling the innumerable hungry mouths that crowded around.

The sheep were insatiable. They chawed up all the turnip-greens the minute they were put on to a new patch, and the rest they gnawed until the ground grew so hard that the roots became immovable. In addition to carting turnips down the hill we had now, therefore, to cart hay up to appease their hunger. And if in the morning I was late getting out to them, they would break out of bounds and the whole hungry horde pour down the hill, baa-ing and bleating round the farm to find me. Such a rush, as Bob and I appeared with the cart! And standing up like a warrior in a chariot, I traversed the field with my army surging, pushing and rocking around me!

LAND GIRL SUFFRAGETTE

The country lay bound in a grip of iron; silent, lifeless, and unmoving. Birds fell frozen from their perches at night, and those that survived gathered daily about our door for crumbs. From all parts came news of skating, tobogganing, and other joys – but such were not for us! Turnips, sheep, hay, cows, calves, and turnips – such was the round that filled our days.

Soon the ground grew so hard that to move the hurdles was impossible. The growing roots were spoilt on many a farm around, and we had recourse to our precious "pits." But for these I know not what we should have done, for the whole field would have been lost. For all the animals now, cows, calves, bullocks, and sheep, turnips must be carted from these pits; and over the rutty ground, frozen into wheel tracks and lumps and ridges, we bumped along with the carts, Tom and I. Captain came with us to help, for it was stiff work for one horse pulling up a load from the bottom of the bumpy field to the gateway at the top, and even with him we had to take a zig-zag course. The change from one tack to the other was a moment that especially annoyed Bob, and I could never persuade him that the more he backed downhill the longer his uphill course would be! Strange, but Bob, I fear, was not blessed with overmuch, brain power. It was rather like trying to persuade Maester that water need not necessarily run uphill. The reason he once gave me for not guttering his fields properly being that there was not enough water in a certain spring to "force it up the hill!" The point of his argument was even more bewildering when one remembered that the spring was at the top of the field to begin with.

To break into those turnip-pits alone was a task meet for Hercules, for the little mounds were covered with a cast-iron sheath. By wielding a pick-axe like a road-maker we broke up the crust, picked it off in solid rocks, and revealed the snug little nest of roots inside. Gradually the frost pierced even through the crust, and every turnip lay swathed in a snowy white covering formed by its own frozen moisture.

Handling the pick was warming work. But what was it handling those frozen turnips! Gloves were of little use, for they soon became wet through, and there was no remedy really but to harden one's hands or put up with the agony. We were out early one morning, Maester and I, pulling a load, before the ground had grown too hard to wrench the turnips

Dartmoor hill sheep deep in snow.

Dartmoor in the grip of winter.

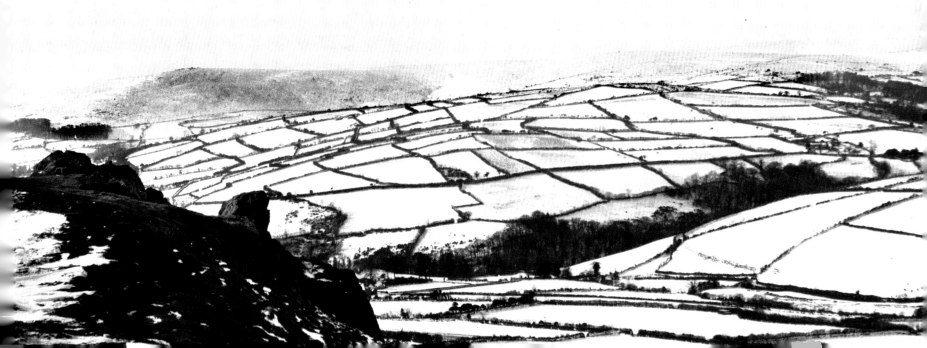

up by the leaves. It was just daylight, on a bleak, grey, windy morning, and we had come up early because the store at the farm had run out, and the cows had gone short for breakfast. At the top of the hill the north wind fairly whistled up across the turnip-field – coming, one would think, straight from the Pole in one long sweeping bluster. Our fingers, wet with closing round the frosted leaves, stung in the wind as if the living skin was being torn away, the acute pain dying only for a moment into a blessed numbness when one hand at a time could be buried in a coat pocket.

We did not wait for a big load, for even Maester looked perished and blue – as pitiable an object as I felt myself, with shoulders hunched up over his ears, one hand pulling the roots and the other thrust deep into his overcoat.

Nor was the agony much less intense coming up to the farm in the early hours. Warm and well-fed to begin with, we turned out into the night, enjoying for the first ten minutes the keenness of the air while we could walk briskly through it. But pottering about in the yard was another matter. Slowly the chill crept over one, reaching its intensity at the tips of our fingers, and the toes in our boots. No amount of periodic dancing of hornpipes or other violent exercise seemed to thaw them. Nor had we time, for the rush to get through was always incessant. To kneel for a minute on a milking-stool, or on the lower steps of the loft-ladder, letting the blood run slowly into the toes, was the only performance that really gave any relief. But it was not often that we could let ourselves stop long enough to thaw them thoroughly.

As soon as daylight came the cold was bearable – often indeed enjoyable. But it was those morning hours, before any sane being was awake, when we stumbled about in the pitchy darkness, doing everything by the dim light of a hurricane lamp, with aching toes and fingers, in a blackness that seemed to last for hours and hours – that time was a daily period of acute misery.

Maester wisely kept his bed those mornings, and it was generally about seven-thirty before the boy appeared. So for the first hour, from six-thirty onwards, James and I had the whole uncouth world to ourselves. When dawn broke at last, and the sun rose up and showed us the white and shining land, sparkling and iridescent in the brilliancy of the morning – then indeed things were changed! By nine o'clock, when we sat down to lunch – often outside in the sunshine under the lee of the wood-pile – we were warm and happy once more, and so long as daylight lasted and we could keep going, no amount of cold could worry us.

At night again, all the work was done by lantern-light. We stayed outside as long as it was possible to see, then lit our lamps for milking and put the large family to bed with food enough to keep them quiet till the morning.

Then came the cosiest hour of all the day. At six, when the work was done, we were free to go home. With hands in pockets we trudged along our dark little woodside lane, winding round the hill, till at the last corner the rush of water greeted our ears and we could see the light from the kitchen-window pouring out a welcoming beam into the darkness.

Then the relief – unpacking coats and sweaters, kicking off boots and leggings, washing our hands in steaming water from the kitchen fire, and all the while wife-Elsie trotting round, making hot toast, frying sardines or sausages, the savoury smell whereof brought to our nostrils a rapture born of hunger and fatigue and intense thankfulness to be at home.

How sweet and cosy that little kitchen looked at night! The square, polished oak table with its burden of multi-coloured leadless glaze plates and cups and dishes all reflecting their white undersides in its shining depths; the bowls of jam, and the big brown loaf, yellow butter in its china dish, and, to crown all, sometimes – what but a brimming bowl of Devonshire cream!

Round the fire waited the three chairs – like Big Bear, Middle Bear, and Little Bear. Elsie's small and humble seat we named Uriah, his aspect being so very unpretentious. My large grandfather was therefore Micawber – big and pompous. Jimmy's never achieved a name, but was an unobtrusive decker who folded himself away and retired when not in use. The fire was an open kitchen range, with oven to one side, piled up with logs which crackled and roared in the frost. Over them hung the cauldron of water for our hot bottles and our very necessary nightly wash.

Not much was done in the evening! Wife-Elsie busied herself with household cares, setting our breakfast for the morning and packing up the luncheon-basket and clearing away the tea. Sometimes (with many a groan) a letter had to be written, but more often we were fit to do nothing but sit round the fire like inert logs, reading – or pretending to read – or sitting, content to do nothing, like the workhouse ancient whose varied life was explained in his own words: "Well, sometimes us sits an' thinks; and then again, for a change, us just sits." That describes our evenings precisely. But we were very happy. And in the winter, thanks to the darkness we could go up to bed at half-past eight, fall asleep five minutes afterwards, and get in a real long night before the five-thirty signal.

Christmas Day was much like any other Sunday. Milking had to be done, and all the ravening beasts must be fed. We had long given up our alternate free Sundays, reserving, however, Sunday afternoons, on which in turn one of us was allowed the treat of staying indoors by the fire instead of turning out again into the wet or cold. There was no holly, even, to mark the passing of Christmas, for though there had been masses of berries back in the autumn, by December the starving birds had eaten them every one.

In January for a week or two there was a lull in the onslaught of the frost – a week or two of mild, open weather when ploughing could be got on with – and some hope returned to poor Maester's worried mind. But by the end of the month it redoubled its severity. Day by day saw the ground harden tighter and all vegetation shrivel up, as the hard, steely wind blew over us from the east. Snow fell intermittently, but it was almost too cold to snow. Twenty degrees of frost were registered on many nights, and the food outside was nil. The roots in our turnip-pits, those that were not already rotten with the frost, had long been finished; and the swedes and mangolds in the root-house were crusted with frost even under their covering of hay. The animals ate voraciously, and Maester saw his hay-ricks disappearing one by one.

Nothing could be done but to send the sheep away, or at the rate that the stuff was being consumed we should finish our winter's food-supply long before the grass began to grow in the spring. He arranged with some farmer down in the warmer southern valleys to take them and keep them on swedes until lambing-time drew near; and as soon as the opportunity came, Shag and I and Topsy were to take them on their journey.

But many and dire were the troubles to come upon us before that day arrived.

One by one, every tap or watering-place on the farm froze solid. First the tap and trough in the yard, then the one in the stable. The kitchen pipes and the bathroom went next, and for a time just one tap – that in the dairy – was spared to us. To this we brought the

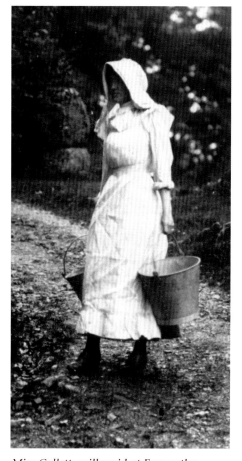

Miss Collett, milkmaid at Foxworthy.

129

Winter lambs in snow on a Dartmoor farm.

horses every day, and from it we carried buckets to the calves. By keeping it always running we hoped to save it. But at last that one went too...

The Missus was in despair. The only source of drinking water now was from our little well at the cottage. And now we had reason to be glad that we were not encumbered with any such "modern conveniences" as pipes and cisterns. Our water was always fresh and pure, always running, brimming over the lip of the well under its little wooden door. The first suggestion from the Missus was that every time we came up to the farm we should carry a bucket with us; but thereat even Jimmy struck. Not if she knew it! It was quite enough, said she, to carry for the animals, and the household might fetch its own. Eventually each day Maester came along with a tub in the cart, and we filled it with jugs and cans from our little spring.

This for the Missus. But for the beasts, for those who could not be turned out to find their drink for themselves, water must be carried from the river below. This meant crossing the length of the yard, out by the kitchen court, along the road, into a field, and down a precipitous little rocky path to the river.

Then the journey was reversed. With as much as we could carry in either hand we climbed the hill, panting with the weight, reaching the yard at last with racing pulse and breaking arms. In this way, with two or three journeys, the strain of morning and evening work was doubled and our tasks seemed wellnigh endless.

To get off with those sheep was the only thing to be done. But every time we planned the journey, something seemed to prevent it.

First of all Tom got ill. The boy turned up one morning looking white and shaky, but came out with me to cut some hay from a rick. I was up in the cart loading, while he started using the knife. But cutting hay is pretty severe work for anyone with influenza coming over them, and soon we had to change places.

The influenza epidemic to which Jimmy and her colleagues at By-the-Way Farm succumb reached Britain in January 1918. This Spanish Flu spread rapidly throughout the world and by its end had killed over 50 million people, many more than who died as a result of the war. The resultant impact on labour shortages at home combined with the gradual reduction in fighting on the Western Front in 1918 allowed the military to release men to take up necessary employment at home. Over 80 000 disabled servicemen, those whose wounds allowed it, found work on farms, often working alongside German prisoners of war – themselves numbering over 30 000. It's curious that Olive makes no mention of these, or of the thousand Conscientious Objectors held at Dartmoor prison who also worked the land. Here German POWs help with the 1918 harvest.

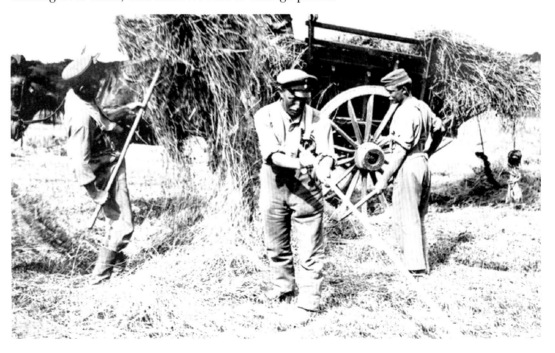

"I dunno as I ever felt like this 'ere," he said, looking dizzy and rolling unsteadily up on the load." What d'ye think the boss 'ud say if I was to go 'ome? 'E couldn't say nort, could 'e?"

We got that load in and home he went. Influenza had him in its grip, and that was an end for a while of him. To us it meant there were his horses to feed and clean and work as well as my own, and no one to help with the carting.

Then Jimmy went down with it, and in addition to the horses and the sheep Maester and I had all her cows and calves to see to, and the milking into the bargain.

Then I grew desperate. If only those insatiable sheep, who clamoured for food every day at the top of the hill, could be got away, the work would be almost halved. But it was a two-days journey, and how could I spare the time? There was time for nothing but to fly from one task to another. It was necessary to do something drastic to get extra labour, and Maester at last, flinging all scruples of wages to the winds, applied to the local military headquarters for soldiers to help. Meanwhile we carried on as best we could.

Fortunately, Jimmy's people lived within range, and as soon as they heard of her collapse they rolled down upon us in a motor-car and carried her bodily away – bed, pillows, flu and all.

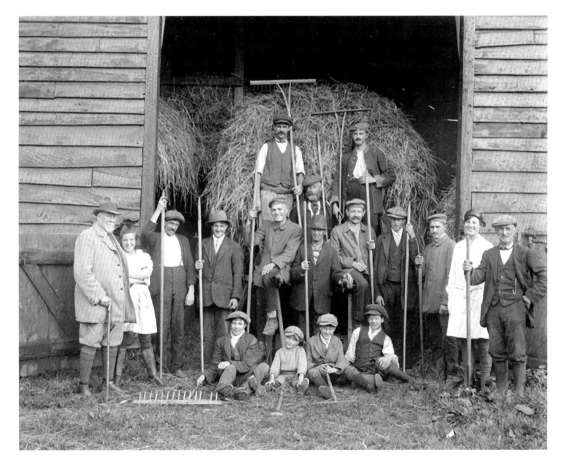

German prisoners of war, invalid servicemen and Land Girls pose alongside farmworkers and their children c.1918.

XV. DEFECTION
January

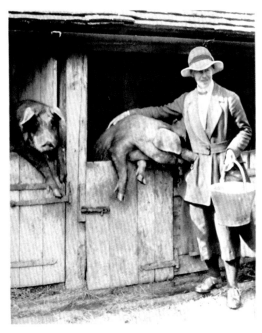

WLA land girl feeding pigs, 1916.

POOR little Jimmy! That was her exit. Influenza led on to appendicitis, and that was the end of her days on the land. Farm-life without her was indeed a stony wilderness. No one to share the labours and no one to share the jokes! Trudging up in the darkness the morning after she left I could have sat down by the roadside and wept for sheer lonesomeness. My spirits were about as low as the thermometer, and on the same level was my rate of energy and inclination for work. The blackness of that morning only equalled the blackness of the outlook, for it was as solidly dark as walking into a black cave. Only by feeling with my feet could I find the road at all, and to hold out my hand was to touch darkness. Neither tree nor hill showed up against the sky, for the sky was down upon us, and through it all, quietly, heavily and unceasingly, fell the snow.

Stumbling round by myself, fumbling with lanterns and tumbling over pigs, waiting in the cold and the falling snow at the dairy-door for someone in the darkened house to open it, life seemed as hopelessly dreary as it well might be.

Not a soul was about that morning, not a sign of life – no light even in the upper windows; the house and its inmates seemed wrapped in slumber while I waited, knocking, in the darkness. If ever I felt like giving in I did at that moment. I would have given all I possessed to be back in the pre-war days of ease, dressing at leisure, and coming down with daylight to a warm and comfortable dining-room, to find – instead of mud and snow and dirty cow-sheds – a dainty breakfast set out on a white damask cloth and polished silver shining in the firelight.

But I was caught in the toils, and no honourable exit seemed possible, whatever way one looked. The work had to be done, there was nothing for it but to go ahead. When daylight came at last my spirits improved; we put our shoulders to the wheel, Maester and I – and assuredly daylight came each day, however drear the morning.

And then Wife-Elsie took the flu. That truly was the last straw, and how I got through that time I never knew. She had no near relations to carry her off and nurse her in comfort, so I had to do what I could myself. We had at that time managed to secure the help of a girl, who came in for a few hours in the day, walking a mile and a half from the village; but she was rather an uncertain quantity, coming only when the weather suited her or she felt inclined. Also, we paid her at a considerably higher rate of wages than our own, and for doing much lighter work, which made the whole position ridiculous.

Luckily with Elsie it was a slight attack, or the farm would have had to go to the wall. As it was, I flew round the early work, flew back to light a fire and get her breakfast, back again to the farm, and home at one to scramble together a meal for us both. To the farm again to cart in some hay or turnips, to milk, carry water, get through the feeding – and so on, till the whirl became almost mechanical, and one kept going just with the force of one's own momentum.

But the first day that she was better and able to come down and do things in the house I determined to set off with the sheep. The day had really arrived; plans were made with one farmer for a half-way rest, and with another to meet the flock at the end of the journey. All seemed clear and possible – and then, that very morning, I broke another metacarpal!

By this time Maester really had no compassion left. He and the Missus simply refused to believe that it was possible to break a finger-bone twice in a year, and at this critical time, of all times. They were convinced that on my part it was nothing but a perverse desire to annoy!

Fortunately this time the hand was not sprained as well, and the finger not painful so long as it was bound up with the rest. It was a neat little break – I heard it snap like a twig as I was hitching Prince into the cart. In his restless way he moved on before the back chain was fastened, and my little finger, which foolishly was crooked in the chain, just doubled backwards.

We got off soon after midday, when the necessary work had been done, I following the flock with Bobby and a cartload of turnips for their supper. It was a fifteen or sixteen mile journey altogether, so we were to take it in two stages. Poor, silly, woolly beasts, bundling along the road – it was quite long enough even then, and they were sorely tired by the end of the day.

A thick covering of snow lay over the country, and the roads, though worn in places, were slippery enough for Bob in his unroughed state. Slowly we crawled along, and it was nearly dusk by the time we had travelled the first six miles and reached the farm where a market friend of Maester's was entertaining the flock for the night.

On horseback driving a flock of sheep down off the high moor.

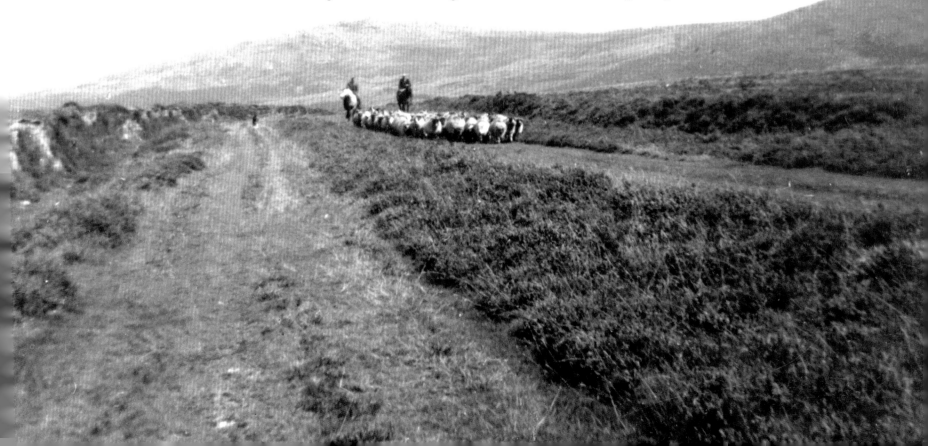

Dartmoor. Feeding the flock in winter.

I turned them into a meadow and went up to the farm to report. They sent a boy out with me to show me the quarters for the sheep, and he helped me throw out the turnips. Then I counted them over and left them, thoroughly contented with their place of rest.

Bobby and I jogged along on our homeward way – travelling slowly and cautiously, however, for it is queer how the least unsoundness in one's body, even injury to an insignificant little finger, seems to react upon one's nerves, and sliding down those hills with an unroughed horse was not really a joke at the best of times. I should have made a poor show of it in the trenches, I remember thinking, when made nervy by a damaged finger and a turnip-cart!

Darkness came over us before we got back, but the long tiring day came to an end, and at about eight o'clock I got home to my tea and my bed.

In the morning I was up betimes; without the use of one hand, it was impossible to milk or to do much about the farm, so I was able to get off early. At sunrise the day was clear and looked promising, a sharp frost and a north-east wind being as much as one could expect as guarantee for a fine day. I made Topsy ready and then went back to light the fire for my ailing wife and to pack up some food for myself.

Then we set off, Topsy, Shag, and I, riding round through the village where he lived, to hunt up Tom on the way, hoping that it might be possible to send him back to help at the farm in my absence. Poor boy, he had had a pretty bad turn, and had only been out of bed two days; but on hearing my recital of woes he promised to come round next day and help if he possibly could.

So we proceeded, Topsy settling into her easy trot whenever the roads were clear, and Shag revolving noisily under her nose, taking about twenty times more exercise than she need. The sunshine of the morning was melting the snow in places, but as we climbed higher, on northern slopes and shady lanes, the way was deep and slippery, and Topsy floundered and all but fell. She behaved very well on the whole, and once out of the stable she was as pleasant a mare as one could wish to ride – big and strong, a good sixteen hands high, a comfortable broad back and a leisurely, swinging trot. A real farmer's hack, but quite lively enough to be interesting, especially after such a long spell without any work.

The sheep seemed pleased to see me when I reached the half-way farm, and Shag rounded them up. I counted them over as they squeezed one by one through the gate into the lane, and then the second stage of their journey began.

Steadily now must we go, for they had still ten or twelve miles before them, and some were already lame from yesterday. No more trotting or excitements for Topsy; we sobered down to a foot's-pace, and dreamily, monotonously continued our course while Shag's intermittent barking wakened the echoes in the silent country.

Higher we climbed, and higher, till villages and fields were left behind and the road wound over a great long shoulder of the moor. In one flying curve it swept from the sky-line above on my right to the vague and distant valley beyond, losing its form and its gleaming whiteness in the blue-grey haze of the low country. On the left the land plunged precipitously through wooded combes to a gorge down which a mountain torrent flung itself from rock to rock. Beyond again it rose up, steeply wooded, and hill beyond hill, enfolded one behind the other, stood blue and bold, burrowing their heads into the grey snow-laden sky.

Slowly during the day the clouds fought and conquered the sunshine, the gusty northerly wind was piling them up on the hills and blowing the snow in eddying whirls

along the road. As I rode on slowly, it raced up behind us, blowing forward the wool of the sheep and penetrating my overcoat, chilling my toes and fingers. My small store of provisions soon vanished – for the task of cutting bread and lighting matches with only one working hand had been too exasperating to stay long over before I left – so I looked forward to laying in a store at the first little market town I had to pass through.

Leaving the moor and the snow and the windy places, we descend by slow degrees to the valley, where even now fitful gleams of sunshine thawed the air. Soon we came to the little town, and I gathered my flock together in the market square and sought provisions.

Feeling like a character in a sporting print, I tossed off a bumper as I sat on my horse in the open – regretting only that the transparent glass should have disclosed my feminine propensity for ginger beer instead of the real, rich, golden, masculine draught of ale. But not even for spectacular effect could I have swallowed the latter...

Then, with pockets stuffed with biscuits and chocolate, I whistled up Shag, collected the sheep, and on we went again. The way lay now along the level flats of an ancient river-bed, a straight hard road, passing now through woods and now through farming country, mile after mile, till the weary sheep lagged more and more, and Shag worked herself hoarse, barking and racing from one to the other, tidying up the straggling flock.

Poor tired sheep! Thanks to Shag's indefatigable efforts we arrived before our time at the rendezvous, and searching round, I discovered a park whose undulating slopes were cropped with rich green grass, the like of which our highlands had not seen for many a winter's month.

A snow-bound moorland above the valley of the River Tavy, Dartmoor.

After asking, and obtaining leave, I turned in my weary flock to rest and browse. They questioned not the good things sent by Providence, but settled down to work at once, and made the most of the time, their little jaws moving quickly as they spread themselves over the grass.

In that sheltered valley we seemed almost to have come down into spring, and for just that hour the sun shone clear and strong. I looked for a sheltered corner, and tying up Topsy, gave her the meal of corn and chaff that had travelled over my saddle, and then sat down myself to rest and eat my biscuits.

In those hard-working days we had but to stop for one short moment, and immediately appeared our ghostly enemy – Fatigue! By dint of going on and on and on, and never stopping till we got to bed at night, we could keep him at bay. But sit down and relax for a moment, and then we were at his mercy. Like a fiend in a nightmare he stood over one, gripping one by the limbs, drying up one's powers, paralysing the will and senses. I sat down against the low stone wall and succumbed. For a moment all seemed ended; I cared not whether the farmer missed me and the sheep stayed there for the rest of their lives, or whether I ever got back to the farm again. My aching body, overtired before the day began, seemed beaten and conquered, and for that half-hour yielded itself up to its conqueror.

The sheep nibbled busily and wandered where they would – little white humpy dots like large daisies flowering over the undulating field; Shag curled herself up, panting, at my side; and Topsy munched contentedly beyond. I shut my eyes and all but slept, undisturbed by curious glances from passers-by on the other side of the wall.

But it was not long before the clatter of a pony's hoofs aroused me, and I looked up to see a man with a sheep-dog riding down the road. This must be the partner of my tryst, so I roused myself and got upon my feet to greet him. We counted the flock once more, and with excellent manners Shag yielded up her charge to the stranger dog; and then again I climbed into the saddle and set off homewards.

Now the responsibility was over there was nothing more to do but to get home as best we could, and resolutely we set ourselves to attack the fifteen miles that lay between us and bed-time – the only longed-for event of the day. As there was no need this time to pass the half-way farm, I decided to return by the lower road, hoping to avoid the snow, and for the first eight or ten miles we could trot along at a fair pace – even though Topsy, who was out of condition, began to lag, and I myself was growing more weary and stiff and sore at every mile.

The sunshine lasted but a little while, and as the clouds rolled back the frost again took hold. The gusty wind that had travelled with me in the morning now blew full in my face, and the lowering sky grew heavier as the afternoon drew in. As we climbed a ridge out of the valley, meeting at the top the full blast from the north, the dusk shut suddenly down upon us, and the air grew thick with fine, wind-blown snow.

Wearily now, working on against the wind, we pursued our way, descending again to the valley and following the river course; slowly, for the new-fallen frozen, snow made the roads slippery as ice, and Topsy, lagging more now at every mile, must feel her way with caution.

For a while after sunset I could make out the dark line of hill against the darkening sky, but soon the night fell over us like a heavy black curtain, shutting out all but the road under our feet.

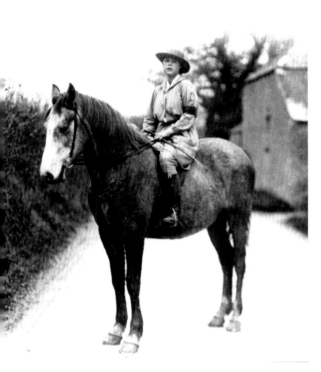

WLA member at Teigngrace, Devon, 1917.

The wind increased, sweeping full upon us at every gust, cutting across one's throat like a knife and driving the frozen snow like needle-points against my face. Even Topsy bent down her head and shirked the freezing blast. Slowly and ever more slowly we travelled, and at every mile, sitting bent over in the saddle, my back ached more till my whole body seemed to dissolve with fatigue.

At one corner as we suddenly emerged from some shelter into the full force of the blizzard, the biting needles fairly gripped and forced us back again. The wind had risen almost to a hurricane, and for the moment we simply could not face it. Topsy swung round, and overwhelmed and beaten back I slipped out of the saddle and we crept for shelter under the hedgerow, where a thick belt of hollies withstood the storm. Shag, whining and scared, crept up against me, and Topsy waited, patient and understanding, until the fury of the wind should be appeased.

But the journey must be faced, and in the momentary lull that followed that whirling blizzard I climbed up again to the saddle and on we went.

Another mile or two, and then the roads became so slippery that Topsy could hardly keep her feet. Nervous and tired, she slid this way and that, until fearing that she would slip and hurt herself, I got down again and walked by her side.

Another couple of miles went by slowly and tediously, until we found ourselves nearing the local village station – still three miles from home. How could I face those last three miles of hill and dale and slippery road and blinding blizzard? I had been nearly ten hours in the saddle, and I was about at the end of my tether. I felt that it was a physical impossibility. For a moment, tempted by lights in the village and the thoughts of cosy rooms with bright log-fires, I decided to give it up and stay for the night at the inn.

But only for a moment. It was too late to send any telegram or message, and the thought of Maester waiting at the farm looking anxiously out into the night, with fear at any rate for his mare, made me realise that somehow I must get on and finish the journey.

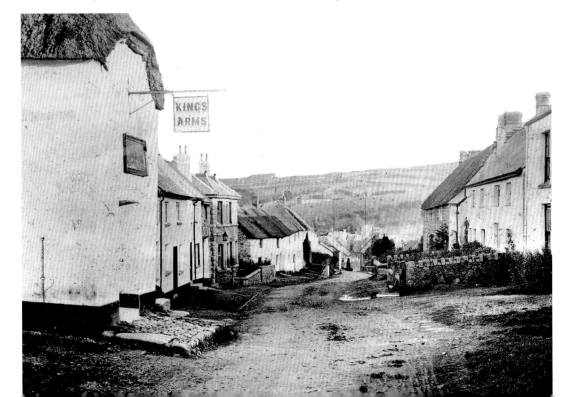

"For a moment, tempted by lights in the village and the thoughts of cosy rooms with bright log-fires, I decided to give it up and stay for the night at the inn..." The King's Arms in South Zeal, Dartmoor, around the time of the First World War.

LAND GIRL SUFFRAGETTE

A cartoon from Mr Punch's History of the Great War, *published in 1919, perpetuates the patronising tone that was generally applied to the notion of women taking the place of men on the land during the war. It was to remain the prevalent response, persisting throughout the Second World War – and well beyond.*

There had been a little more traffic about the village, so the roads were better, and though round the corner of the market square another shattering blast of needle-points nearly carried us away, yet Topsy recognised home roads and, pulling herself together, perked up her pace, and we trotted up the street between the darkened houses and on into the darker night.

On and on we travelled, winding up that interminable hill that I had seen under snow on the day of my first arrival a year ago. With my weary mind and aching limbs I looked back at my former self, and wondered, amazed, as I remembered the young and enthusiastic applicant for work who had climbed that hill with such ease. I felt at least ten years older from the year's hard work – temporarily tired and worn, perhaps, but hardened and strengthened in ways I had never thought possible before. I could lift weights and endure fatigue such as I had never attempted in my old life, strenuous though I had always supposed it to be. And if only that, by comparison, it made easy things that formerly seemed arduous (things such as scrubbing a kitchen-floor or digging a garden-bed), the year's work would have had its value. I should always be the richer, for I was stronger and infinitely more capable, though for the moment tired almost to the point of exhaustion. I dared not think of the day's work on the morrow. The same unending round would have to be gone through, but how to do it was a problem that seemed insoluble.

Nearly rolling from the saddle with sleep, I turned side to the wind and wound my way up the last little lane, stooping low between its sheltering banks.

The farm buildings loomed over me, and solid blackness filled the yard under its vaulted roof; but in one corner a lantern hung in the stable, burning low.

Thankfully we turned out of the storm and entered the shelter of the yard, and I slipped from Topsy's back once more and let her into the loose-box. Fastening the halter, I measured out her corn; and then went round to the house to report my adventures.

As I opened the kitchen-door the sudden dazzling light from inside blinded my eyes after their long hours of darkness, and, blinking and hiding them from the glare, I went on to the parlour.

"Come in, Sammy!" called the Missus cheerily as she heard my step. "Come in and sit down by the fire, and I'll get you a cup of tea."

Maester came to the door to meet me, and with inexpressible relief and thankfulness, I sank deep into his familiar big red armchair.

"I bin thinkin' o' you, Sammy!" he said sympathetically, "when this yur storm come on. You 'ave a cup o' tea first, and then tell me how you got on."

"An' I've a bit o' news for you too, Samuel!" he said, handing me tea and piling my plate with bread-and-butter and cake, which I was far too tired to eat. "We got a wire from the military soon after you left, an' they tu soldiers came up this afternoon. They be proper old varrm-'ands, so now us'll get along a bit more shipshape!"

So that is how the end came. Our responsibility was over. Wife-Elsie in any case was leaving us; Jimmy was not allowed to come back, and I, with my broken finger, which was by this time becoming painful, was temporarily helpless. All our beloved animals – horses, cows, calves, and cats, we left to the care of the borrowed soldiers – and what happened after that we have never heard to this day.

<p style="text-align:center">* * * *</p>

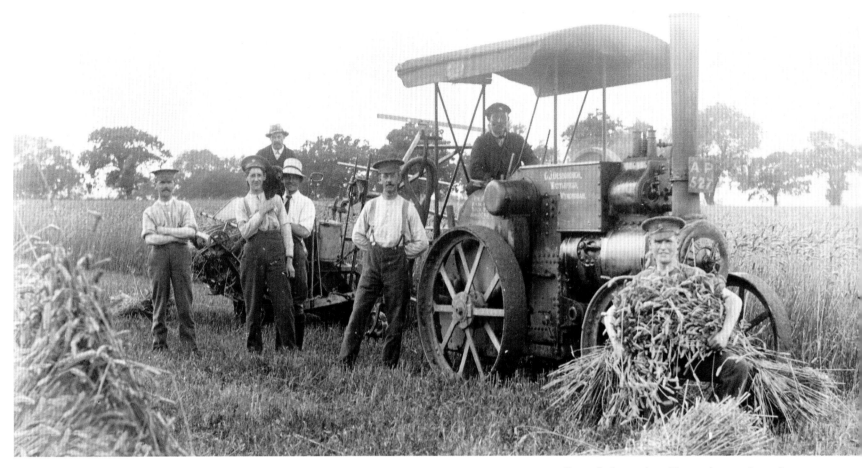

We may have been failures, but we did our best. We failed, indeed, at the end; but the task was almost super-human. It would have taxed the strength and endurance of any man not brought up to the work from childhood, as the hardened labourers are. Looking round among men I know, I can hardly think of one who would have stood one week of the work that we did – and it comes to me at times to wonder if the labourers themselves would stand it if they were not tied and bound to the wheel, with starvation for themselves and their families threatening them always underneath. Such was their plight, at any rate before the war. Toil or starve, day in day out, week by week, with never a pause or rest, and with twelve or fifteen shillings on Saturday nights to keep the wolf from the door, and on which to bring up children fit to carry on the dignity of the race in the next generation.

Is it to be wondered that so many grow up under-fed and under-sized, with rickets and anaemia and consumption, and fill the workhouses and asylums and the ranks of the unemployed? Let us hope those days are gone for ever – that now the country will spend on wages and homes for the living the millions it has been forced to spend on workhouses and homes for the dying. And if this new faith is brought to birth in England – faith in the living and care for the growing instead of the decaying – then the war will have done

Towards the war's end increasing numbers of soldiers, while still under military rule, were selected for labour detail on farms. Those who had previous experience working on the land were given priority.

Which way now? A WLA shepherd arrives at the crossroads.

more for our country than merely to crush the enemy, and with all its misery and bloodshed it may have been worth while.

To know so much of the labourer's life has been a rare privilege and one we shall never regret. We learned to know and to respect and to admire him; and we learnt how much the weight of the world rests upon the patient shoulders of the manual workers, the class formerly of all others to be despised, but now in the future to receive its due – in honour at least, if not in worldly riches.

For ourselves, we saw the seasons through in all their changes of work and weather. And finally we proved to our own satisfaction, and to many a farmer round about, that though woman be weak, ignorant, and inexperienced, yet with energy and determination and a little friendly teaching she can, at any rate in an emergency, just stand in and "carry on".

END

Postscript

The passionate demands, which drove the suffragettes to such extremes in the years before the outbreak of war in 1914, were largely overshadowed by the horror of the events on the Western Front. The grievous effects of a million British dead and missing left little appetite for either side of the suffrage debate to pursue their pre-war aims – the nation was exhausted. As if waking from a dream, politicians – perhaps inspired by the part women had played in supporting the war effort – set aside earlier intransigence and in 1918, the Representation of the People Act enfranchised all women over the age of thirty. In 1928, women received the right to vote on the same terms as men. These seemed somewhat pyrrhic victories for those women who, in the decade before 1914, had risked all fighting for such rights, for while gaining the vote was core to their campaign, universal suffrage was not the end but the means to an end in which women might achieve equality in all spheres of society.

AFTER THE WAR PROBLEMS.
Shall I still wear 'em — or shall I get married?

There was to be no such triumph. Even before the war's end, with many conscripts now surplus to requirements, women found themselves being dismissed from war work, their jobs being taken back by men. Within weeks of the Armistice in November 1918, women were thrown unceremoniously out of their factory and farming jobs, often with little or no notice – and certainly with little thanks. In London and Glasgow redundant women workers marched in protest, to no effect. Indeed women who protested against losing their jobs were greeted with cries of 'blacklegs' and 'limpets'. Nor was their objection merely one of losing the 'right to work'. These were women who, with breadwinners at the Front, had earned meagre wages in order to support fatherless families – in many instances mothers whose husbands would *never* return, and for whom the death toll of so many eligible young men meant lifelong widowhood.

Gaining the vote was one thing; realising the aspirations of women who were seeking a truly equal and just society seemed as unreachable as ever. Equal opportunities in work and education, equal pay, the recognition of the value of labour, of art, animal rights and anti-vivisection – all these things Olive Hockin touches upon in the story of her year on Dartmoor, not forgetting her declaration that "in the name of Medicine and Progress man keeps alive those who naturally would die, leaving the world the better and the healthier for their loss." A startling concept and a dilemma that our society, a hundred years on, is only now waking up to..

Sadly we have no further writings from Olive Hockin that might provide us with a

clearer view of her thoughts on post-war Britain – a country which largely failed to live up to the expectations of all those men and women who gave sacrifice through their work, their wounds, or their deaths. We only know that Olive continued her painting career, evidenced by the few artworks that have come to light in recent years. We know too that on 12 August 1922, aged 41, she married John Harvey Leared, first cousin to Glynne Barrington Leared Williams, who had married Mabel Frances Floyer, sister of Olive Hockin's mother, Margaret Sarah Floyer. It is almost certain that Olive and John had first met in Argentina as teenagers.

At the time of their marriage, John, then aged 46, is described as a trainer of polo ponies – a calling inherited from his family in South America. The couple later have two children: Richard Oliver Leared, born in 1926, and Nicholas Floyer Boxwell Leared in 1929. Olive sees neither of her sons into their teenage years as she contracts leukemia and dies on 5 February 1936, aged 55.

Olive's few known paintings and her story of her year on a Dartmoor farm nonetheless provide enough to conjure a picture of a remarkable woman, fearless and true to herself and her ideals. A woman of her times: artist, author, arsonist.

Bibliography

Adie, Kate. *Fighting on the Home Front*. Hodder & Stoughton, London 2013.

Arthur, Max. *Forgotten Voices of the Great War*. Ebury Press, London 2002.

Aulich, James. *War Posters: Weapons of Mass Communication*. Thames & Hudson, London 2007.

Blythe, Ronald. *Akenfield*. Book Club Associates, London 1972.

Bostridge, Mark. *The Fateful Year: England 1914*. Viking, London 2013.

Bourne, George. *Change in the Village*. Penguin, London 1984.

Brears, Peter. *The Old Devon Farmhouse*. Devon Books, Exeter 1998.

Butler, Simon. *Goodbye Old Friend. A Sad Farewell to the Working Horse*. Halsgrove, Wellington 2010.

Butler, Simon. *The War Horses. The Tragic Fate of a Million Horses in the First World War*. Halsgrove, Wellington 2010.

Butler, Simon. *The Farmer's Wife. The Life and Work of Women on the Land*. Halsgrove, Wellington 2013.

Cockcroft, V. Irene. *New Dawn Women*, Watts Gallery, Surrey 2005.

Crawford, Elizabeth. *The Women's Suffrage Movement- A Reference Guide 1866-1928*. Routledge, London 200.

Dangerfield, George. *The Strange Death of Liberal England*. London, 1935.

Dart, Maurice. *Images of Plymouth & South Devon Railways*. Halsgrove, Wellington 2007.

Emmerson, Charles. 1913: *The World Before the Great War*. The Bodley Head, London 2013.

Evans, George Ewart. *The Pattern Under the Plough*. Faber & Faber, London 1966.

Evans, George Ewart. *Ask the Fellows Who Cut the Hay*. Faber & Faber, London 1965.

Gaze, Delia (ed.). *Dictionary of Women Artists*. Routledge, London 1997.

Grayzel, Susan R. *Women and the First World War*. Pearson Education Ltd, Harlow 2002.

Higonnet, Margaret Randolph et al. *Behind the Lines. Gender and the Two World Wars*. Yale University Press 1987.

Jansen, Diana Baynes. *Jung's Apprentice. A Biography of Helton Godwin Baynes*. Daimon Verlag, 2003.

Laffaye, Horace A. *Polo in Argentina: A History*. Mcfarland, 2014.

Lomax, Pam. 'Women Volunteer Motor Drivers' in the *Journal of the Cornwall Association of Local Historians*. Truro 2008.

Le Messurier, Brian. *Dartmoor Artists*. Halsgrove, Wellington 2002.

Marlow, Joyce ed. *Women and the Great War*. Virago, London 1999.

Martin, E.W. *The Shearers and the Shorn*. Routledge and Kegan Paul, London 1965.

Ouditt, Sharon. *Fighting Forces, Writing Women. Identity and Ideology in the First World War*. Routledge, London 1993.

Stanes, Robin. *The Husbandry of Devon and Cornwall*. Privately published, Exeter 2008.

Stanes, Robin. *The Old Farm*. Devon Books, Exeter 1990.

Stephens, Henry. *The Book of the Farm*. Blackwood & Sons, London 1844.

Stopes, Charlotte Carmichael. *British Freewomen: Their Historical Privilege*. Swan Sonnenschein, London. 1894.

Storey, Neil R. and Housego, Molly. *Women in the First World War*. Shire Publications, Oxford 2011.

Storey, Neil R. and Housego, Molly. *The Women's Land Army*. Shire Publications, Oxford 2012.

Street, Sean ed. *A Land Remembered. Recollections of Life in the Countryside 1880–1914*. Claremont Books, London 1996.

Talbot, Meriel (ed.). *The Landswoman*. various issues. London, 1918.

Torr, Cecil. *Small Talk at Wreyland*. Cambridge University Press, Cambridge 1918.

Various authors. *The Halsgrove Community History Series*. see www.halsgrove.com

Woods, Stephen. *Dartmoor Farm*. Halsgrove, Tiverton 2003.

Woods, Stephen. *Dartmoor Stone*. Devon Books, Exeter 1988.

Woollacott, Angela. *On Her Their Lives Depend*. University of California Press, Berkeley 1994.